IMAGES of America

LIGHTHOUSES AND LIFE-SAVING ON THE OREGON COAST

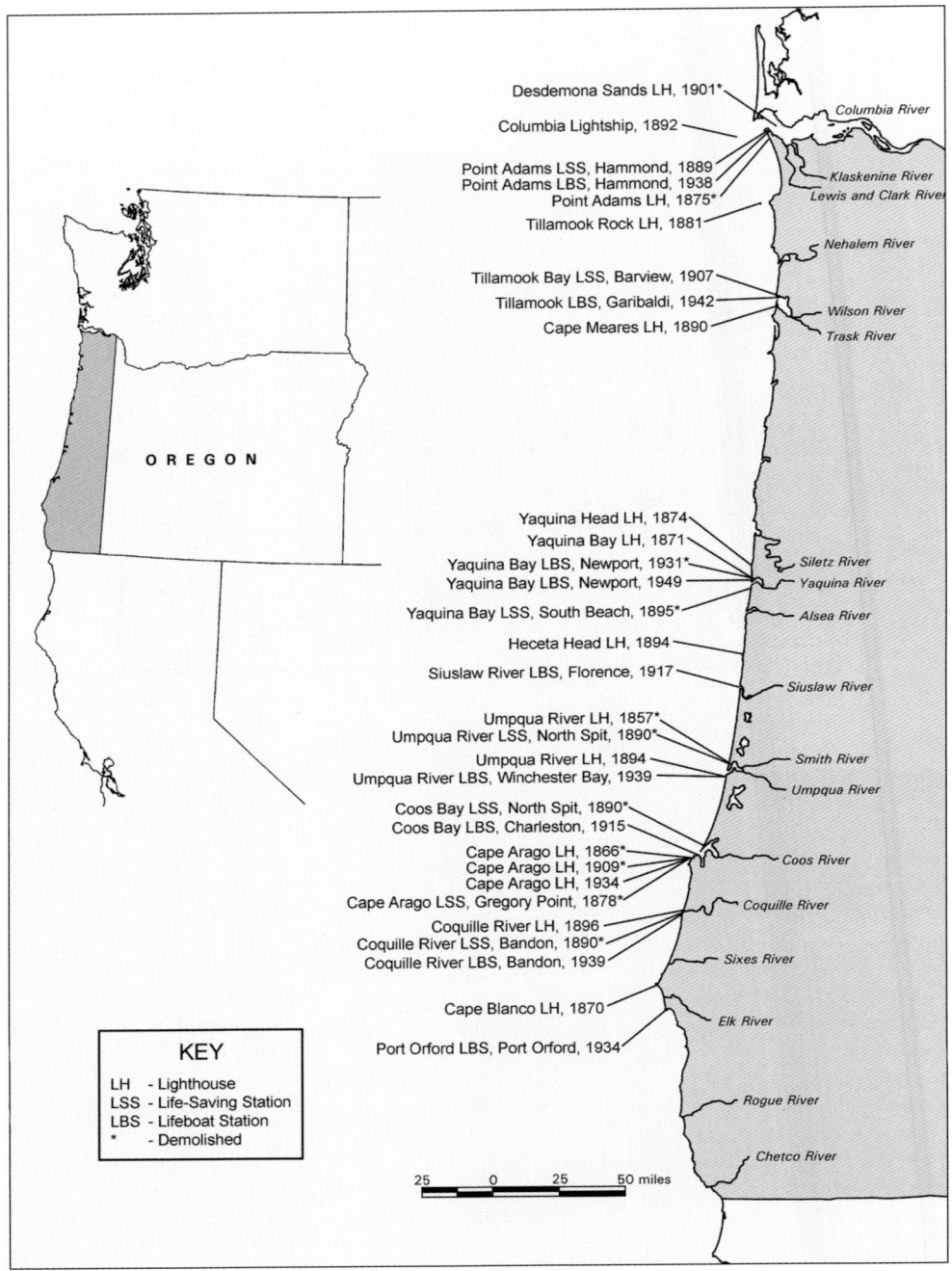

This map of the Oregon Coast shows all the lighthouses, life-saving stations, and lifeboat stations built before 1950. Most still stand; those that don't are marked with an asterisk. (Author's collection.)

ON THE COVER: This photograph was taken around 1910 at the Cape Meares Lighthouse. Cape Meares was, and still is, a popular destination for Portlanders escaping to the coast. Many photographs were taken of tourists on the steps of Cape Meares, seemingly more than at any other lighthouse on the Oregon Coast. (Courtesy of Mike Byrnes.)

IMAGES
of America

LIGHTHOUSES AND LIFE-SAVING ON THE OREGON COAST

David Pinyerd

Copyright © 2007 by David Pinyerd
ISBN 978-0-7385-4887-6

Published by Arcadia Publishing
Charleston, South Carolina

Printed in the United States of America

Library of Congress Catalog Card Number: 2006941035

For all general information contact Arcadia Publishing at:
Telephone 843-853-2070
Fax 843-853-0044
E-mail sales@arcadiapublishing.com
For customer service and orders:
Toll-Free 1-888-313-2665

Visit us on the Internet at www.arcadiapublishing.com

For those who, in the course of their calling, made the ultimate sacrifice

Contents

Acknowledgments		6
Introduction		7
1.	Columbia River	9
2.	Tillamook Rock	25
3.	Tillamook Bay	31
4.	Yaquina Bay	45
5.	Heceta Head	63
6.	Umpqua River	71
7.	Coos Bay	83
8.	Coquille River	101
9.	Cape Blanco	115
Bibliography		127

ACKNOWLEDGMENTS

Many people proved essential in gathering information concerning the lighthouses and life-saving stations of Oregon. The principal contributor was the U.S. Coast Guard archives in Washington, D.C., headed by Robert Browning, whom without this book could not have been created. I am particularly grateful to Mike Byrnes, John Galluzzo, Ralph Shanks, Judy Knox, Michel Forand, Jodi Weeber, Rick Francona, James Claflin, Gail Hemmen, and Glenn Mason for their valuable contributions, encouragement, and support. A special thanks goes to James Gibbs, Oregon's premier lighthouse historian, whose books aided and inspired me greatly. Also thanks to Lewis McArthur, both father and son, for creating and updating their masterwork, *Oregon Geographic Names*.

Special thanks go to Bernadette Niederer for cheering from the sidelines and supporting me unwaveringly.

Finally, I do not claim that this book is comprehensive. The history of the U.S. Lighthouse Service and U.S. Life-Saving Service in Oregon is too complex to be described thoroughly in this short work. I have tried to be as accurate as possible, but in the process of its creation, I have uncovered inconsistencies and errors in other works on the subject and feel deep research is needed to ferret out the facts. Therefore, this book should not be considered the definitive work on the subject; that work has yet to be penned.

INTRODUCTION

In 1857, the lantern of the first federal lighthouse on the Oregon Coast blazed to life at the mouth of the Umpqua River. In 1864, the lighthouse collapsed into the river and was extinguished. Clearly this was not an auspicious beginning to the history of the U.S. Lighthouse Service in Oregon.

The U.S. Life-Saving Service had equally humble beginnings. In 1878, the first life-saving station was erected at Cape Arago. A single keeper manned the island station, and when rescue was needed, he would have to be told of the emergency because he had no view of the coastline. He'd then have to row to town to look for volunteers. Years went by without a single rescue.

Fortunately, after these shaky beginnings, both the Lighthouse Service and Life-Saving Service flourished in Oregon. They became intimately involved in the local economies and were the hub of social activity in their small, coastal towns. Today both services are well represented by their successor institution, the U.S. Coast Guard.

The U.S. Lighthouse Service was established in 1789, the ninth law passed by the new federal government, though America's first lighthouse was built at Boston Harbor in 1716. The U.S. Life-Saving Service was established in 1871, but the service had its roots in the Massachusetts Humane Society, founded in 1785. Maritime trade was key to the survival of the young nation. With shipwrecks came not only loss of life but also monetary loss, and that needed to be stanched.

Lighthouses worked hand in hand with life-saving stations. Lighthouses helped to prevent wrecks; once ships got into trouble, life-saving stations cleaned up the mess. Lighthouses were built at prominent headlands and harbors as aids to navigation for mariners. Only 16 lighthouses were proposed in the early surveys for the entire Pacific Coast, as compared to hundreds for the Atlantic Coast. This was due not only to a smaller population and less shipping, but also to a different manner of sailing on the West Coast. On the East Coast, the shoreline is pockmarked with harbors and villages; therefore, ships tend to hug the shore and dart into safe harbor when storms arise. On the West Coast, ports are farther apart, so ships tend to go farther out into the Pacific and then cut in at harbors. Even still, the mouth of the Columbia River is nicknamed "the Graveyard of the Pacific" for one reason: more than 230 major shipwrecks have occurred in or around the Columbia Bar.

By 1900, there was a full complement of nine lighthouses and one lightship along the 300 miles of Oregon coastline. The staff of a lighthouse consisted of a keeper and often two assistant keepers. Their primary job was to maintain the light. The light was expected to be ready by 10:00 a.m., lit at sunset, and then extinguished at sunrise. Keepers often brought along their families to live with them at the station. Family members were then recruited to help with the light and to maintain the buildings. Since most of the lighthouses were in isolated locations, lighthouse tenders resupplied the station during the year, but most of the lighthouses were made self-sufficient through gardens and livestock. Besides the lighthouse itself with an attached oil room, there would usually be a keeper's house, an assistant keepers' house, plus auxiliary buildings.

By 1907, the Life-Saving Service had erected nine stations at Oregon's major ports. Life-saving stations were larger operations than lighthouses and usually geographically separate. A life-saving

station needed to be near a spot where they could launch a boat during a storm. A life-saving crew was typically made up of eight crewmen and a keeper. The number of men was determined by the numbers needed to row a lifeboat. The keeper was in charge and ran the station like a ship. Typically there would be a station house and a boathouse, but most stations had many auxiliary buildings, often including tiny homes for the families of crew members.

The weekly schedule of the Life-Saving Service was military in precision. Mondays and Thursdays were spent practicing with the beach apparatus. This involved firing a small cannon with a projectile that carried a line over a simulated wreck mast or wreck pole. The crew then erected a breeches buoy, used to rescue people from ship to shore. Tuesday was reserved for boat drills that involved launching, capsizing, rowing, and landing. Wednesday was signal flag practice. Friday was dedicated to medical training. Saturday was station and equipment maintenance day. On a rotating basis, crew members each got one day off a week.

Today the work of the Lighthouse Service is well known, but the Life-Saving Service is less so. Lighthouses were the skyscrapers of their day—stout edifices that still impress. The buildings of the Life-Saving Service were more ephemeral. There are few visible signs left in Oregon of the Life-Saving Service. After their merger with the Revenue Cutter Service in 1915 to become the U.S. Coast Guard, their buildings became more substantial to support larger crews. The Coast Guard stations built during the World War II–era are still few, but they are easily recognized and well known in Oregon.

The emphasis for this book is the period between 1857, when the first lighthouse in Oregon was erected, and 1939, when the Lighthouse Service was merged with the U.S. Coast Guard. The lighthouses and life-saving stations are presented geographically by chapter from north to south, down the coast. In each chapter, the photographs are presented in roughly chronological order starting first with lighthouses and then with life-saving stations.

One

Columbia River

The Columbia River is the largest river on the West Coast and separates Oregon from Washington. At Oregon's northwest corner, the Columbia River flows into the Pacific Ocean. Where the two bodies of water meet, the confluence produces some of the most consistently turbulent water anywhere in the world. Due to these hazardous conditions, the area has become known to mariners as the "Graveyard of the Pacific."

At Oregon's northwest corner are Point Adams and the town of Hammond. The area around Hammond was home to the earliest Euro-American settlements in the West. Lewis and Clark settled in for the winter of 1805–1806, just six miles southeast of Hammond on Young's Bay. Five miles to the east, Astoria was the first American city established on the West Coast. Settled as a fur trading post in 1811, Astoria was named for Pacific Fur Company pioneer John Jacob Astor, 88 years before Hammond officially became a town. The original indigenous populace of the area were the Clatsop Indians.

All the people who settled on the tip of Oregon were drawn by the same thing—the Columbia River. The river acted as a highway into the interior, it provided plenty of fish and ample game along its banks, and there were seemingly inexhaustible supplies of fur-bearing creatures. Despite a tense feud between the British and Americans, Astoria held on, and gradually American settlers began to populate the area. In the 1840s, Portland was becoming the major trade center north of San Francisco. The news of gold strikes in California in 1848 solidified the link between Portland and San Francisco, with Astoria acting as a waypoint for those traveling by sea. A customs house was established at Astoria in November 1848 to monitor goods sailing between San Francisco and Portland.

Development of the ports along the Oregon Coast was hampered by a lack of aids to navigation. When the *Tonquin* arrived with Astor's party from the Pacific Fur Company in 1811, they lost two boats and eight men while taking soundings to navigate over the Columbia bar. Soon a primitive range system was set up for river navigation. White flags would be tied to trees on the shore, so that when the pilot aligned the ship with the flags, it showed that the ship was in the channel. At night, the flags would be substituted with bonfires; however, piloting in the dark was rarely risked. Bar pilots came into use in the 1840s and were licensed by the Oregon provisional government starting in 1846.

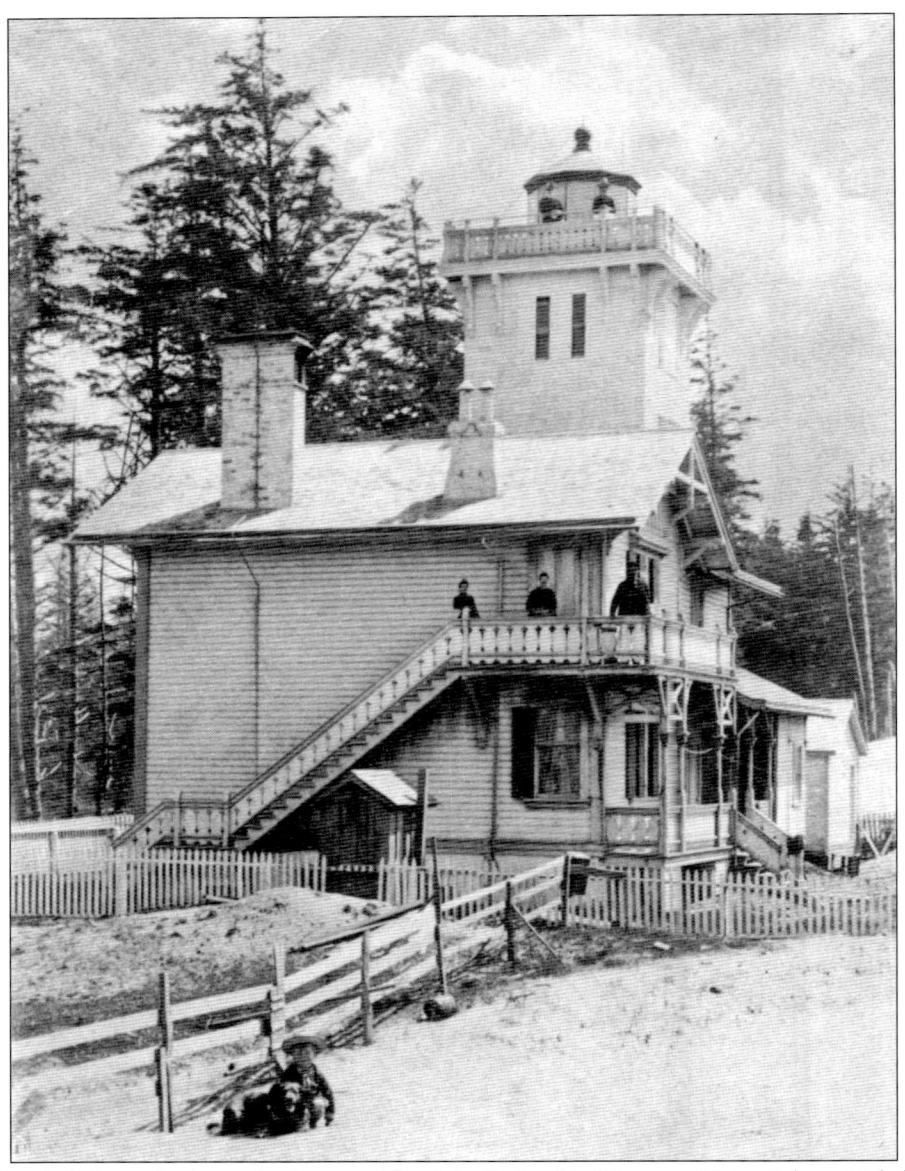

The first lighthouse built on the Oregon side of the Columbia River was Point Adams Lighthouse in 1875. Arguably the most ornate lighthouse to be built in Oregon, it was a wood-frame tower protruding from an Eastlake-style house. The tower rose 49 feet high and held a fourth-order lens, visible for 11 miles. (Its partner light was the Cape Disappointment Lighthouse on the river's Washington side, the first major navigational aid to be established in the Oregon Territory when it was lit in 1856. The Cape Disappointment light is still active today and is the oldest on the Pacific Coast.) The Point Adams Lighthouse was located one mile south of Point Adams, near the current site of Fort Stevens' Battery Russell (1897). Because of its location facing the ocean, the lighthouse was made somewhat redundant with the opening of the Tillamook Rock Lighthouse in 1881. In 1899, the lighthouse was discontinued but found use as a fire control station for the coastal defenses. The former lighthouse was torn down in 1912, leaving behind very few photographs and no aboveground remains in the dunes. (Courtesy of Friends of Old Fort Stevens.)

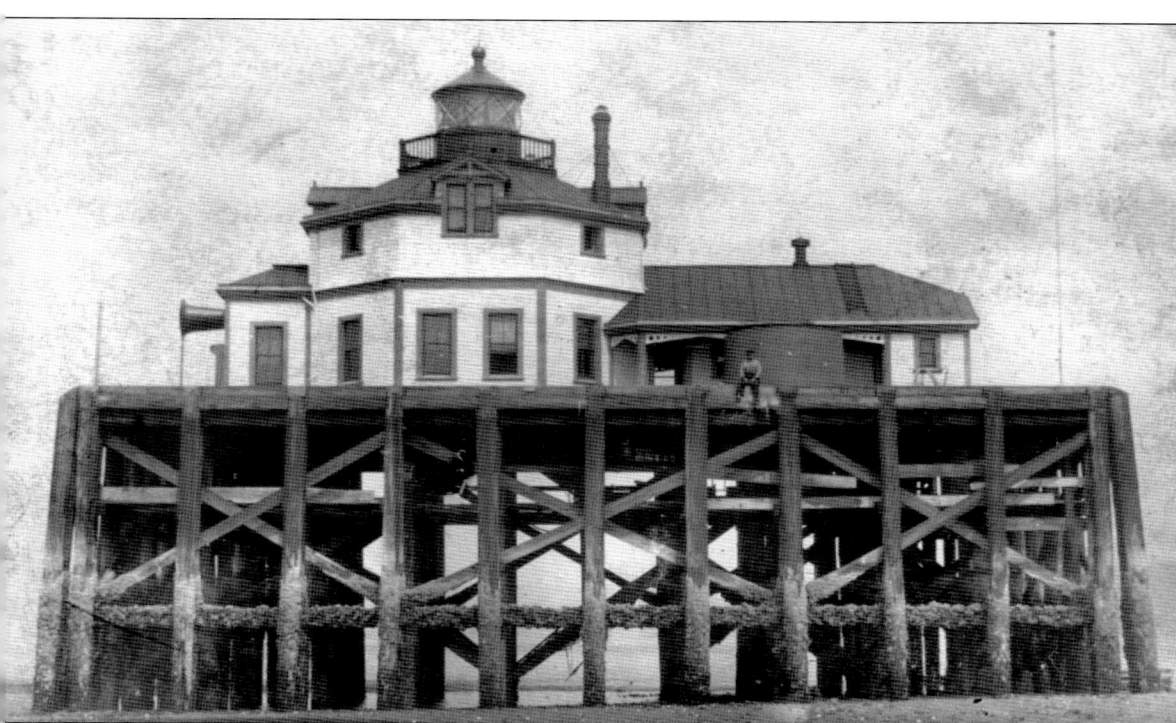

The Desdemona Sands Lighthouse was built on the end of a shoal named Desdemona Sands, inside the mouth of the Columbia River, and within sight of Astoria. The lighthouse was basically an octagon-shaped house with a lantern mounted on top. It was built in 1902 on large pilings and rose 48 feet above the water. Inside the tower was a fourth-order, fixed-lens light that could be seen for 12 miles. On the west side of the structure was a Daboll foghorn. A cistern collected rainwater for the station off the metal roof. Fire was always a concern, and in 1916, the station almost burned to the ground when a bottle of alcohol exploded. Flames were seen on both sides of the river and a flotilla of boats rushed to the scene; however, the keepers were able to bring it under control by the time they arrived. (Courtesy of Michel Forand.)

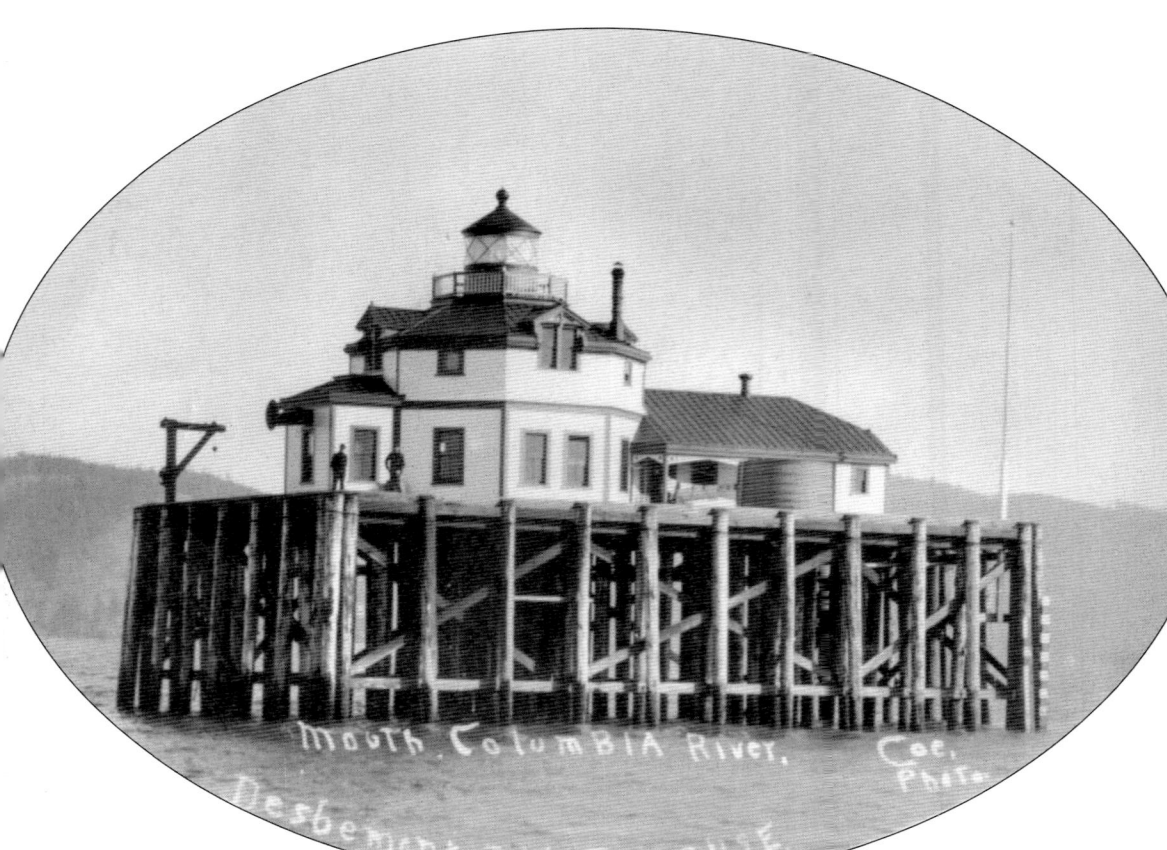

Desdemona Sands received its name from the wreck of the *Desdemona* on New Years Day 1857. Its captain, Francis Williams, was trying to win the prize of a new suit by getting his cargo in quickly from San Francisco and attempted to navigate the Columbia River without a bar pilot. He ran aground on the shoal that now bears his ship's name. Attempts were made to pull the bark off, but she held fast. Salvage operations began immediately, but a storm came up, sinking a lighter and drowning one worker. The ship was sold to Moses Rogers for $215, who stripped it of everything useful and abandoned the hull. The sands of the shoal eventually enveloped the skeleton. (Courtesy of Michel Forand.)

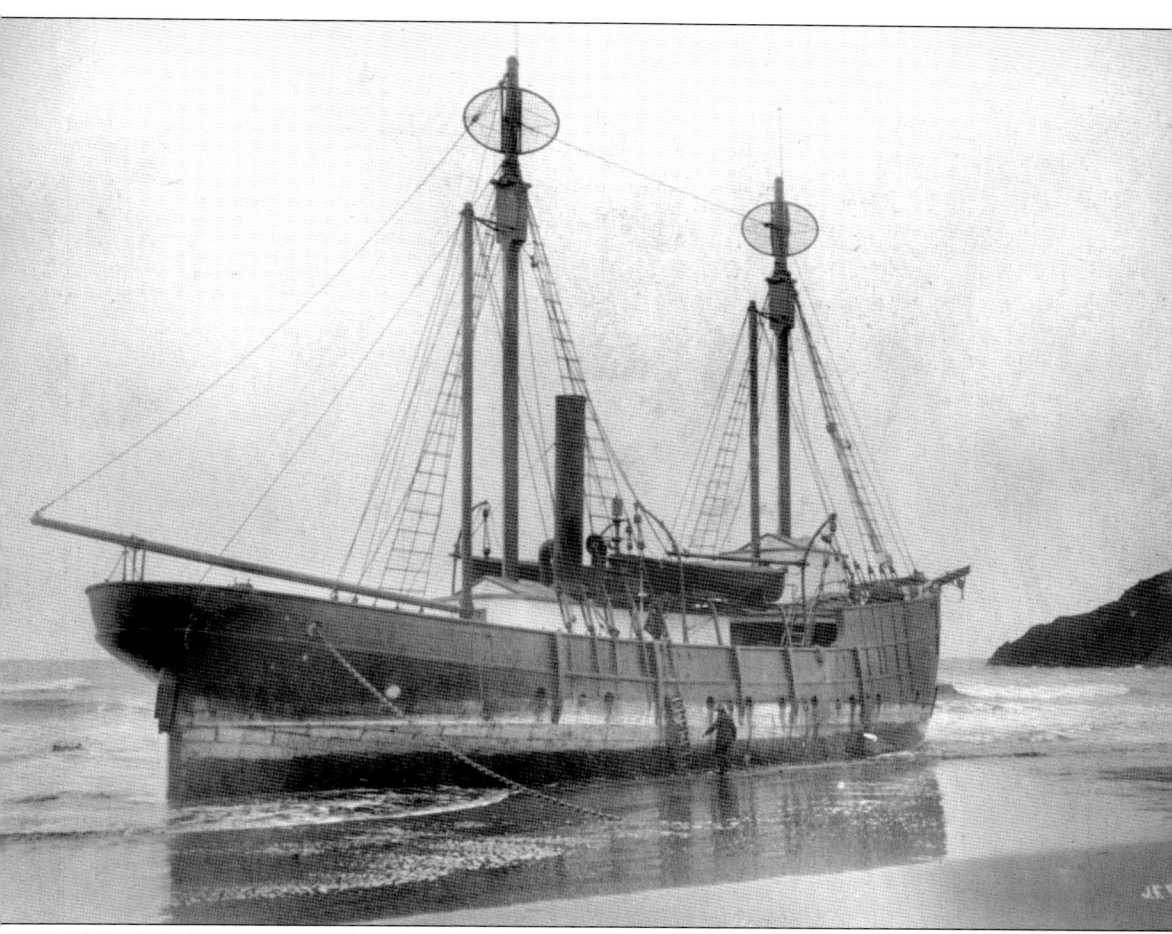

The *Columbia River Lightship No. 50* was put in service on April 9, 1892. The ship was solidly built in San Francisco and was 123 feet long. Oil-fueled lanterns topped the ship's two masts. It had boilers to operate its foghorn and windlass, but it had no means of propulsion other than sails in an emergency, so it was towed into place about five miles southwest of the river's mouth. The lightship was fixed in place in 210 feet of water by three anchors totaling 9,300 pounds. However, on the night of November 28, 1899, a heavy sea tore apart her anchor cables. The crew raised the sails, which helped keep her offshore but were eventually shredded by the storm. Three ships came to her aid in the morning and got lines to her, but all lines parted, and the *Columbia* went up on the beach at McKenzie Head north of the Columbia River's mouth. Fortunately, the ship went up on a sandy beach. The life-saving crews from both Cape Disappointment and Point Adams stations arrived at the scene, set up a breeches buoy, and were able to get the crew off the ship alive. (Courtesy of U.S. Coast Guard.)

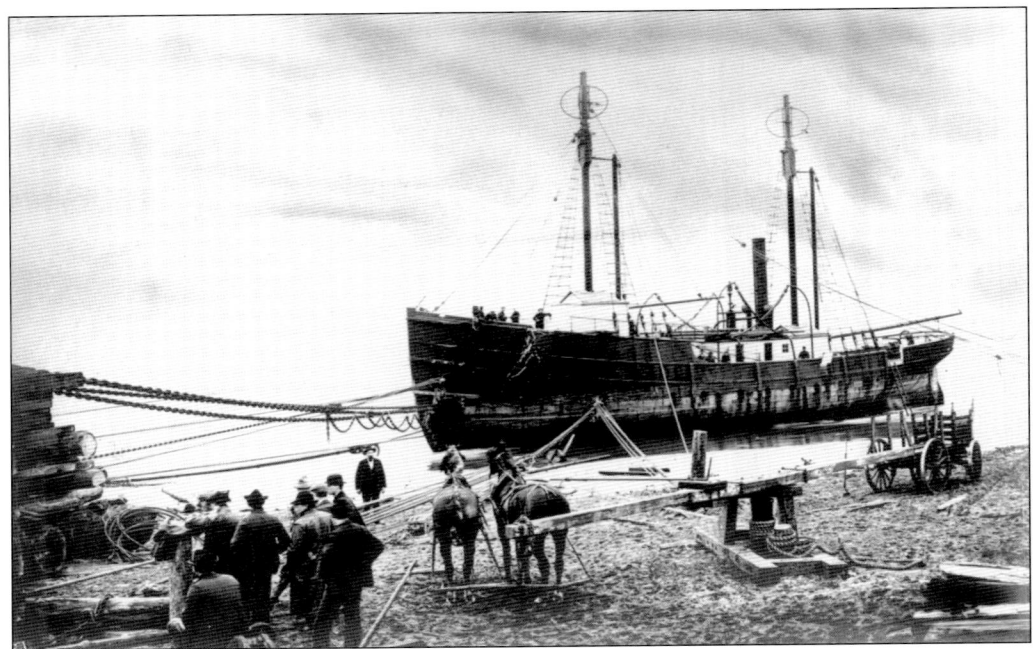

All December, the Pacific pounded the sturdy ship. In January, a contract was signed to allow Capt. Robert McIntosh to try and get the ship off the beach. He managed to get the *Columbia* afloat, but the ship was driven back even higher on the sand. The contract was cancelled in June, and new bids were requested to rescue the ship. The firm of Wolff and Zwicker was chosen to try and pull the ship off, but by this time a large sandbar had built up on the seaward side of the *Columbia*. They tried and failed. In January 1901, bids were requested one last time to save the ship; however, this time the proposal required that the ship be moved overland. (Courtesy of U.S. Coast Guard.)

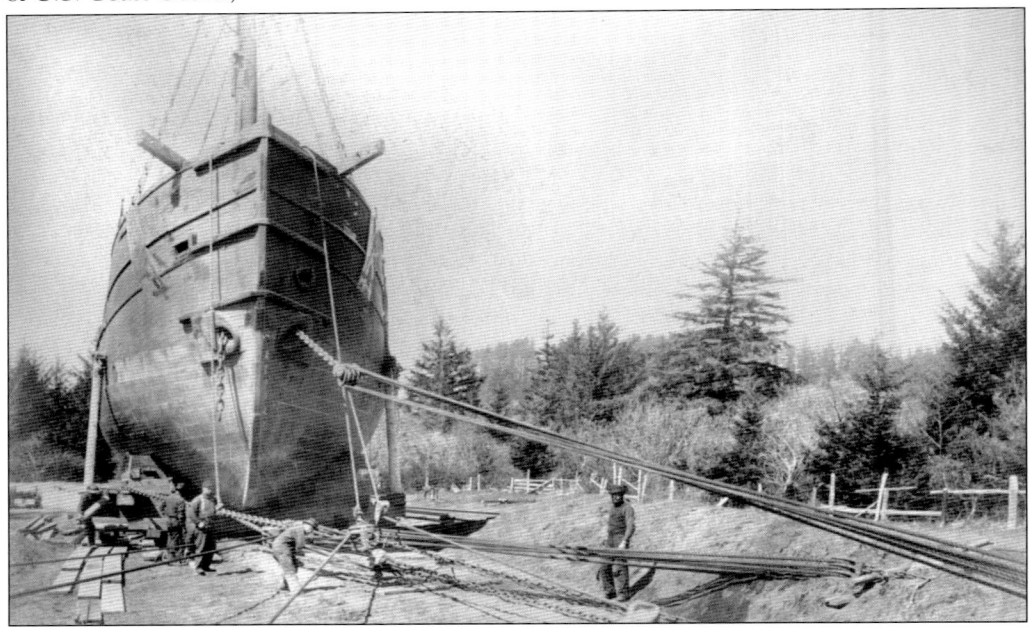

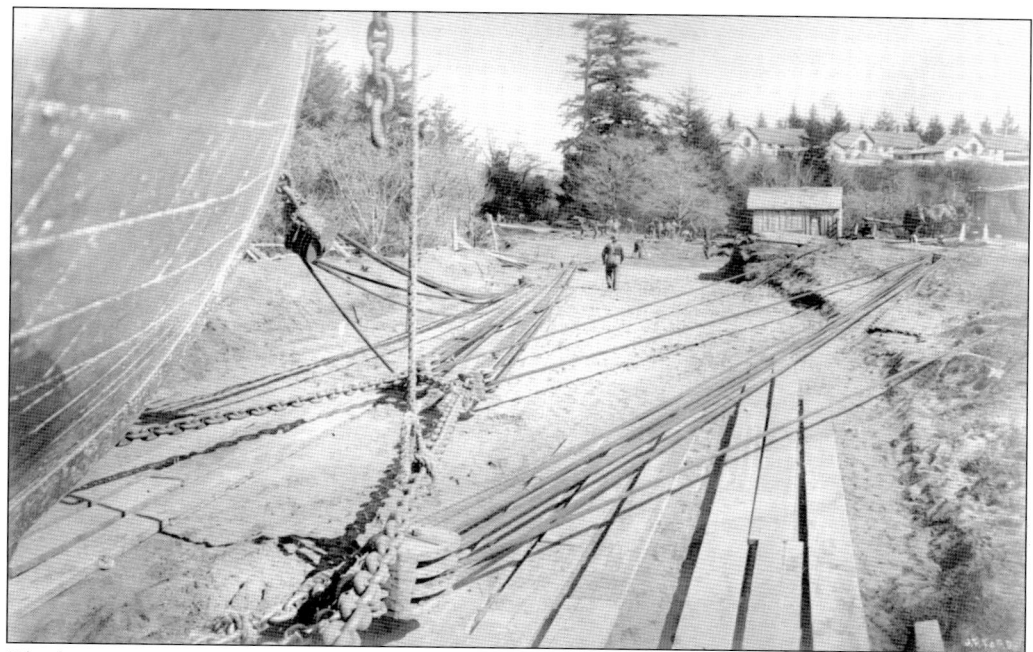

The house-moving firm of Allen and Roberts submitted a bid to drag the ship overland across a narrow neck of land and to relaunch the ship in quiet Baker's Bay. Their $17,500 bid was accepted as was their promise to complete the work in 35 days. Work began on February 22, 1901, with a team of 40 men. March proved fruitless, but in April, the men were able to get cables under the ship and raise it up into the air. This series of 9 photographs comes from a book of 35 images taken by J. F. Ford and printed by the partnership of Andrew Allen and J. H. Roberts in commemoration of the overland move of the *Columbia* lightship. (Courtesy of U.S. Coast Guard.)

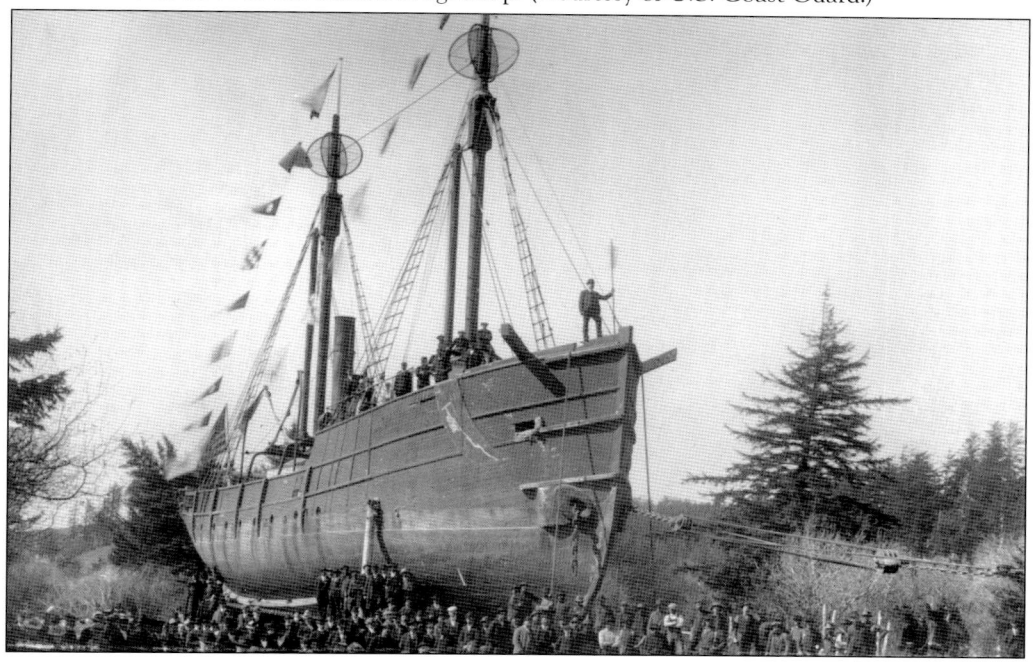

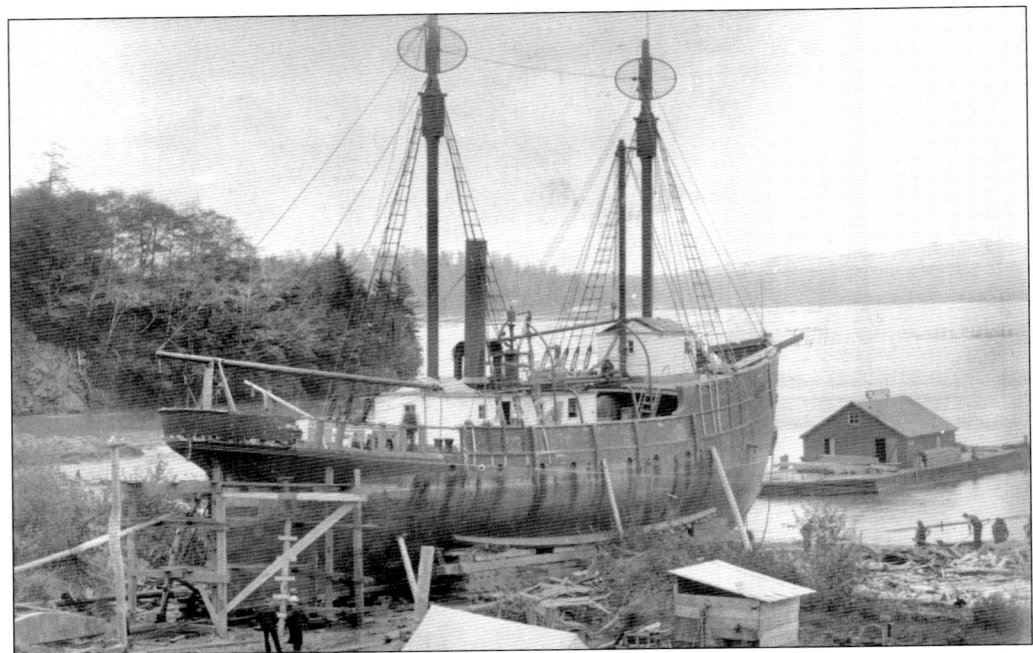

Though the promised 35 days had run out, the government decided to waive any time penalties and let Allen and Roberts continue with the move as progress was finally being made. Spectators came from miles around, as the ship in its cradle started gliding over the sand and up the hill toward its destination a half-mile away. On April 21, with the ship almost in Baker's Bay, the move was halted. The ship had taken a great pounding over two winters; the *Columbia* had lost her keel, sternpost and rudder, and some of her copper hull cladding. Allen and Roberts were awarded the contract to do the repairs and started building a launch ramp. (Courtesy of U.S. Coast Guard.)

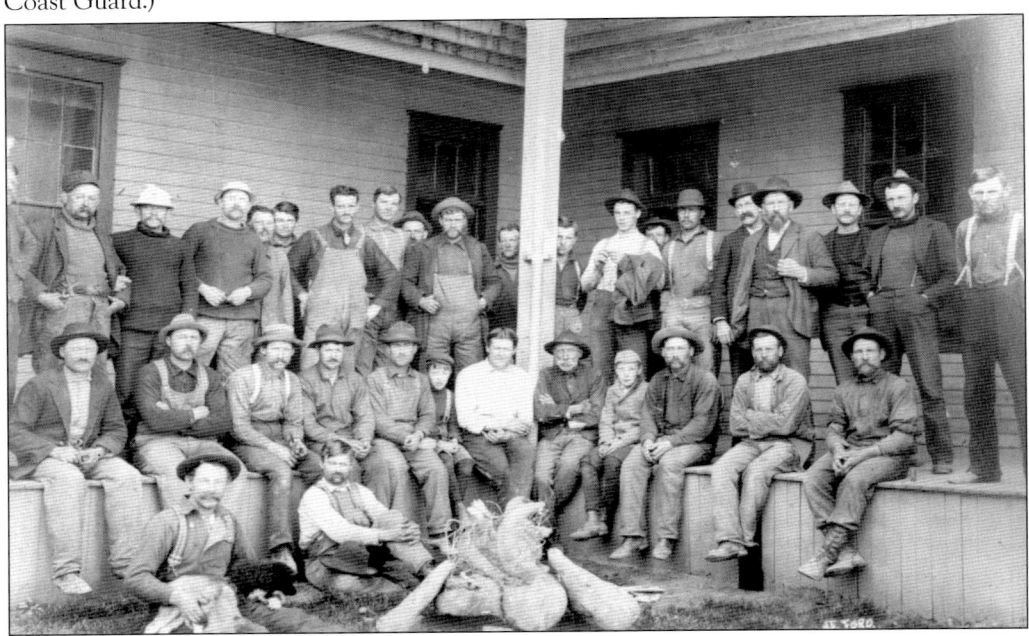

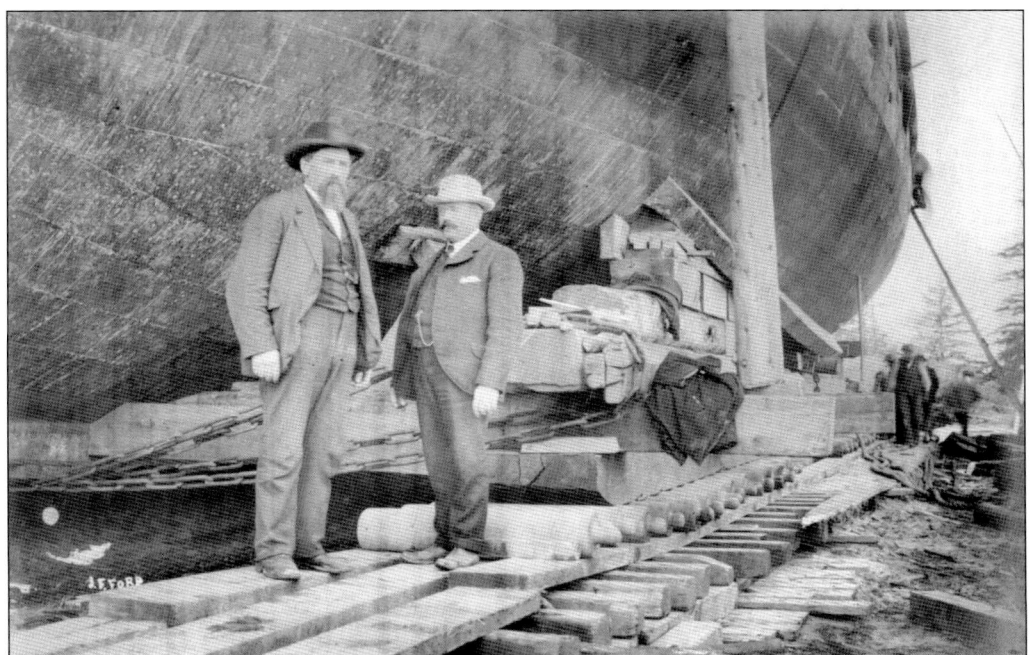

Andrew Allen (left) and J. H. Roberts (right), standing next to the hull before the *Columbia's* relaunching into Baker's Bay, had silenced naysayers with the successful overland journey of the ship. On June 2, the lightship was relaunched and towed to Astoria by the *Callender*. On August 18, 1901, *Columbia River Lightship No. 50* was back on station. In 1909, *Lightship No. 88* arrived, and *Lightship No. 50* was retired. In 1914, it was sold to become the Mexican freighter *San Cosme*. In 1920, she returned to the United States as the *Margaret* and served a cannery. In 1935, she was scrapped in California at the age of 44. (Courtesy of U.S. Coast Guard.)

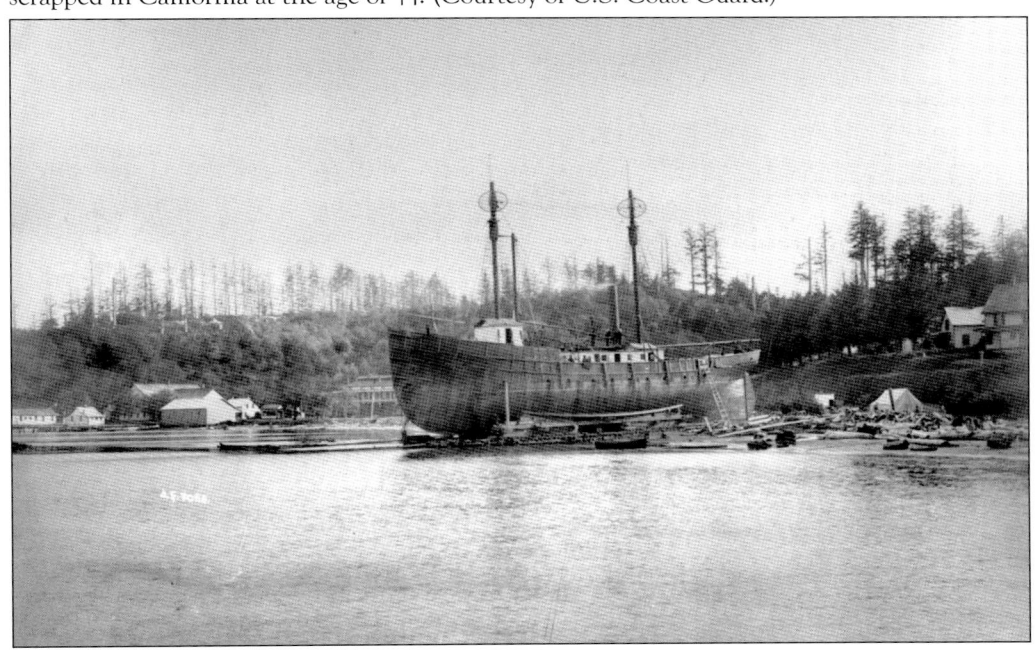

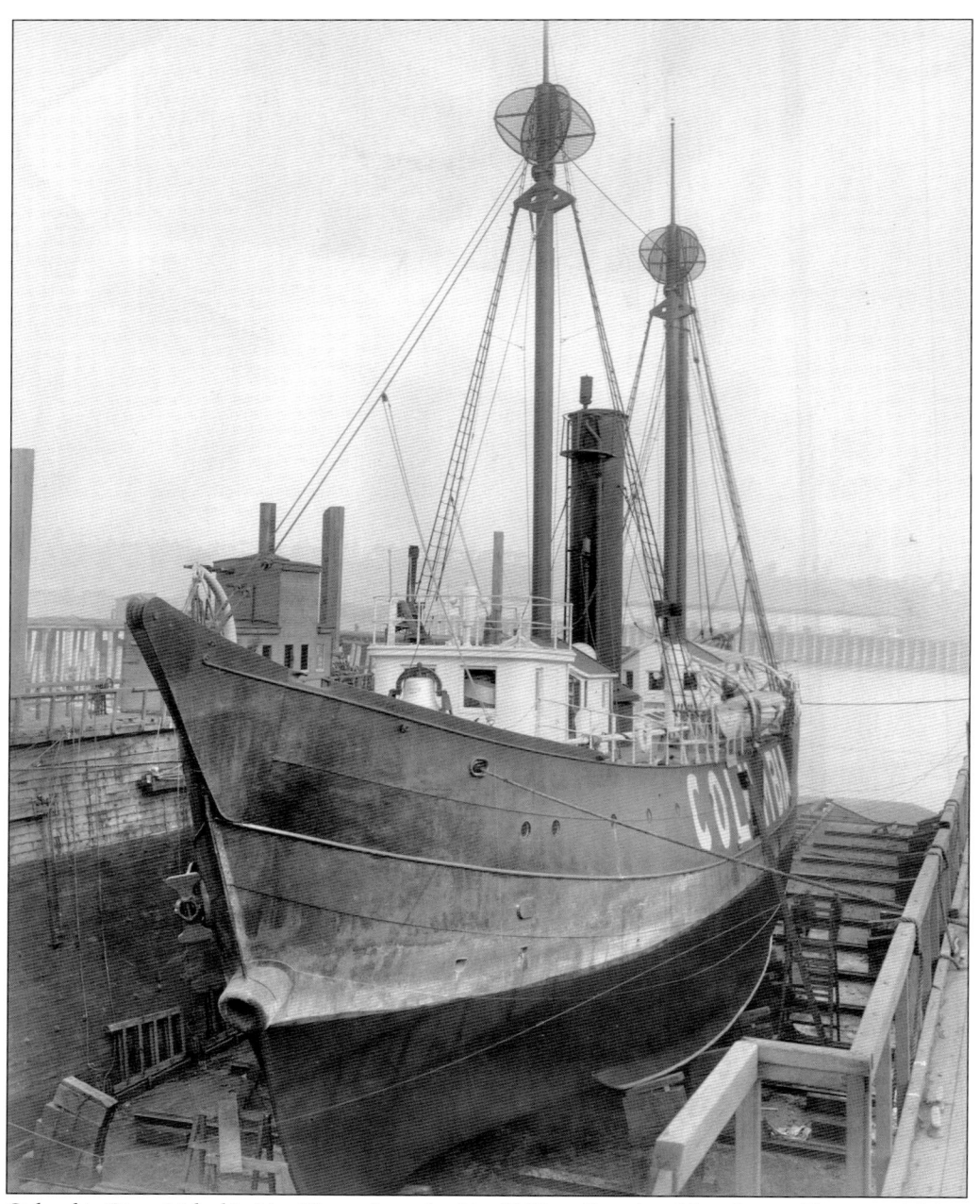
Columbia River Lightship No. 88 was launched in 1907 in Camden, New Jersey. She was 125 feet long and, in a departure from her predecessor, had steam propulsion. In 1939, when the Coast Guard took over the Lighthouse Service, *No. 88* was shifted to Umatilla Reef and renumbered *No. 513*. The *Umatilla No. 93* took over at the Columbia River and was renamed the *Relief No. 93*. (Courtesy of U.S. Coast Guard.)

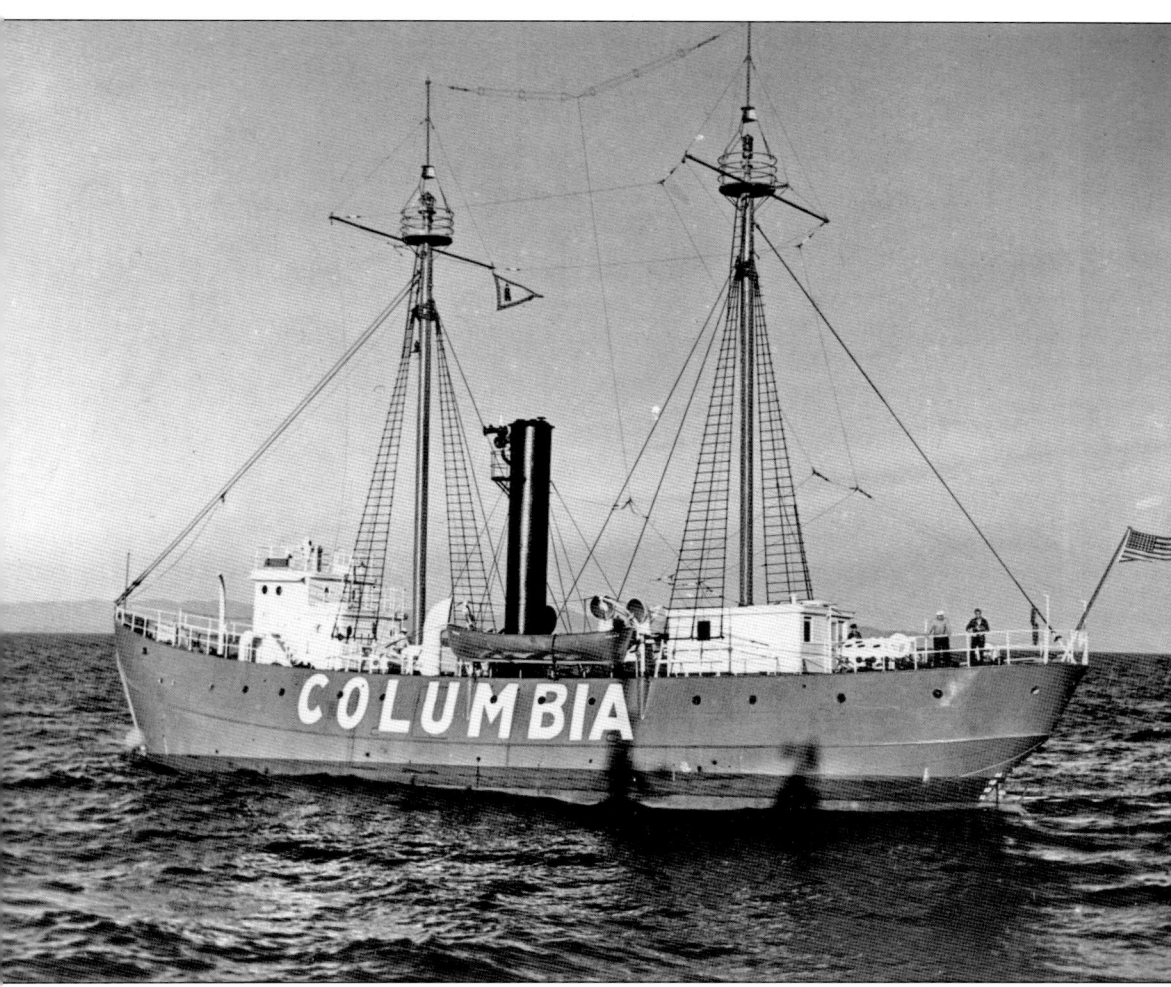

Columbia River Lightship WAL-604 was built in 1950 by the Rice Brothers in East Boothbay, Maine. She took over the position at the mouth of the Columbia from the Relief No. 93 in 1951. No. 513 (formerly No. 88) was decommissioned in 1960. In 1979, the lightship WAL-604 was retired and replaced with an unmanned buoy. The WAL-604 is on permanent display at Oregon's premier maritime museum, the Columbia River Maritime Museum in Astoria. (Courtesy of U.S. Coast Guard.)

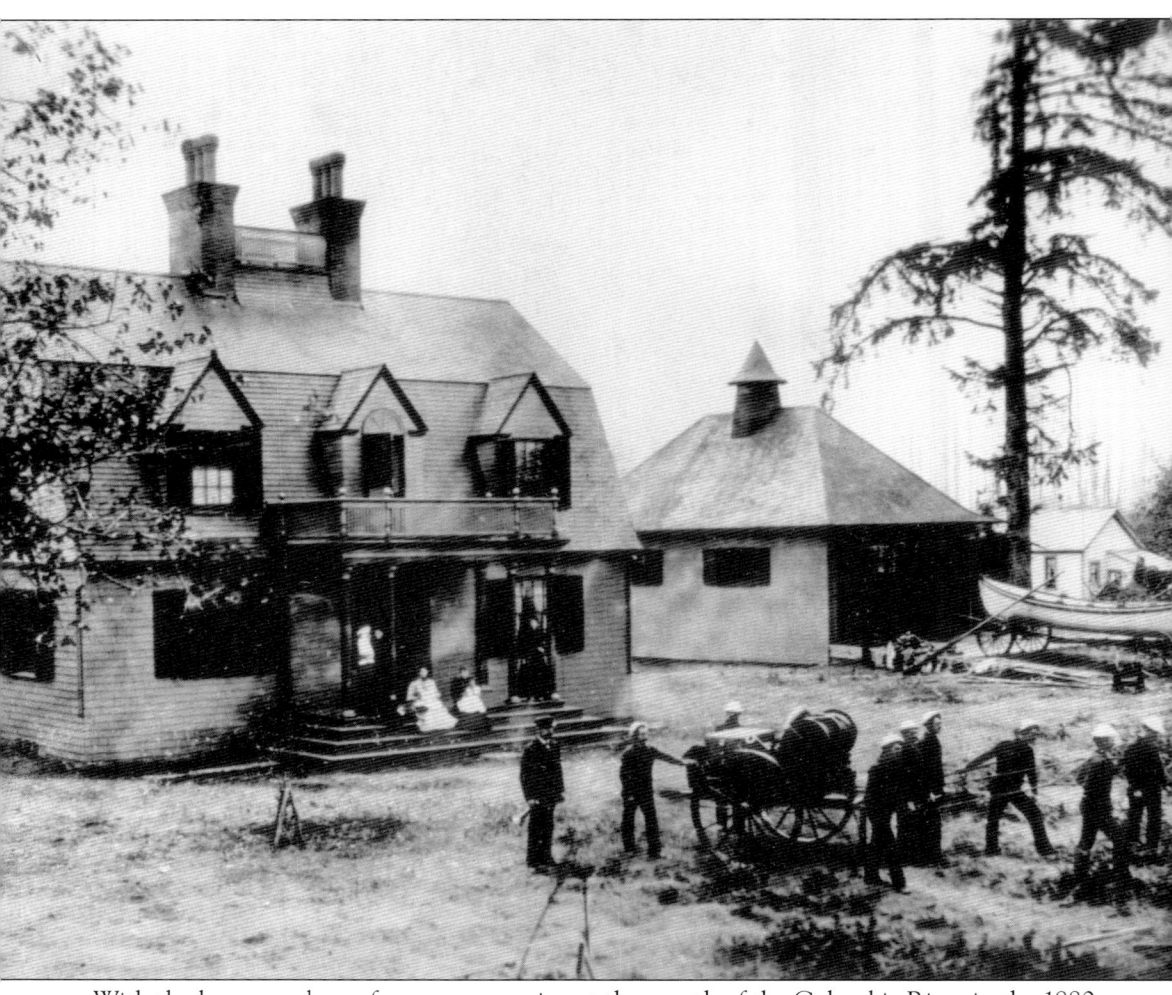

With the large numbers of rescues occurring at the mouth of the Columbia River in the 1880s, Superintendent Sumner Kimball deemed another station necessary on the south side of the river to join the Cape Disappointment Life-Saving Station (1882) on the north side of the river. Oregon Sen. John H. Mitchell requested an appropriation for a life-saving station at Fort Stevens in early 1886. In April, Congress quickly approved funding. Land was purchased at a lightly populated, waterfront area east of Fort Stevens on the north edge of what was soon to become the town of Hammond. The Point Adams Life-Saving Station was built during 1889 and put into service in December. It was the first true life-saving station to be erected in Oregon, as the Cape Arago Life-Saving Station did not have a crew, only a keeper, prior to 1890. (Courtesy of U.S. Coast Guard.)

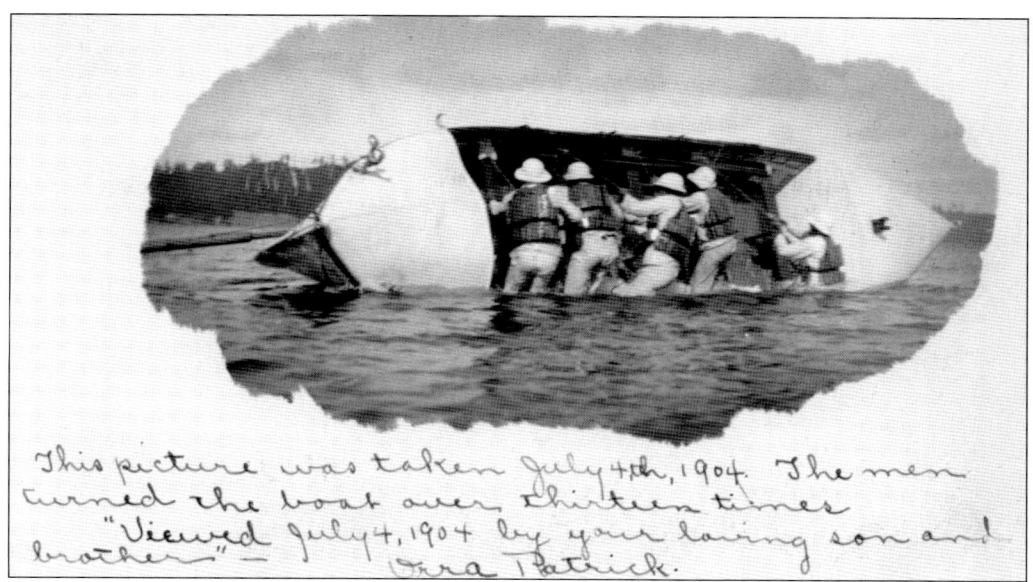

Capsizing at sea was serious and that is why surfmen trained for it. A capsize drill would start with the men seated; they would then grab lines, pull to one side of the boat, and flip the boat upside down. The crew would then lift one side of the boat in unison while still in the water, flip the boat right side up, pull themselves in, and return to their seats on the thwarts. The fastest time ever recorded to capsize a lifeboat and return to the seated position was 13 seconds. (Author's collection.)

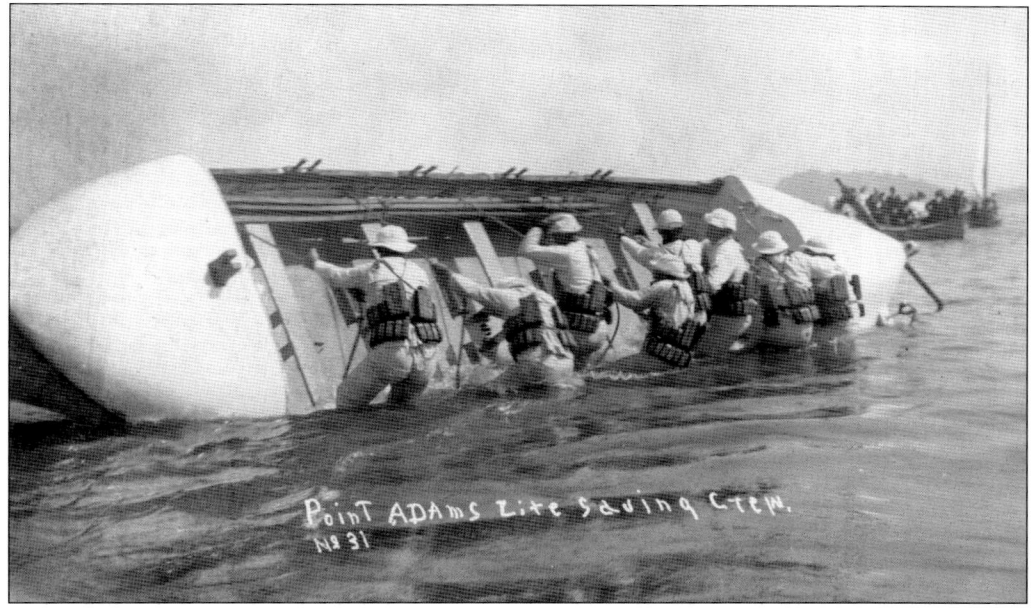

The Point Adams station had eight men on duty year-round. Starting in 1900, an extra man supplemented the crew from May 1 to August 25, the only Oregon station to have such a large crew during the Life-Saving Service era. The Cape Disappointment station across the river also received a ninth surfman in 1900. The Point Adams and Cape Disappointment stations were two of the five most heavily staffed stations in the nation. (Author's collection.)

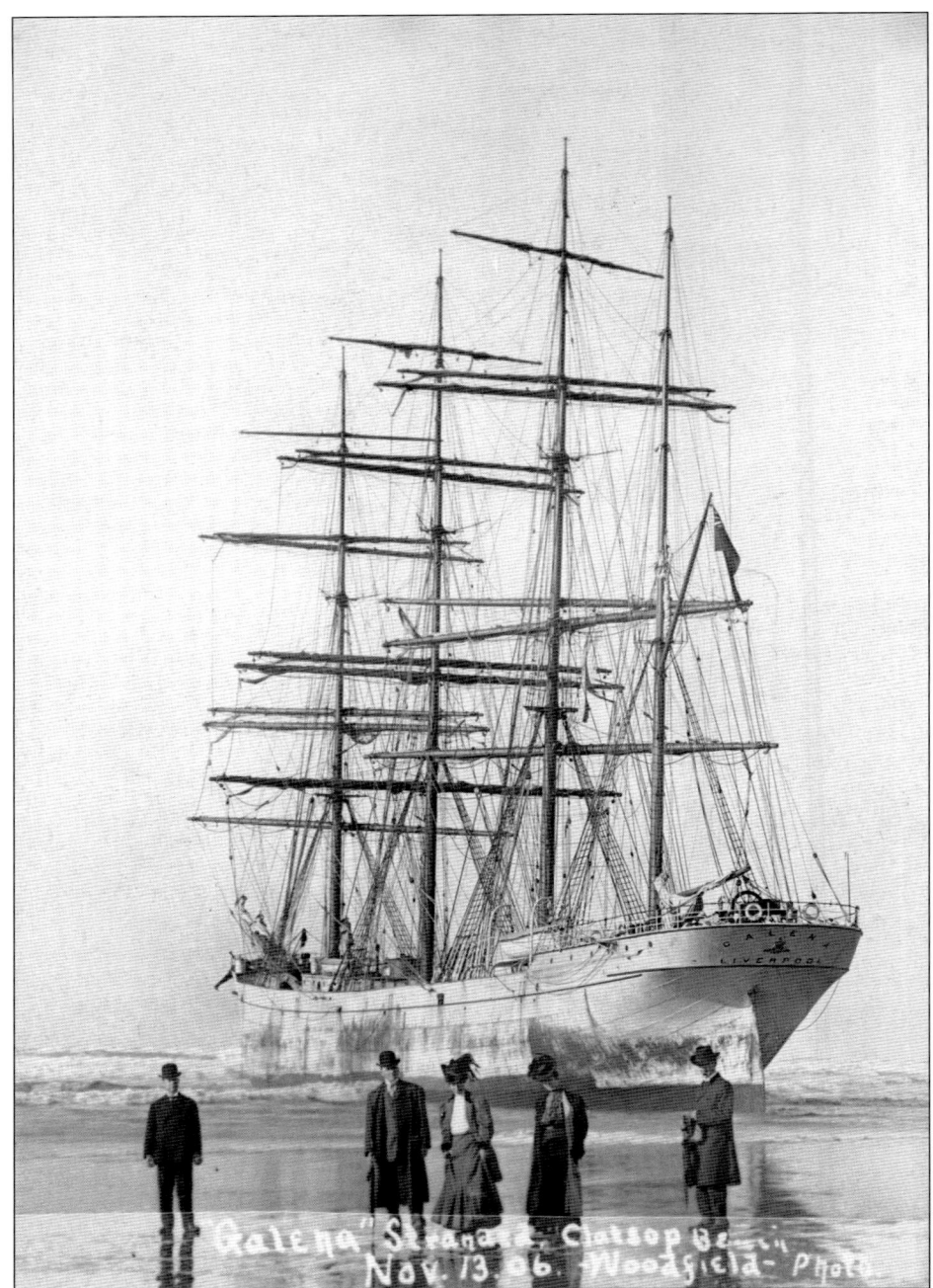

The British bark *Galena* ran aground at Clatsop Beach on November 13, 1906. She was inbound from Chile to load grain at Portland. The weather was severe, and the vessel was waiting outside the mouth of the Columbia River to pick up a pilot. She got in too close and was carried onto the beach just 18 days after the *Peter Iredale* had stranded under similar conditions a few miles north. Although the *Galena's* hull remained more or less intact for some years, she was finally scrapped. The rusty remains of the *Peter Iredale* are still visible today in the sands at Fort Stevens State Park. (Courtesy of Mike Byrnes.)

The Point Adams Lifeboat Station was erected to replace the inadequate life-saving station house built 50 years earlier in 1889. The new station was the first of the four Roosevelt-type stations to be built on the Oregon Coast. These stations followed a standard plan developed by the Coast Guard and were for the most part built during Franklin Roosevelt's administration (1933–1945), hence the designation. The new Point Adams station was begun in October 1938 as a Public Works Administration (PWA) project. George Buckler of Portland was the general contractor, and it cost $44,000 to build. What was unusual about the construction process at Point Adams was the proximity of the old and new buildings. The Coast Guard designers wanted to put the new station as close as possible to the site of the old station; however, they also wanted to continue to use the old station until the new station was ready in April 1939. Therefore, the new station was built just a few feet in front of the old station. (Courtesy of U.S. Coast Guard.)

The Point Adams and Cape Disappointment life-saving crews found themselves extremely busy during fishing season. Just outside the mouth of the Columbia lay the favorite fishing ground for gillnetters. Almost every year, the U.S.L.S.S. *Annual Reports* document the death of one or two of the fishermen. The boats the gillnetters used were small and crewed by two men, a boat puller and a net puller. The nets were long and heavy and often dragged the boat and the men into the breakers. (Author's collection.)

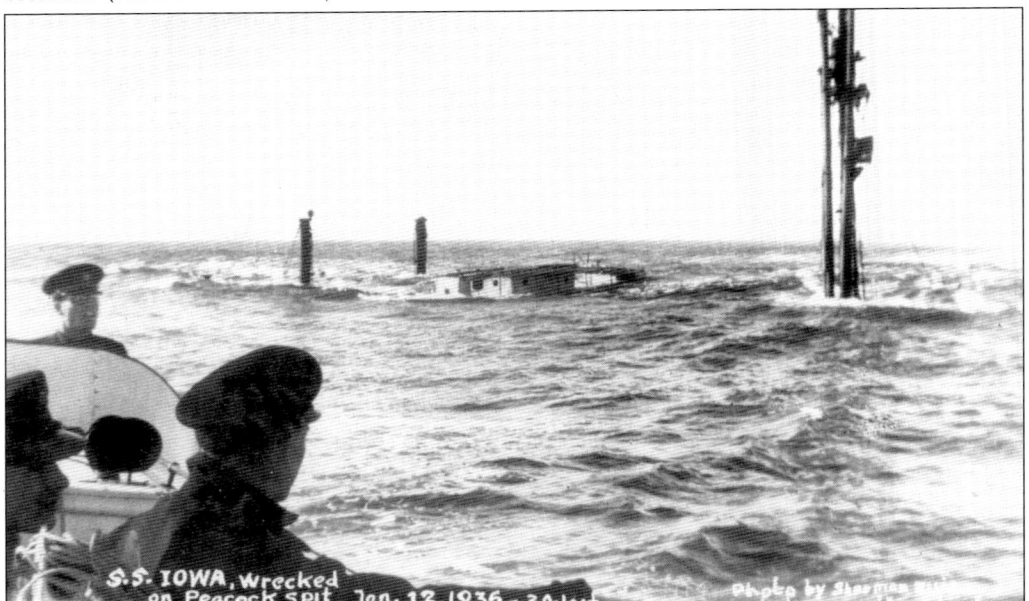

On the night of January 12, 1936, the freighter *Iowa* left the mouth of the Columbia River bound for New York City into a fierce gale. One faint SOS was heard, and the Coast Guard cutter *Onondaga* put out immediately in search of the distressed vessel. She was located within a few hours, broken in half with only her masts above water. Thirty-four sailors died, with only six bodies ever recovered, creating one of the worst maritime disasters at the bar. (Author's collection.)

Two

Tillamook Rock

For generations, the Tillamook Rock Lighthouse has captivated visitors to the north coast, making it one of the most famous lighthouses in America. It sits 1.25 miles off shore and often disappears into the fog and sometimes even under the waves. Natives believed the rock it stands on to be the home of a god. It is also the only Oregon lighthouse not accessible by foot. Today its light does not shine, but the building itself still stands as the only lighthouse in the America used as a columbarium.

It all began in 1878, when the government decided to build a lighthouse at Tillamook Head. Further investigation revealed that the headland would not be a good place for a lighthouse because the only place to build on the headland was 1,000 feet up the cliff and that was too high up into the fog layer. In July 1879, the Lighthouse Board finally decided that the light would be built upon Tillamook Rock, a small islet of rock off Tillamook Head.

Master mason John R. Trewavas drowned trying to reach the island to do survey work. Word spread that the project was too dangerous, and a local campaign was mounted to stop the project. Charles A. Ballantyne was hired to replace Trewavas, and he recruited workers outside the area and kept them sequestered from the locals. On October 21, 1879, four laborers were dropped off on the island with tools and a few provisions. A breeches buoy was rigged between the ship and the rock to deliver more materials over the following weeks. All work was done completely exposed to the elements, as there was no place to shelter. Work was slow as they hacked out a ledge on which to erect a derrick.

They worked through the winter, sleeping in wet tents bolted to the rock. Their supply shelter and some of their tools were washed away in January 1880. By May, they had succeeded in blasting off a shelf for the lighthouse. A 45-foot derrick was built with a 75-foot boom. Stone started arriving from Astoria; Bellingham, Washington; and Portland's Mount Tabor. After 15 months of perilous construction on the rock, the lamp was lit on January 21, 1881. Total cost was $125,000—nearly the cost of two lighthouse stations onshore.

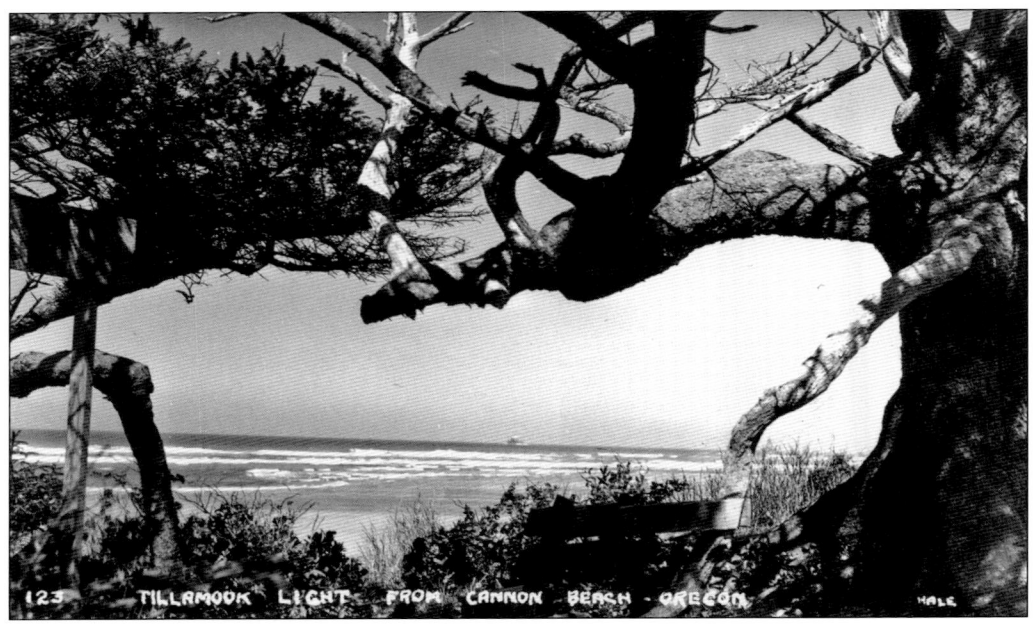

Landing at Tillamook Rock was an ordeal in itself. The first attempt to get a man on the island in 1879 resulted in a drowning. A second attempt got two men on the island by surfboat, but to get back, they had to jump into the frigid water and then be pulled into the boat. Finally, lighthouse engineer H. S. Wheeler was able to get onto the island and climb the guano- and slime-covered rock to take some measurements. Wheeler informed the Lighthouse Board that a lighthouse could be built, but understated the proposition by writing that it would be "a task of labor and difficulty." (Author's collection, above; courtesy of U.S. Coast Guard, below.)

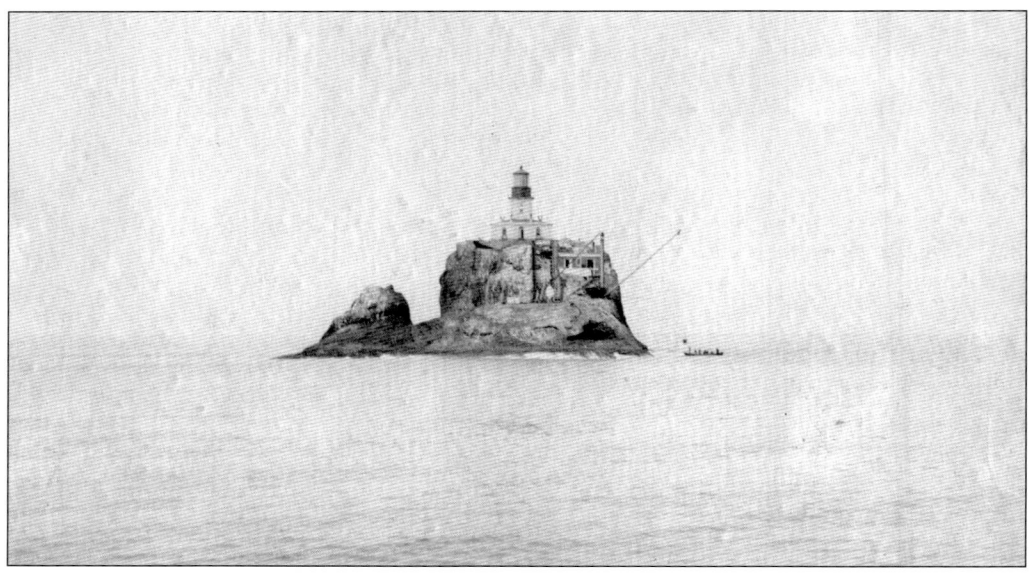

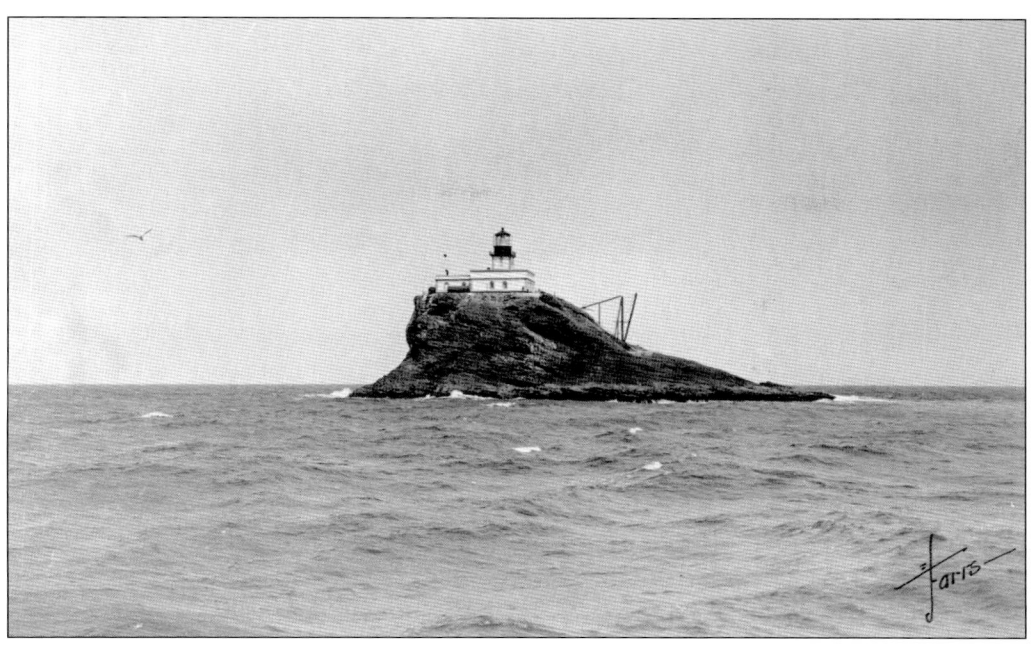

Tillamook Rock was supplied by a variety of lighthouse tenders owned and operated by the U.S. Lighthouse Service. The tenders provided the means to bring provisions and workers to the isolated lighthouses. The rocky nature of lighthouse locations made this duty very hazardous. Around 1915, when the photograph below was taken, it would be the *Columbine* pulling up to the rock. The *Columbine*'s sister ship, the *Manzanita*, sunk in 1905 but was later salvaged to become the steam tug *Daniel Kern*. (Courtesy of U.S. Coast Guard, above; author's collection, below.)

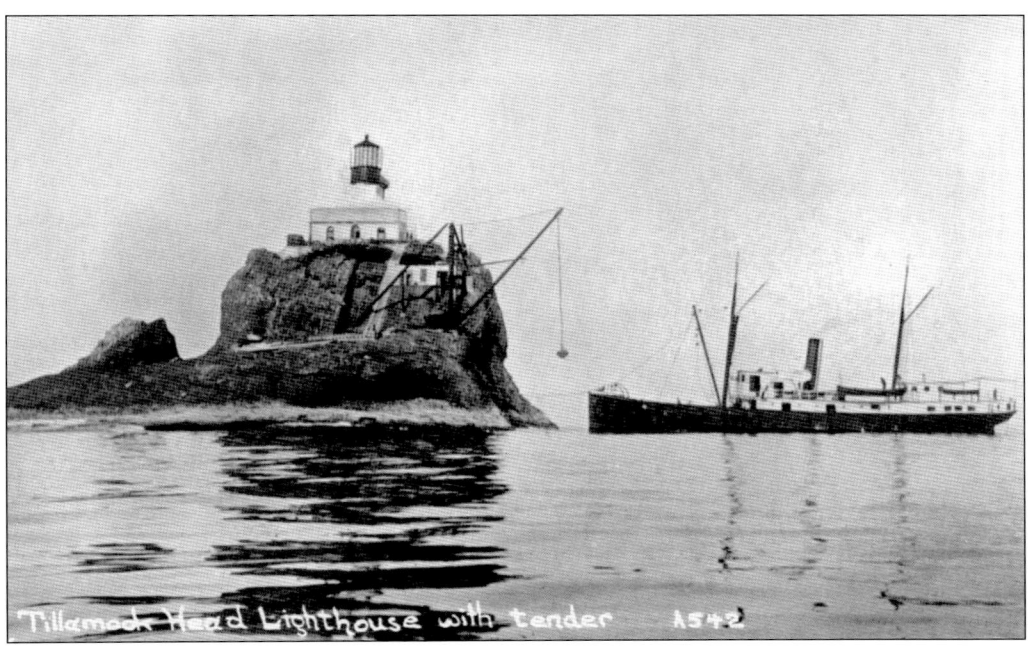

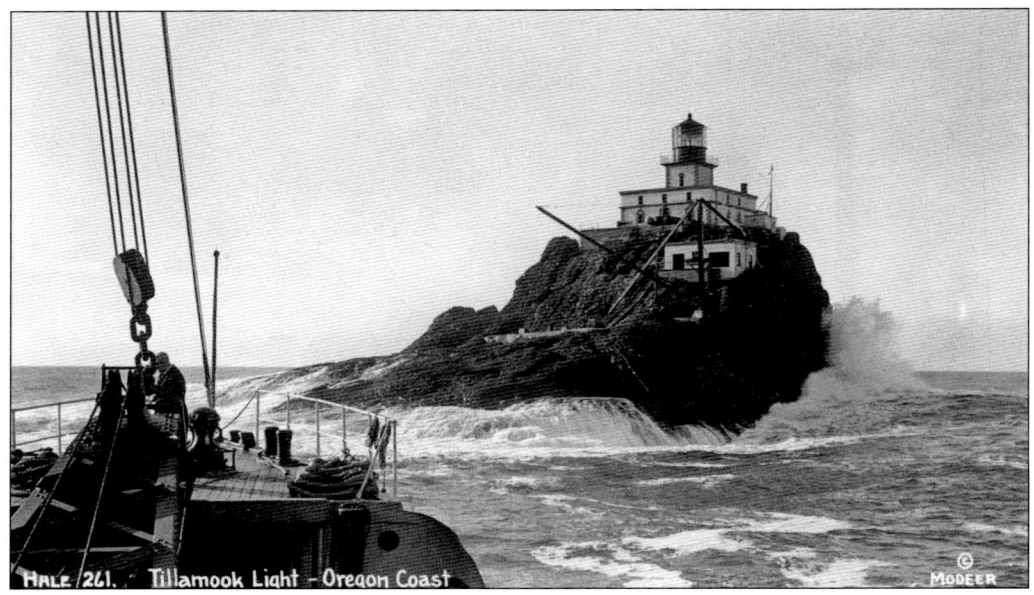

On arrival at Tillamook Rock, a vessel would point its bow to the west and run out lines to three buoys. These spar buoys were tethered to the sea floor. Additional bow and stern lines were sent to the rock and tied to iron rings bolted 3 feet into the basalt rock. The derrick boom then could be swung out over the vessel to lift supplies or people from the tethered ship. (Author's collection.)

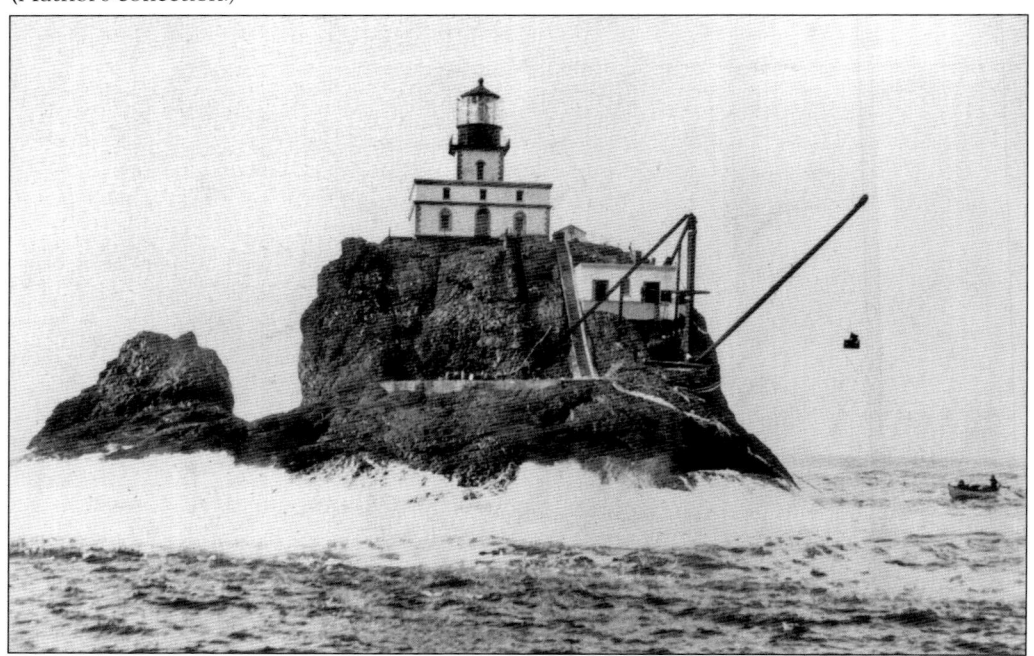

The lighthouse and fog signal were contained with an 80-by-45-foot footprint. The building was designed to accommodate four male keepers with supplies for six months. No families, women, or children were allowed on Tillamook Rock. Nicknamed "Terrible Tilly," the lighthouse was one of the three most exposed lighthouses in the United States. (Courtesy of U.S. Coast Guard.)

The 48-by-45-foot, one-story, stone building contained a room for each keeper, a kitchen, and a storage room. A 32-foot-long wing facing west contained the boilers and fog signal equipment. A 16-by-6-foot square tower rose 62 feet from the keepers' quarters. Its first-order Fresnel lens was 133 feet above the water. (Courtesy of U.S. Coast Guard.)

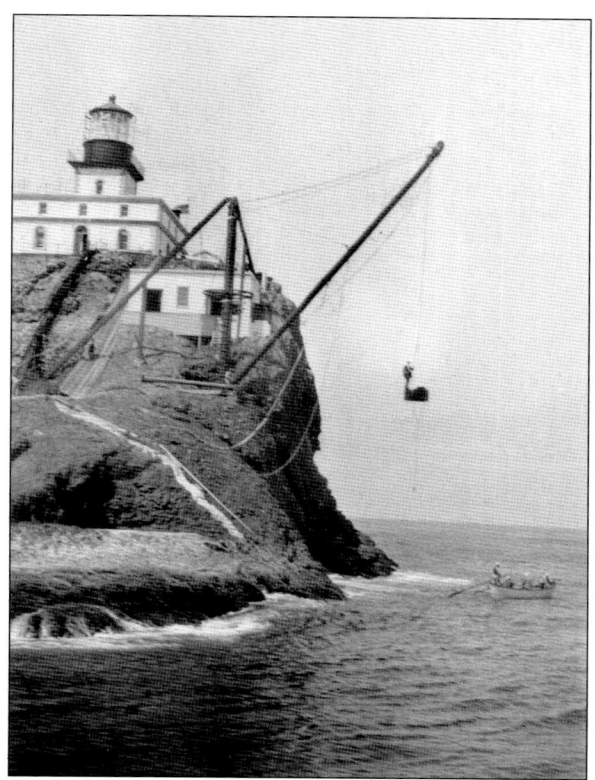

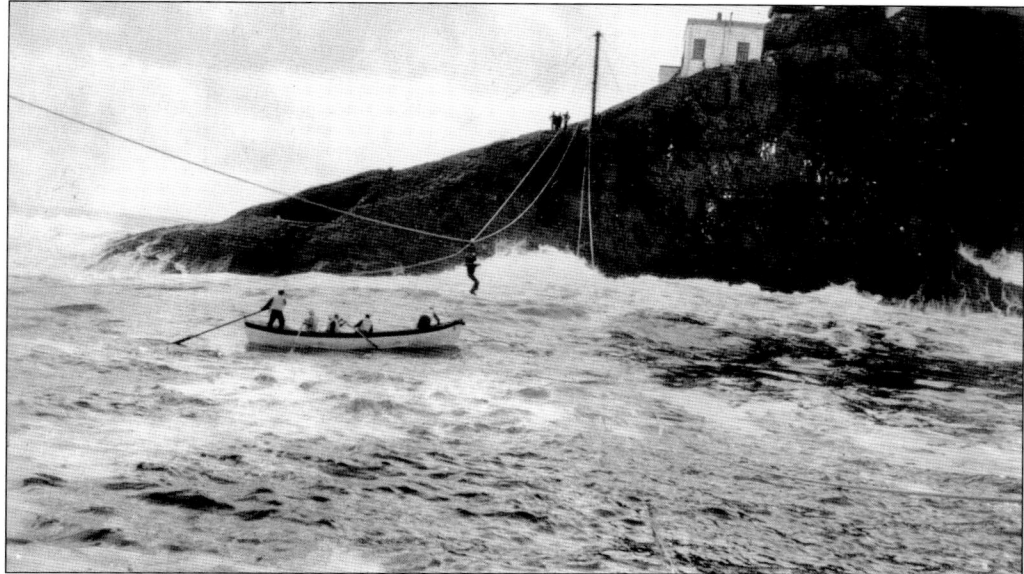

Besides being lifted in a basket hooked to the derrick, a person could be transferred from ship to shore via breeches buoy. The breeches buoy was rigged between the mast of the ship and the island. As the ship rocked, the line on which the breeches buoy rode would go slack and then taut, causing the traveler to be alternately dunked and then shot upward. This photograph was taken soon after a storm had sheared off the boom in 1934. (Courtesy of U.S. Coast Guard.)

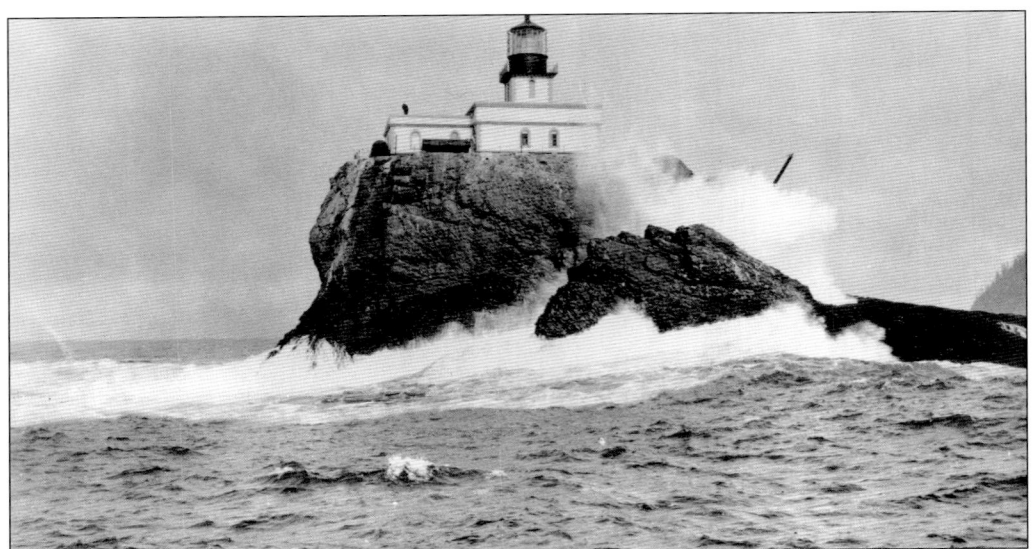

Maintenance on the battered lighthouse was a nightmare. The fog trumpet would clog with seaweed; rocks tossed up by the ocean would break windows 133 feet above the water. A 2-foot-thick slab of concrete was eventually poured to replace the metal roof that was constantly being punctured by rocks. In a 1934 storm, chunks of basalt, weighing up to 150 pounds, were tossed through the lantern room, destroying the Fresnel lens. In 1957, the Coast Guard finally closed the lighthouse. (Courtesy of U.S. Coast Guard.)

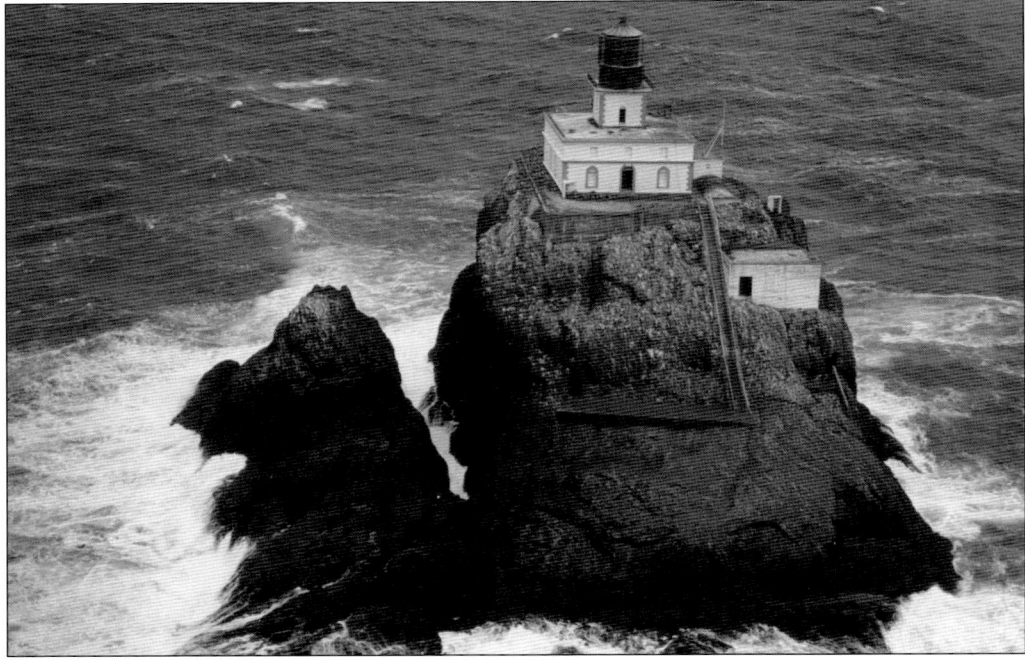

In 1980, Tillamook Rock Lighthouse was bought and gutted to become the first lighthouse in the world to be turned into a columbarium. Its windows were filled, and its lantern panes replaced with sheet metal. A Portland firm, Eternity at Sea, owns the National Register–listed lighthouse and stores the ashes of the dead within its walls. (Courtesy of U.S. Coast Guard.)

Three

Tillamook Bay

In 1788, John Meares, a British naval officer with Portuguese papers, was searching for the Columbia River. Unable to locate the river, he traveled farther south and discovered what he called Quicksand Bay. Living on and near the bay was a band of Salish Indians. When Lewis and Clark came across the same natives nearly 20 years later, the explorers referred to them in their journals as the "Kilamox" and "Killamuck." Over the years, the name evolved into "Tillamook," and Quicksand Bay became known as Tillamook Bay.

Slowly but persistently, American settlers drove the Tillamook away from the bay. Dairy farms began to dominate the area's fertile valleys. Tillamook County was created by the Oregon territorial legislature on December 15, 1853, solidifying the spelling of Tillamook. A post office was established at the town of Tillamook on March 21, 1866. The town of Barview, closer to the mouth of Tillamook Bay, was named in 1884. Dairy continues to be the dominant industry in the county. The Tillamook Cheese Factory is the world's largest cheese plant. Much of the rich timberland surrounding the area was destroyed during the Tillamook Burns of the 1930s. Today timber harvesting has returned as reforested areas mature.

The dairy and timber products had to travel by sea to reach their markets. Aids to navigation were required to help mariners reach those markets. However, the entrance to Tillamook Bay was not considered extraordinarily dangerous. The Lighthouse Board finally recommended a lighthouse be erected at Cape Meares, a headland about five miles south of the entrance to Tillamook Bay, in 1886.

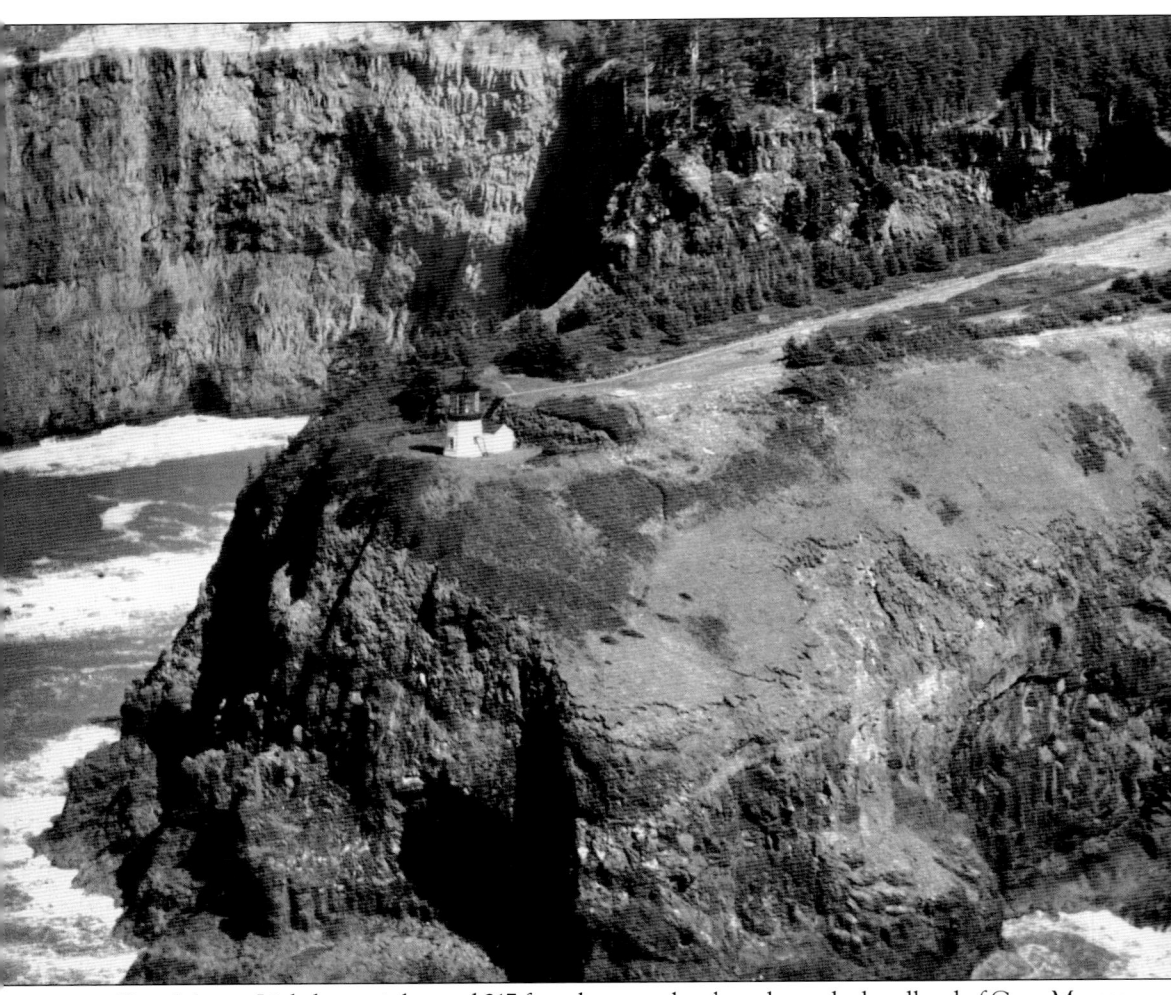

Cape Meares Lighthouse is located 217 feet above sea level on the rocky headland of Cape Meares. Like most of Oregon's lighthouses, it was equipped with a first-order Fresnel lens. However, that was all it had in common with other Oregon lighthouses. The light is only 38 feet tall and built principally of iron. The Willamette Iron Works of Portland won the sheet iron contract for $7,800. The general contractor was Charles B. Duhrkoop, who made the bricks and cut lumber on site and charged $2,900. Richard Seaman won the contract for building the two keepers' dwellings, two oil houses, and a barn for $26,000. Starting construction in early 1889, the lamp was lit on January 1, 1890. (Courtesy of U.S. Coast Guard.)

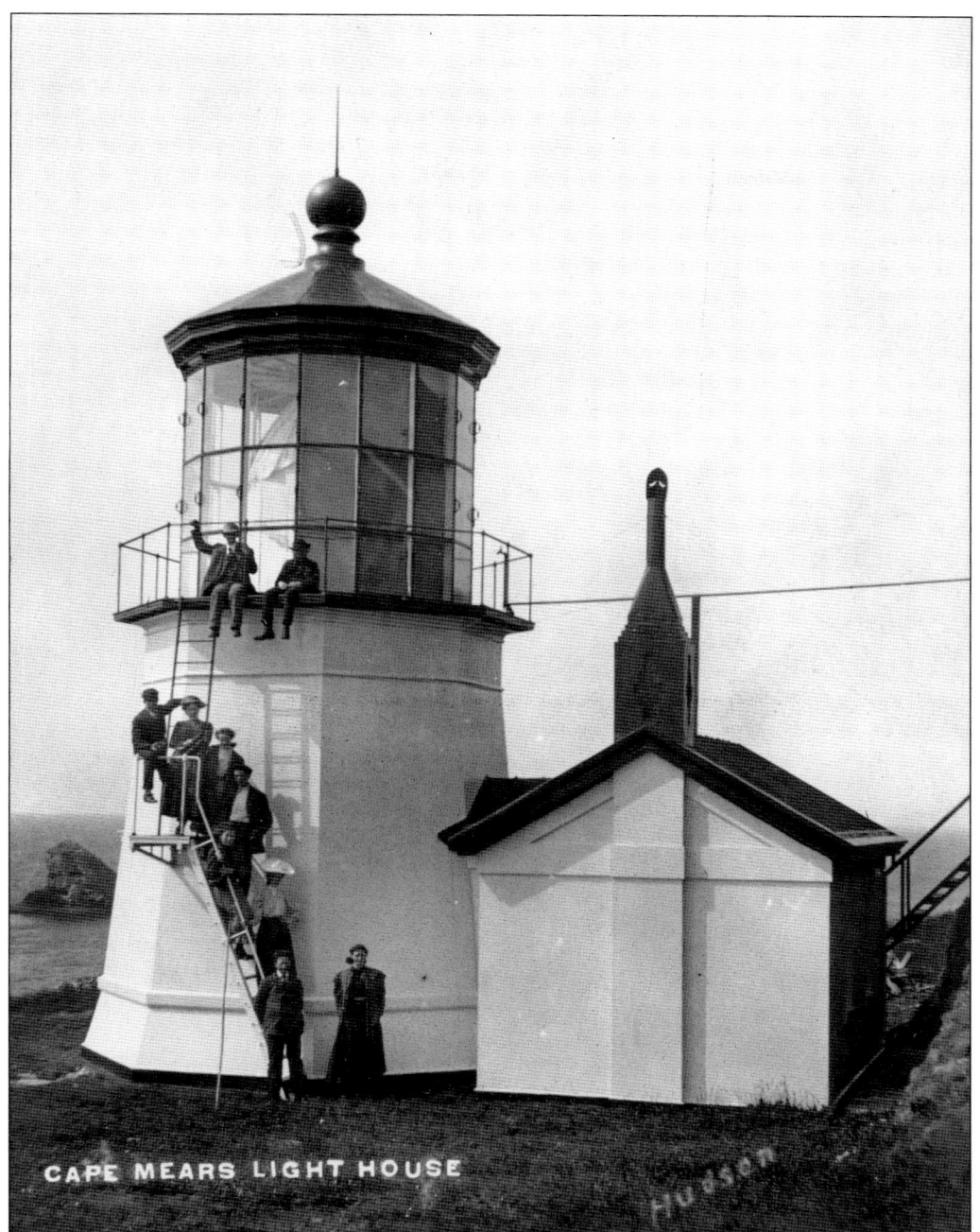

The first-order optics were by Henry LaPaute of Paris and manufactured in 1887. (The "order" of Fresnel lenses ranged from first to sixth, indicating lens size from largest to smallest. A first-order light could be up to 12 feet tall and weigh 3 tons when assembled.) The lens and its carriage were shipped from France, around Cape Horn, brought to the base of the headland by lighthouse tender, and then cranked up the 217 feet by a hand-operated crane. The five-wick kerosene lamp was visible for more than 21 miles. The masonry workroom attached to the lighthouse was not built until 1895. (Courtesy of Mike Byrnes.)

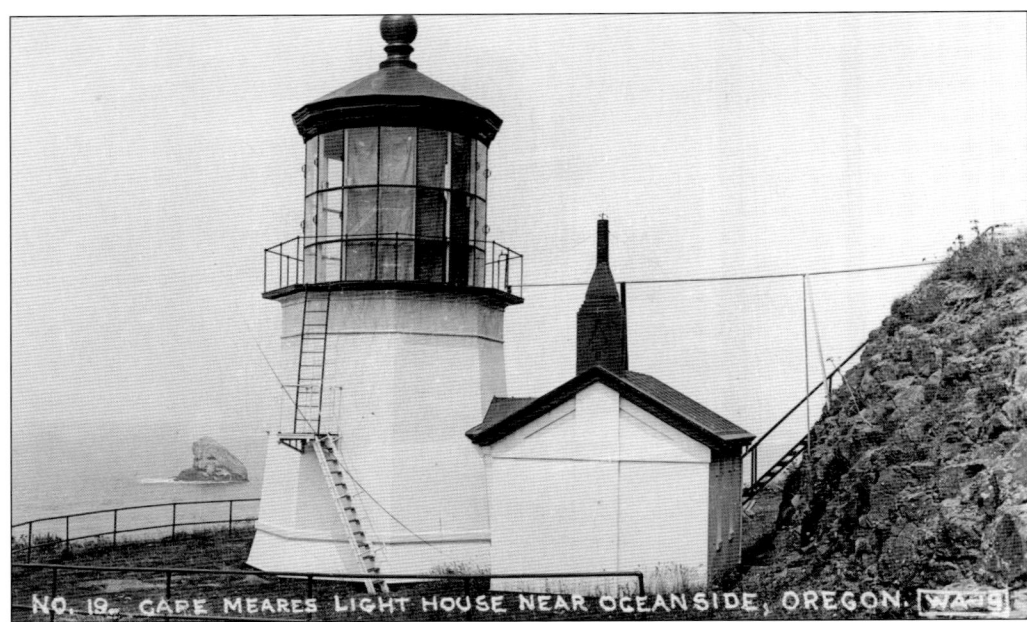

Two oil houses originally existed at the site were similar to those at Heceta Head Lighthouse. They stored five-gallon cans of kerosene for the lamps. The buildings were masonry and far enough away from the lighthouse to prevent worry. In 1934, electricity arrived at the lighthouse, and an electric lamp replaced the kerosene lamps; however, a spare kerosene lamp was kept around just in case. The oil houses were dismantled that same year. The lighthouse was automated in 1963. (Author's collection, above; courtesy of U.S. Coast Guard, below.)

With the replacement of the lighthouse with an automated beacon, there was discussion of removing the lighthouse entirely. The attached workroom was demolished. However, the local citizens came to its rescue, and the Coast Guard agreed to turn over the lighthouse to Tillamook County in 1964. The station buildings had to be torn down due to deterioration and vandalism. The county in turn transferred the resource to Oregon State Parks in 1968. In 1978, a reproduction workroom was built to accommodate visitors, and the diminutive tower was restored. (Courtesy of U.S. Coast Guard.)

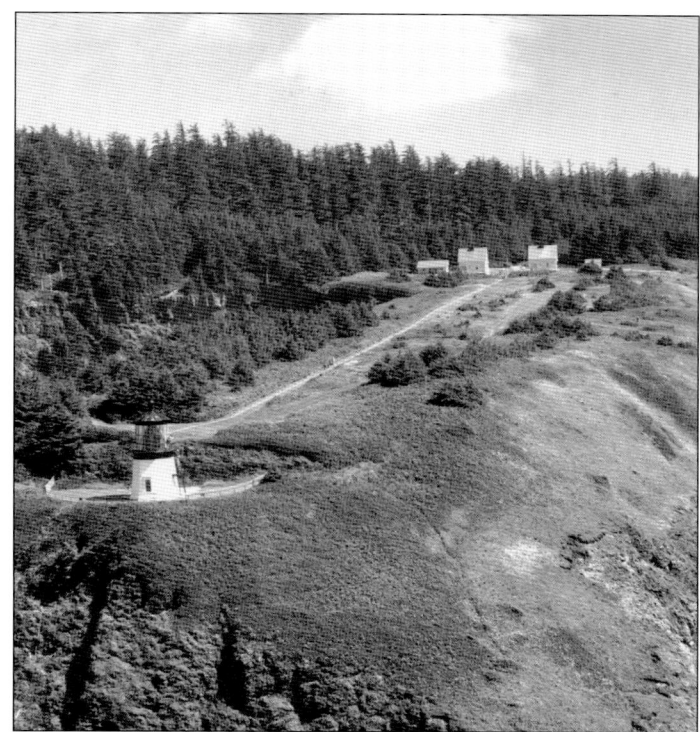

As early as 1889, Oregon representative Binger Hermann was pushing for a life-saving station at Tillamook Bay. Simultaneously he was also crying out for one at the nearby Nehalem River. Unfortunately, Hermann was denied both locations. In 1904, Representative Hermann tried again, pointing out that there were no stations between the Columbia River and Yaquina Bay. For 50 miles in either direction of Tillamook Bay there was no protection. This was the largest stretch of unprotected coastline in Oregon. This argument prevailed, and Congress approved the construction of a station on April 28, 1904. (Author's collection.)

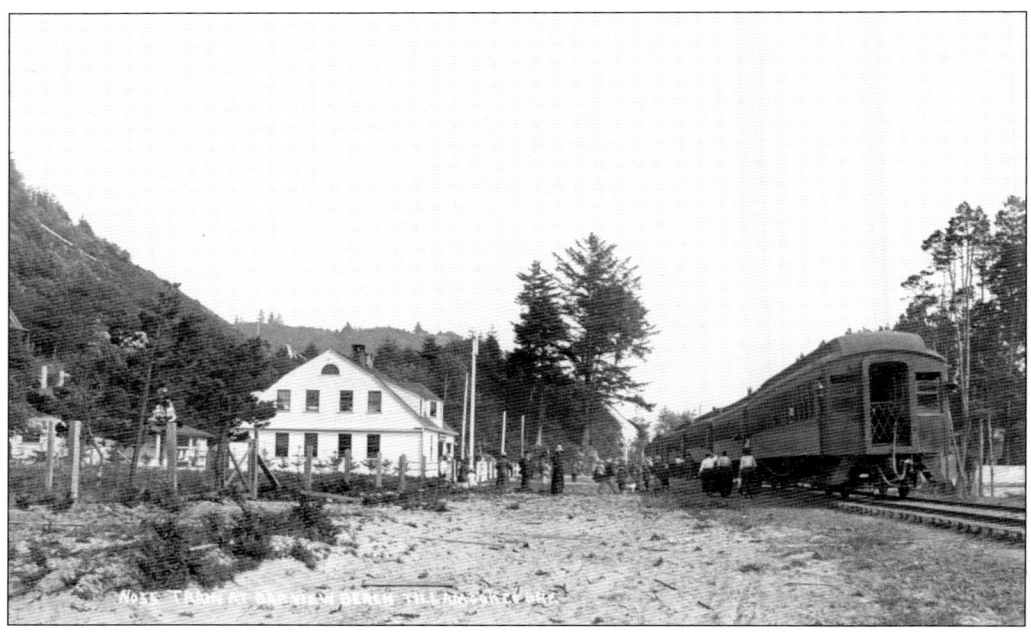

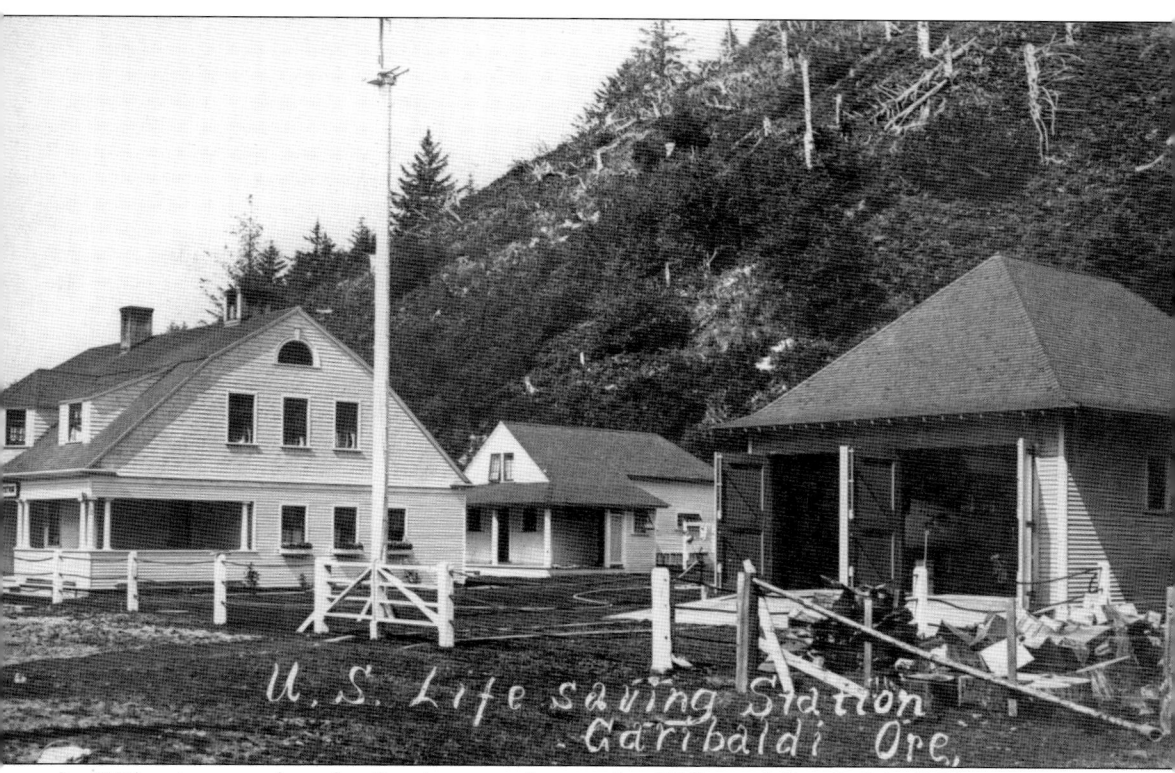

In 1905, a site was selected at Barview near the mouth of Tillamook Bay. In July 1907, a contract was let out to Ferguson and Houston of Astoria to build the station house, boathouse, outbuilding, flagstaff, and drill pole. The price was set at $8,797 and was to be completed by December 31, 1907. It is assumed the station was completed on time, as Keeper Robert Farley started to get the station ready prior to May 1908. On May 21, Keeper Farley reported that the station was "in condition for service." (Author's collection.)

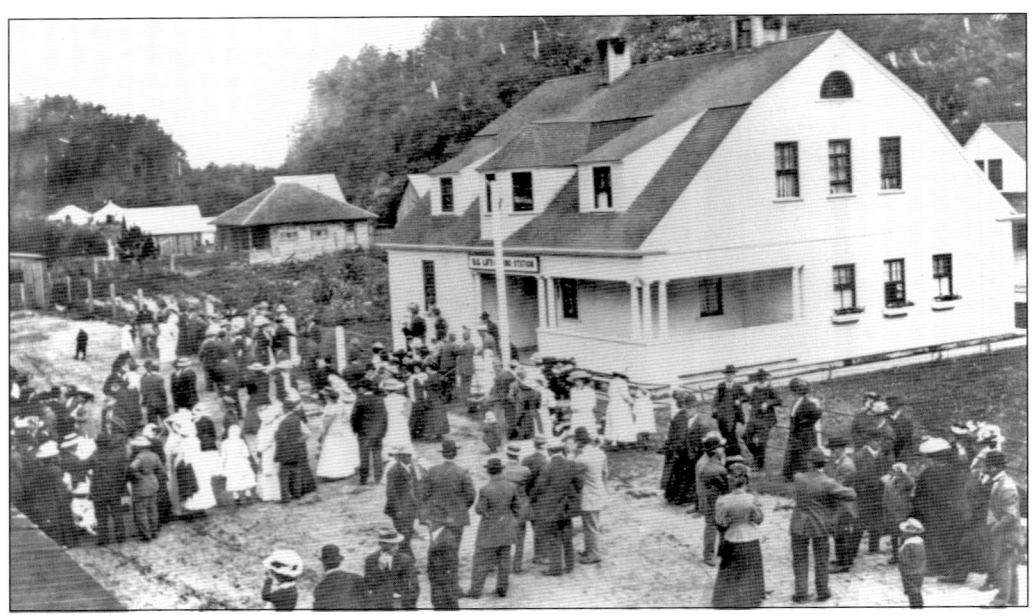

It is often assumed that this photograph (top) is of the life-saving station's grand opening. However, this image was taken several years after its 1908 opening. The Pacific Railway and Navigation Company constructed a rail line from Hillsboro to Tillamook between 1907 and 1911 that ran right in front of the station, separating the station from the bay. The gathering is actually the passengers waiting for the train. The life-saving station was shown as the train stop in the railroad's timetables, the only station designated as such on the Oregon Coast. (Courtesy of U.S. Coast Guard, above; author's collection, below.)

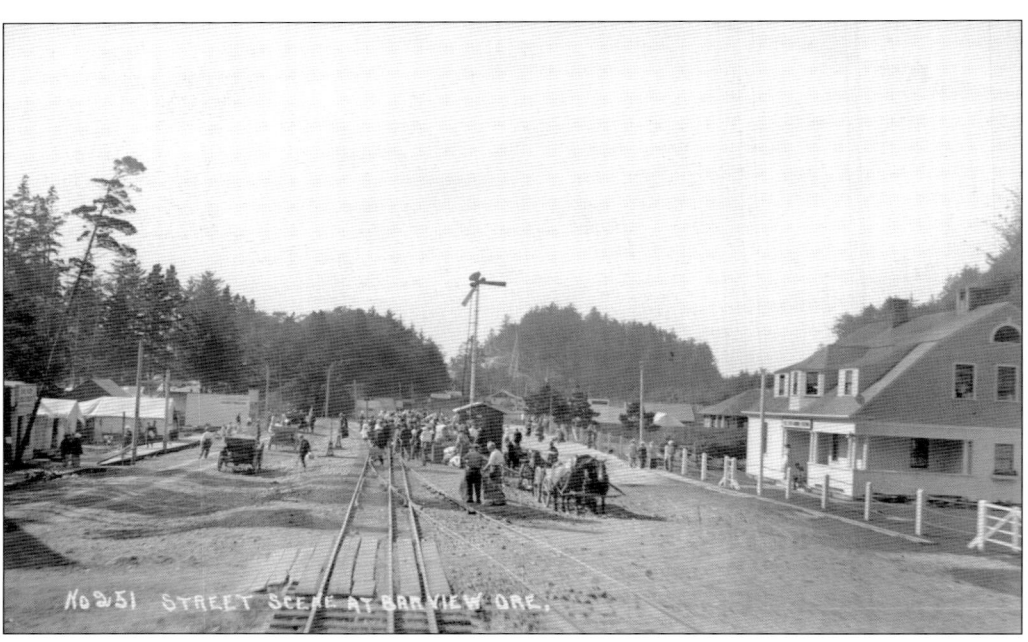

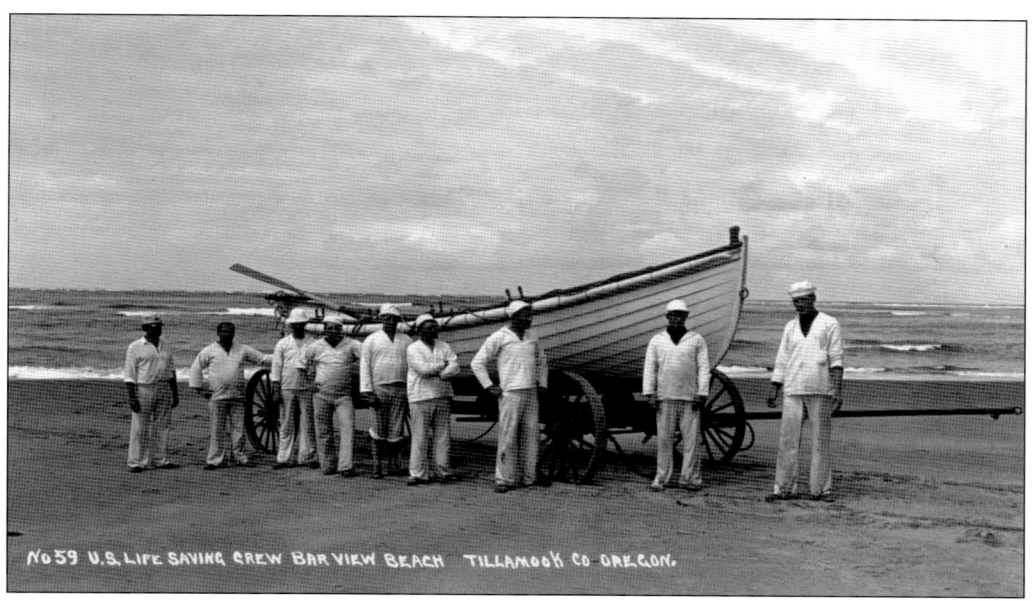

Surfmen trained during good weather and bad, as rescues were almost always performed in bad weather. The men dragged the boat to the surf line on a cart and then manually launched the boat, a difficult task even in good weather. The surfboat was relatively lightweight being between 700 and 1,000 pounds and 25 to 27 feet long, depending on the type. Some stations had horses to help with hauling the boat cart through the sand. Here the Tillamook Bay Life-Saving Station crew poses before launching their surfboat around 1910 in good weather. (Author's collection.)

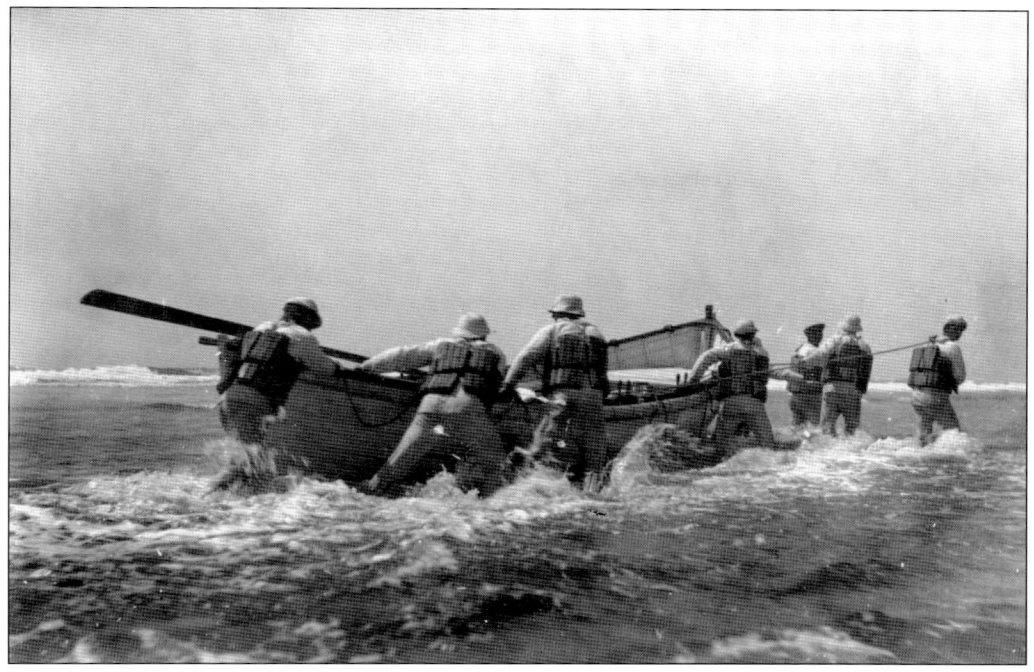

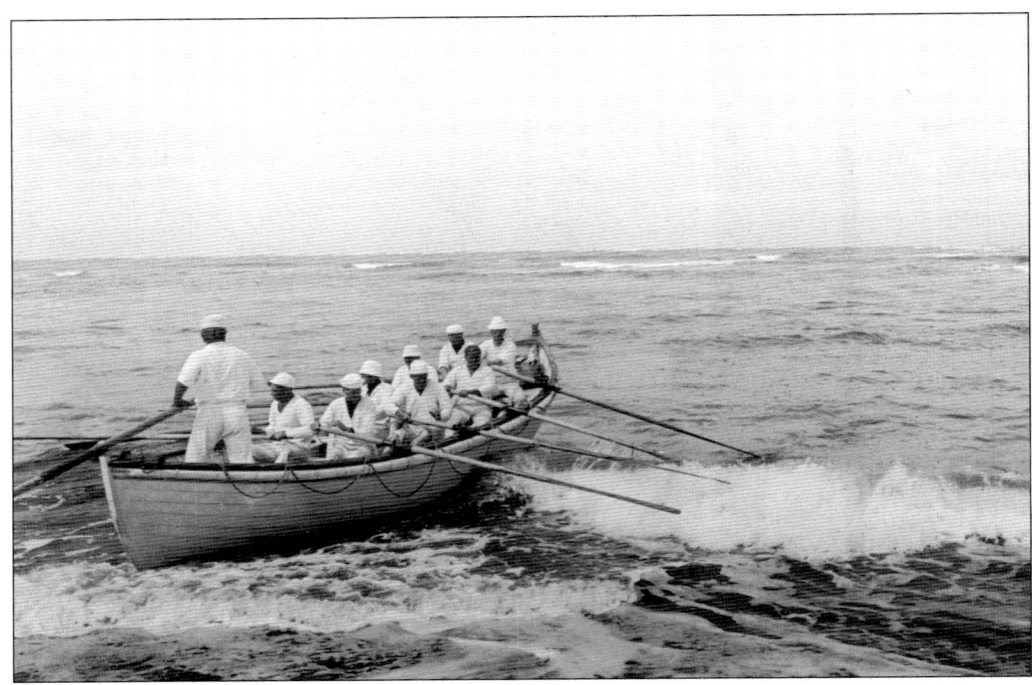

Six crewmen were needed to row the surfboat with the keeper manning the long steering oar. The boats were highly maneuverable and excellent for short distances when only a few people were imperiled, but often the crew arrived at the scene of a rescue completely worn out and then had to mount a rescue and return safely back to shore. In 1899, the Life-Saving Service began experimenting with motors. The first-designed motor lifeboat was put into operation at Neah Bay, Washington, in 1908. (Courtesy of Mike Byrnes, above; author's collection, below.)

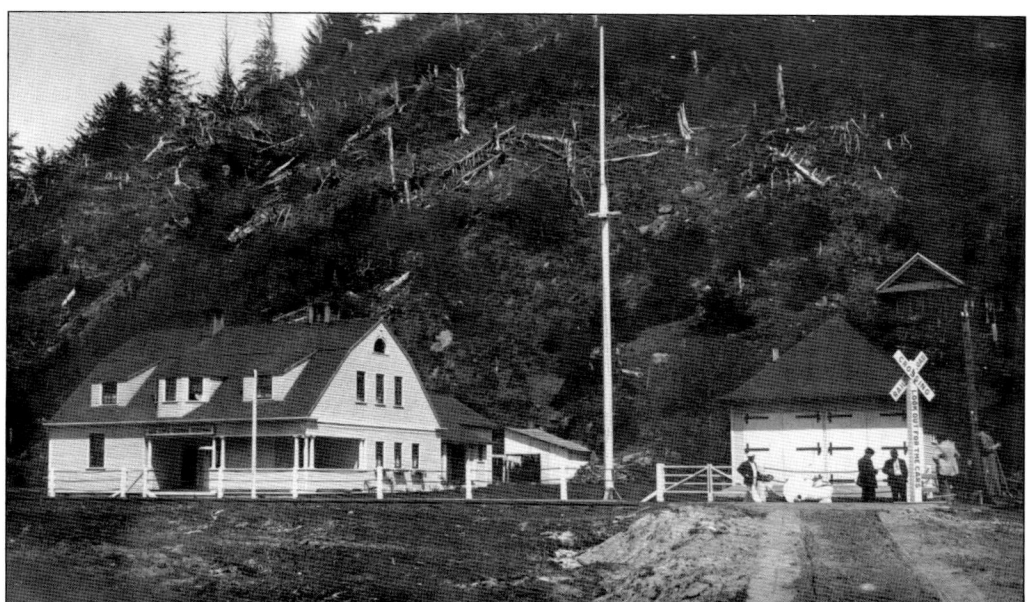

The design for the station came from Life-Saving Service architect Victor Mindeleff in 1898. It was drawn for the Petersons Point Life-Saving Station on Grays Harbor, Washington. The Petersons Point station and the Tillamook Bay station were the only ones built from the plans, and the Tillamook Bay station is the only one left standing today. (Author's collection.)

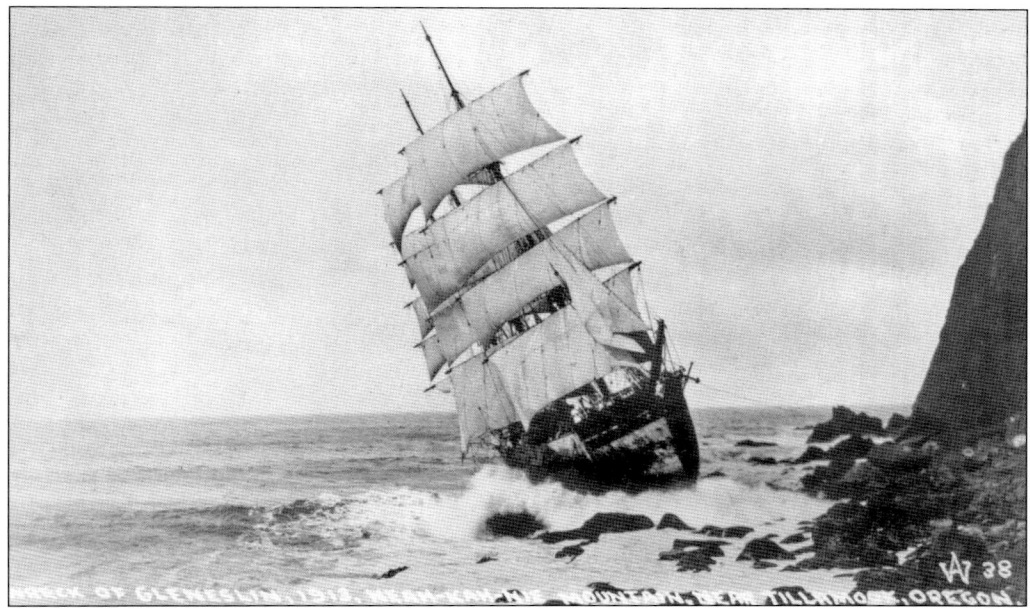

The British square-rigger *Glenesslin* sailed straight onto the rocks at the base of Neahkahnie Mountain on October 1, 1913, just north of Tillamook Bay. Having sailed the seas since 1885, the beautiful ship came to a sad end when it was run aground by inexperienced hands. There was much speculation that it was wrecked in calm, clear weather for the insurance money. (Author's collection.)

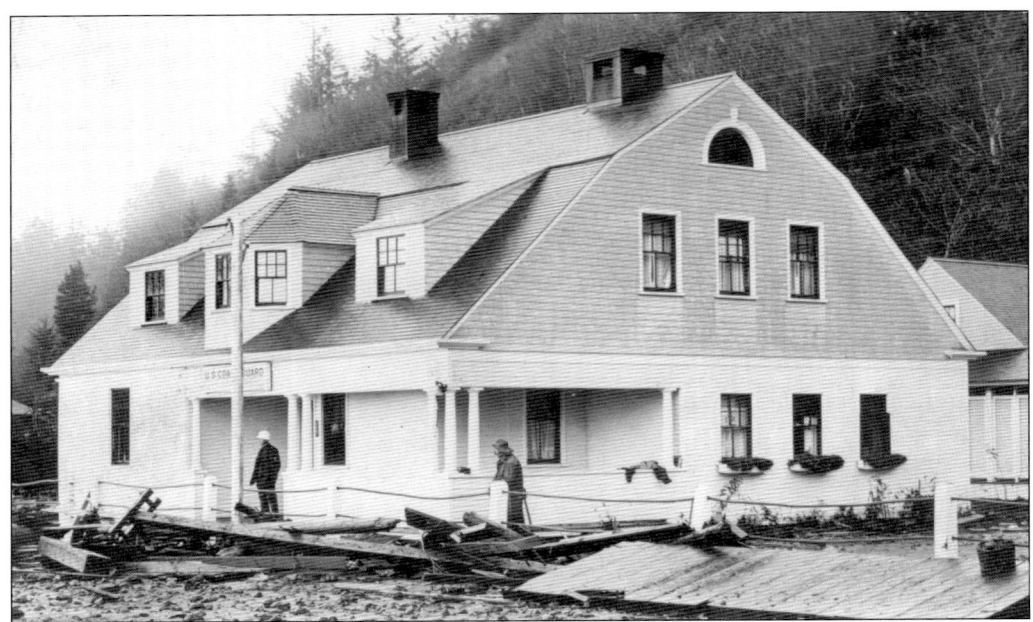

In 1912, construction began on a jetty on the north side of the bay's entrance. However, on October 23, 1915, before the jetty was complete, a large storm came up and washed out the entire stretch of beach and the neighboring buildings in front of the station. The station yard was littered with rocks and logs, which can be seen in the top photograph. The railroad grade probably saved the station from being leveled by the ocean. The jetty was completed by 1917, and the railroad grade was thoroughly riprapped all along its course on the edge of Tillamook Bay. However, another storm came up on January 4, 1936, and cut through the jetty, littering the station yard once again with debris. Since the 1936 gale, no storms have come into Tillamook Bay to cause such havoc. (Author's collection.)

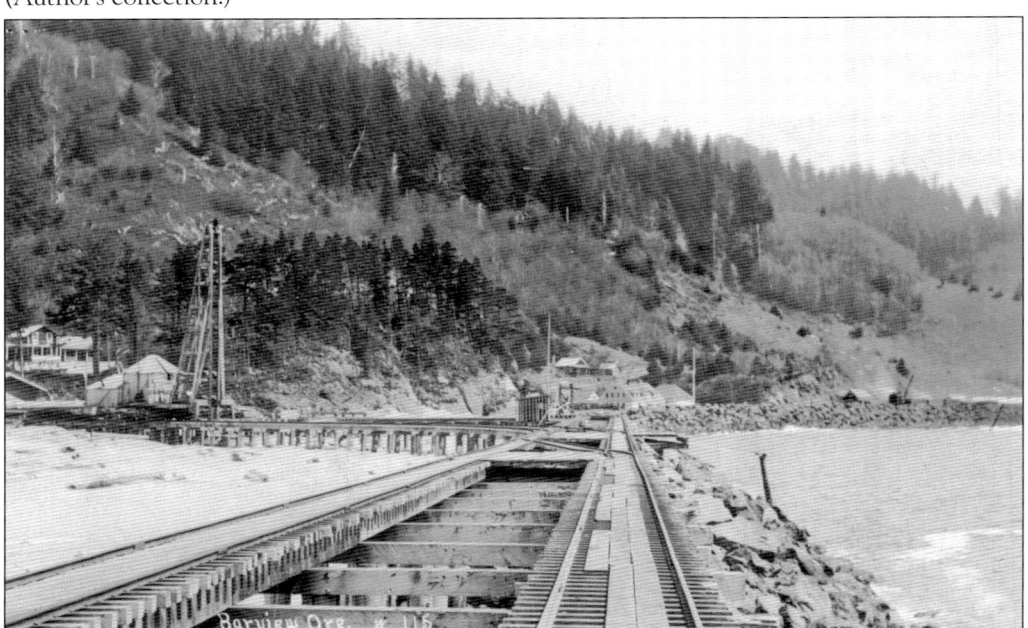

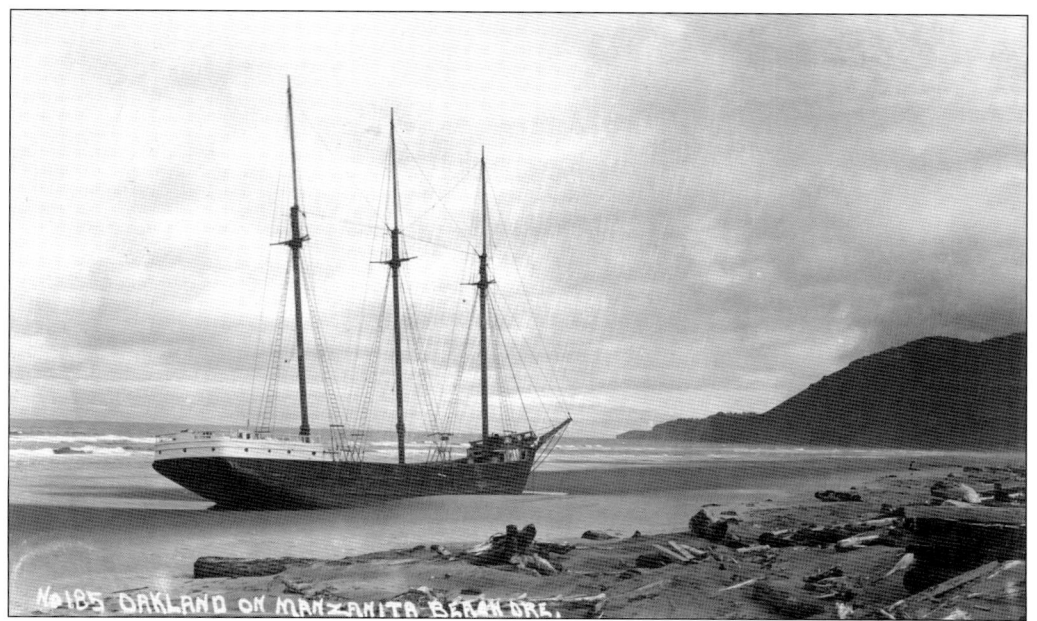

The *Oakland* was a three-masted schooner built in Oakland in 1902. On March 22, 1916, she was abandoned at sea when she became waterlogged and unmanageable and went ashore at Manzanita Beach, just north of Tillamook Bay. She was refloated and went back to sea in 1918 as the *Mary Hanlon*. She foundered off Mendocino, California, on June 24, 1924, but the passengers and crew got ashore without mishap. (Courtesy of Mike Byrnes.)

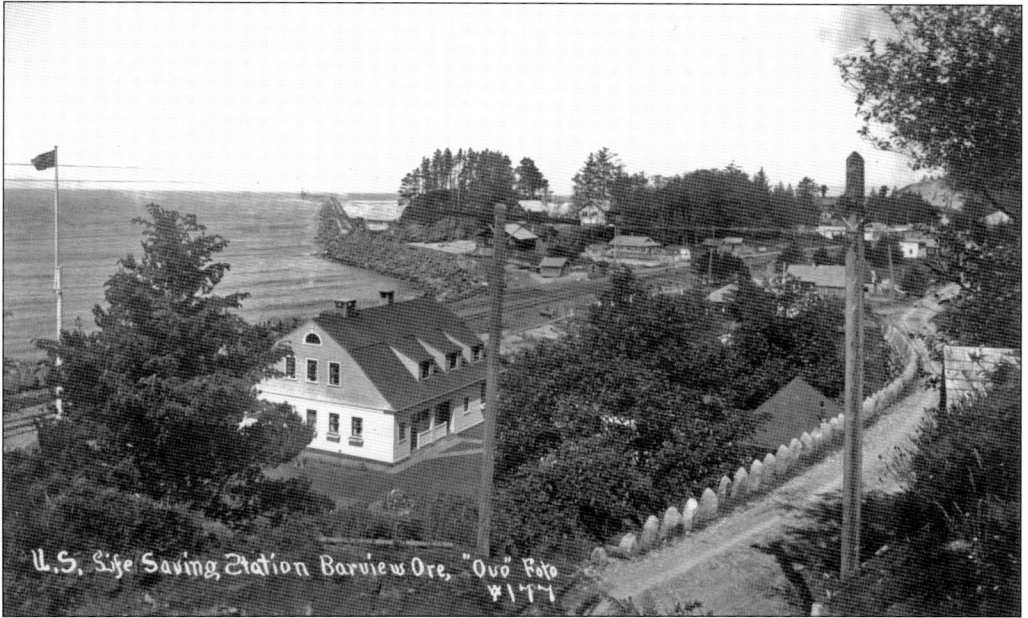

The Oregon Coast Highway (Highway 101) came through the area in 1936; however, the highway went over an existing road behind and above the station, built in the 1920s. The road's right-of-way and stone retaining wall filled in the back area of the station grounds right to the back door of the station's shop. (Author's collection.)

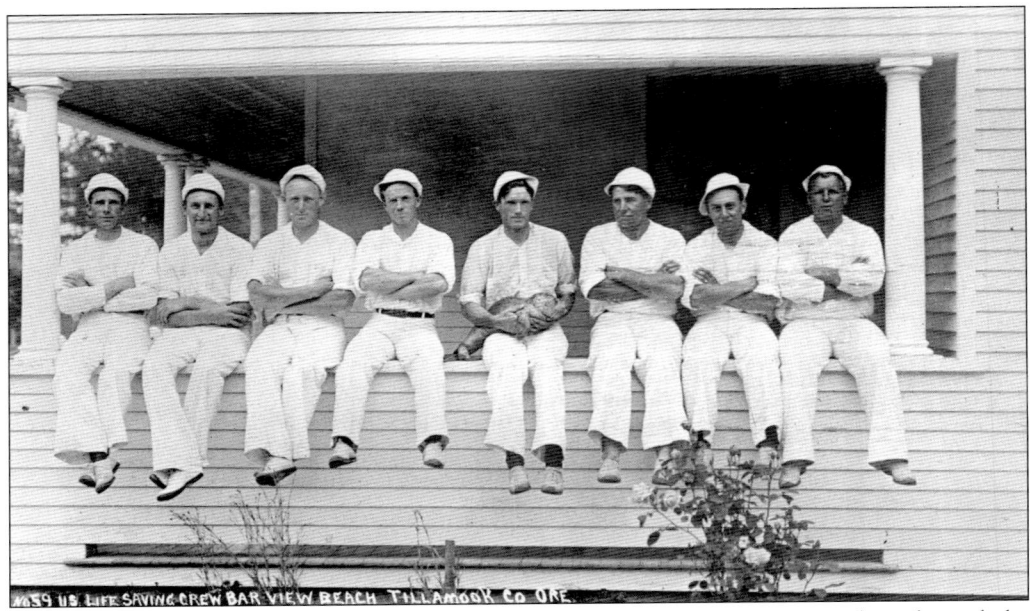
Stations usually had a mascot, generally a dog. The Tillamook Bay crew appeared to adopt a baby harbor seal as theirs. In 1943, the surfmen moved southeast 1.5 miles to their new, modern station at Garibaldi. The station complex then passed into private hands. The complex is still in private hands, the only complete life-saving station left in Oregon. (Author's collection.)

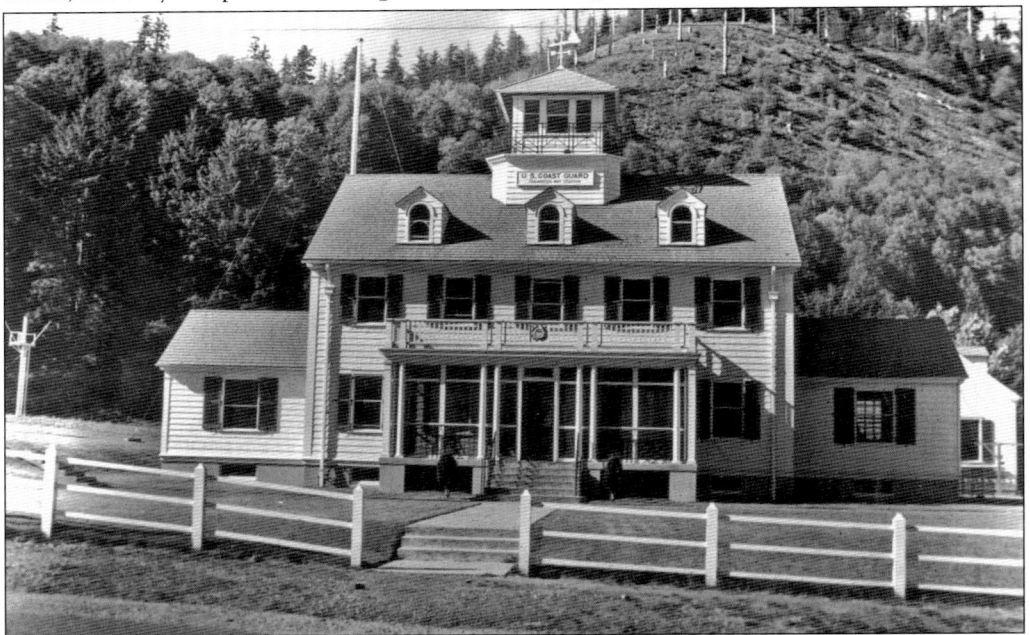
In 1939, President Roosevelt declared a national emergency when Germany invaded Poland. In Oregon, defending the coastline fell to the Coast Guard. Stations were built at an unprecedented rate and beach patrols were constant. Land had been bought in 1938, construction finally began in 1942, and the crew moved into the new station in January 1943. The Garibaldi station is still in use by the Coast Guard today. (Courtesy of U.S. Coast Guard.)

Four

YAQUINA BAY

Yaquina Bay forms the southern boundary for the town of Newport on Oregon's central coast. The bay was at the center of the Siletz Indian Reservation, which was created by treaty in 1855, stretching from Cape Lookout (near Tillamook) 115 miles south to the Umpqua River. As early as 1856, Yaquina Bay was visited by the *Calumet* carrying supplies for the military enforcing the reservation. When the Yaquina Bay oyster beds were discovered in 1862, great profits were made by exporting the delicacy to San Francisco and beyond. Yaquina Bay was opened to white settlement in 1864, while the surrounding area didn't officially open up to white settlement until 1895.

Newport and Seaside were the earliest Oregon coastal towns to develop a tourist trade. In 1866, Samuel Case and Dr. J. R. Bayley built Ocean House, Oregon's first coastal resort hotel, at the west end of the Newport waterfront. At the other end of the waterfront was a dock large enough for small schooners. It took an entire day for travelers from Corvallis to traverse a rough wagon road connecting the Willamette Valley with Newport. More resorts and summer cottages followed, paving the way for Newport's incorporation in 1882 and establishing the community as a tourist destination along the Oregon Coast. In 1885, the railroad was pushed through to Yaquina City, east of Newport on the upper bay. Tourists would take the train from Corvallis and then board a ferry for a three-mile cruise to Newport's waterfront.

Automobiles began coming to Newport in the 1900s, though the road connecting the coast with the valley was impassable for most of the year. In 1919, voters approved a local bond issue to improve the road connecting the coast to the valley. By the 1920s, tourism had become a major industry in Newport and elsewhere along the coast due to these road improvements and the growing number of automobile owners in the state. With the completion of the Yaquina Bay Bridge in 1936, the Oregon Coast Highway (Highway 101) was complete, solidifying Newport's role as a seaside escape along the Oregon Coast.

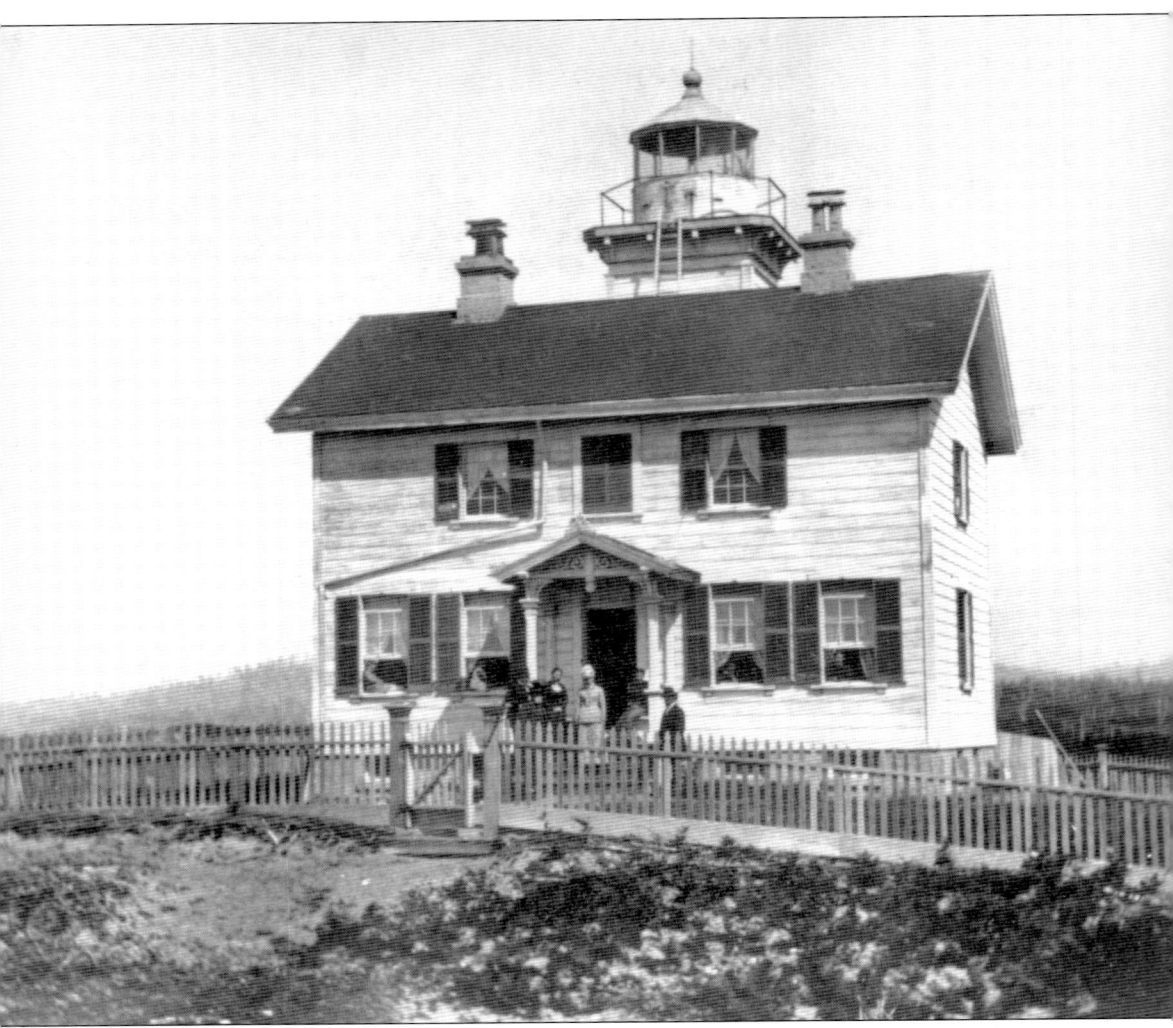

The Yaquina Bay Lighthouse, built in 1871, is the second-oldest existing lighthouse on the Oregon coast. The structure is the oldest building in Newport, a seaport town founded in 1866. The Yaquina Bay Lighthouse is situated on a 65-foot-tall bluff on the north side of the mouth of Yaquina Bay. Robert Stockton Williamson, lighthouse engineer, designed the lighthouse with Cape Cod massing and details. The builder was Ben Simpson, a local contractor. It was constructed between May and October 1871, and illuminated on November 3, 1871. The lighthouse is a two-story, wood-frame structure built on a high brick basement. Today the Friends of Yaquina Lighthouses assists Oregon State Parks in managing and interpreting the site. (Courtesy of Oregon Historical Society, OrHi #38714.)

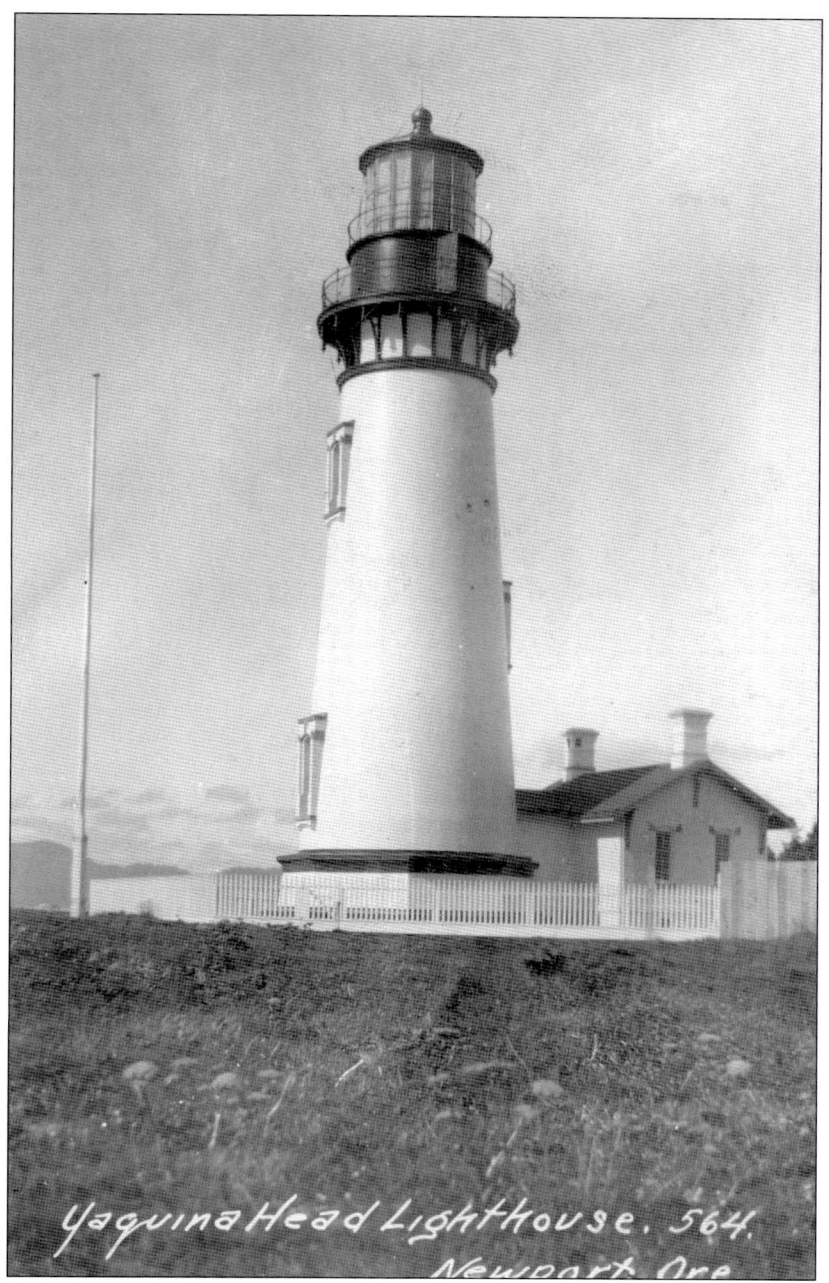

The Yaquina Bay Lighthouse was superseded by the Yaquina Head Lighthouse just three years after construction of the bay light and just three-and-a-half miles away to the north. On October 1, 1874, the light at Yaquina Bay was extinguished. Keeper Charles Pierce, his wife, and eight children moved south for duty at the Cape Blanco Lighthouse. Royal Bensell and his wife moved into the Yaquina Bay Lighthouse as caretakers, as the Lighthouse Board did not relinquish title to the structure. In 1888, the U.S. Army Corps of Engineers moved into the Yaquina Bay building while harbor improvements were underway, including the construction of the Yaquina Bay jetties. (Author's collection.)

FIRST ORDER L. H. for YAQUINA HEAD, OREGON

Construction began in fall 1871 on the Yaquina Head Lighthouse. Boats bringing materials often had difficulty landing in a cove on the south side of the head. At least two boats overturned in the surf, losing their cargo. The 93-foot tower was made from 370,000 bricks from San Francisco. The lighting of the first-order Fresnel lens was delayed due to parts of the lantern being lost in transit. Finally, after almost two years of construction, the lighthouse was lit on August 20, 1873. The tallest lighthouse on the Oregon coast, it has a sibling in the Pigeon Point Lighthouse, California. (Courtesy of U.S. Coast Guard, above; Michel Forand, below.)

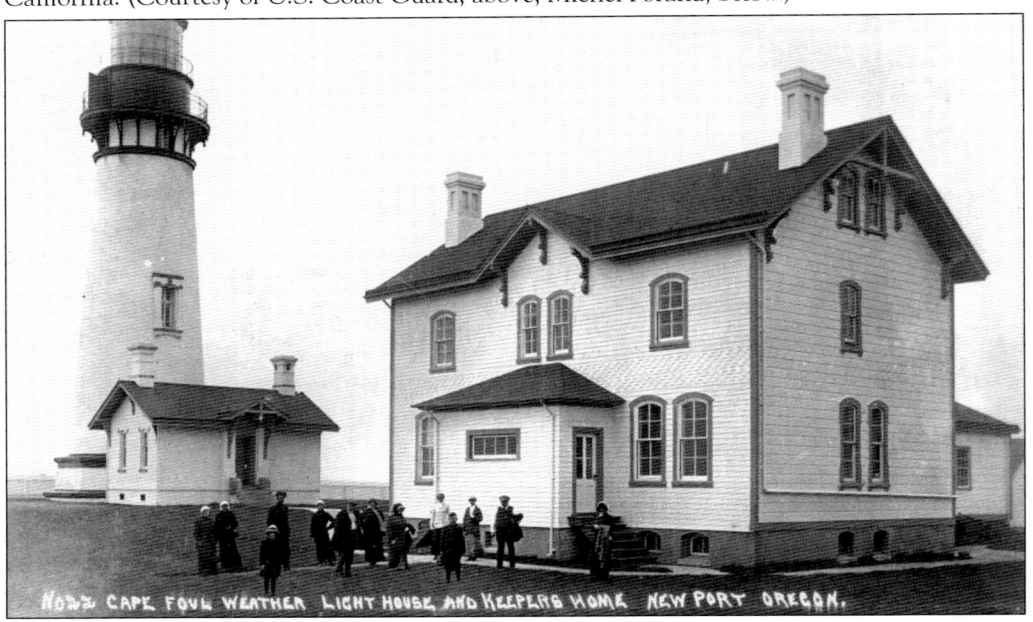

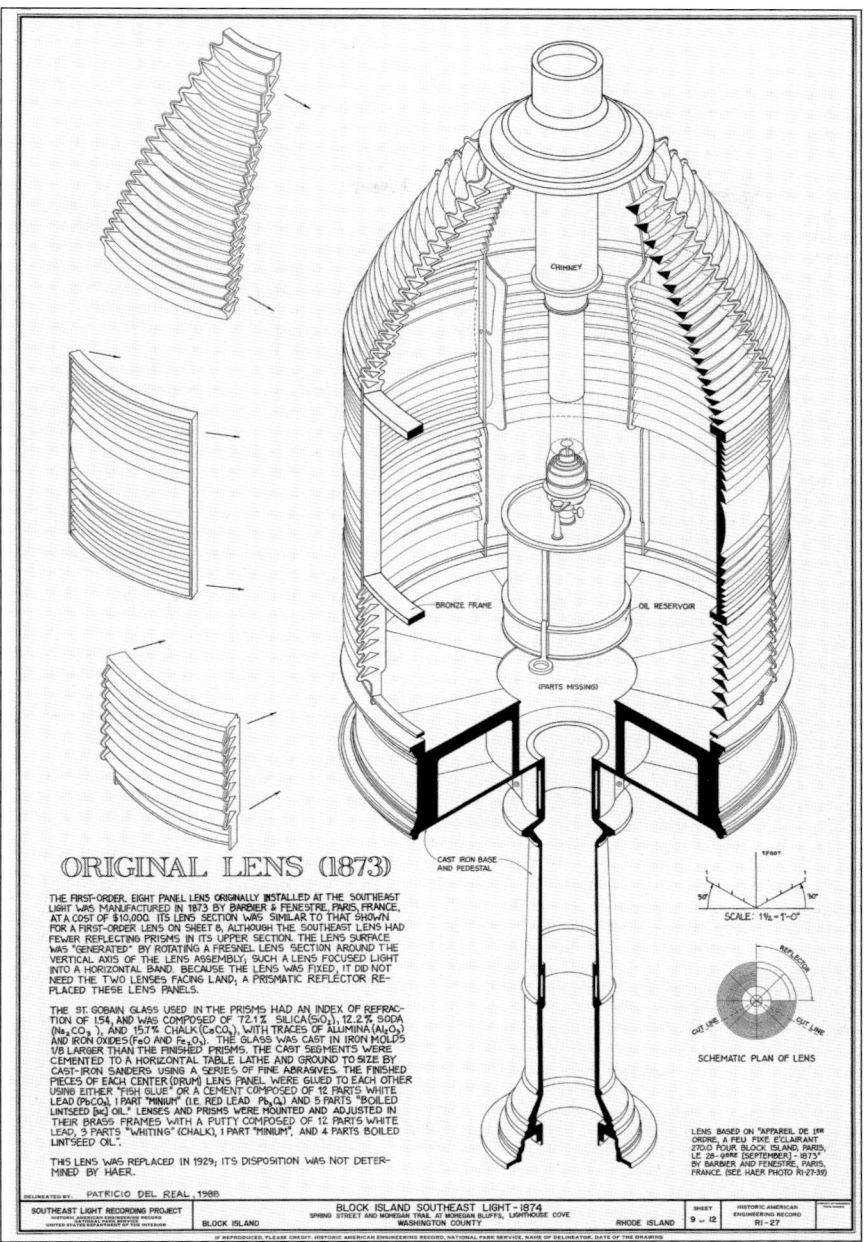

The lens at Yaquina Head Lighthouse was nearly identical to the one made for the Block Island Lighthouse, Rhode Island. Barbier and Fenestre of Paris made both; Yaquina Head was completed in 1868 and Block Island in 1873. Unlike most Oregon lights, the lenses didn't rotate around the light; therefore, Yaquina Bay doesn't have bull's-eye lenses so common to lighthouses. Instead the beam of light was horizontal coming out of the lens and the lighthouse's signature was a steady beam. Since a beam of light wasn't needed into the woods behind the house, two and a half panels at the rear of the light were prismatic reflectors. Once the station was electrified, a flashing light became its new signature. This axonometric drawing was made for the Historic American Engineering Record in 1988 by Patricio Del Real. (Courtesy of HABS/HAER.)

With the close proximity of the Yaquina Head Lighthouse to the Yaquina Bay Lighthouse, there has always been speculation that the Yaquina Head Lighthouse was supposed to be built farther north at Cape Foulweather. The story goes that Yaquina Head was often referred to as Cape Foulweather and that supplies for the lighthouse had been unloaded at the wrong location. However, a careful check of the records shows that both lighthouses were built right where they were supposed to be. (Author's collection.)

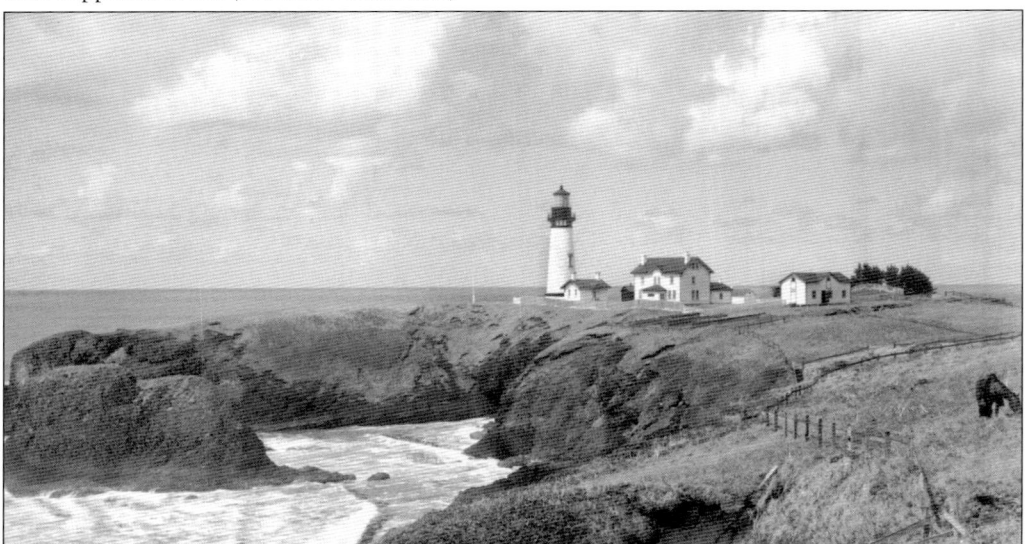

In the early 1920s, Keeper William Smith went into town with his family, leaving Assistant Keepers Herbert Higgins and Frank Story in charge. Higgins fell ill, and Story drank a few too many. Seeing that Story had not tended the light, Higgins got out of his sickbed and went into the tower, collapsing near the lantern room. Smith saw from Newport that the light was dark and rushed back to the lighthouse. Upon his arrival, he found Higgins dead and Story drunk. After that, Story filled with guilt, feared Higgins's ghost and always took his bulldog with him into the tower for protection. (Courtesy of U.S. Coast Guard.)

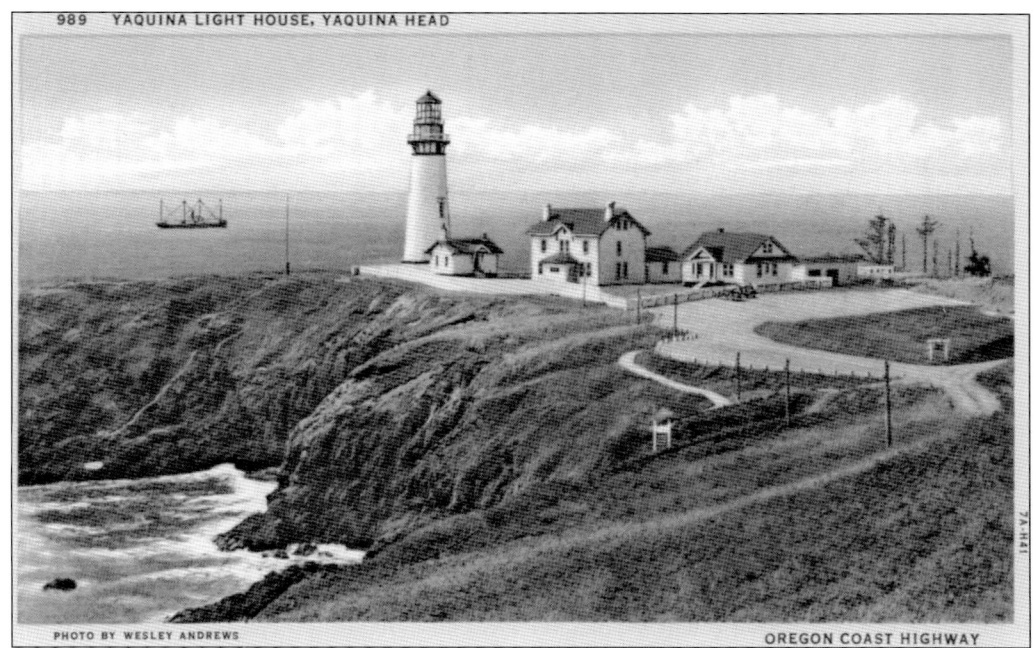

The lighthouse was a popular travel destination—14,196 visitors were recorded in 1931 alone. Note the large parking area in front of the houses. By this time, a new keeper's dwelling had been built in place of the barn to join the original keeper's dwelling. The old keeper's dwelling was torn down with the transition to the Coast Guard in 1939. A new dwelling was built, left vacant when the lighthouse was automated in 1966, and then torn down in 1984, leaving only the lighthouse on the headland. (Author's collection, above; courtesy of U.S. Coast Guard, below.)

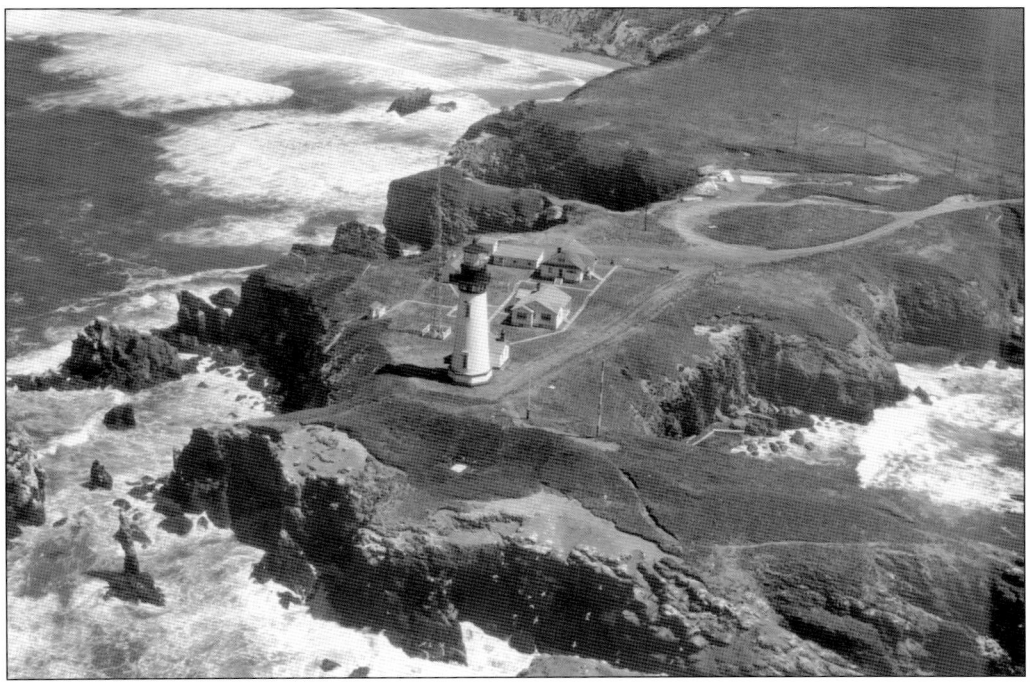

Jetty construction was vital in creating a controlled channel into Oregon's ports. Jetties were some of the first efforts by a young Oregon to increase shipping to its harbors. The south jetty at Yaquina Bay was the first started on the Oregon Coast. The south jetty was begun in 1880 and the north in 1888. (Author's collection.)

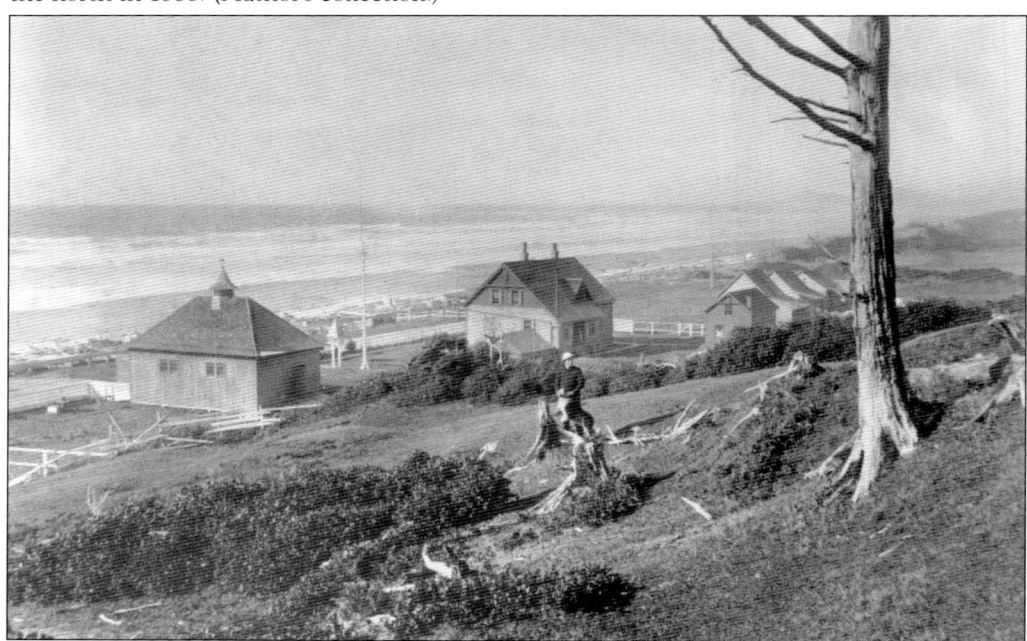

The logical location for a life-saving station would be a site where a surfboat could be launched easily and close to the probable location of shipwrecks. A site 1.5 miles south of the mouth of Yaquina Bay was chosen to satisfy these two desires for the Yaquina Bay Life-Saving Station. The site was flat with an easy transition from stable land to the beach sand, plus most of the shipwrecks occurred south of the Yaquina Bay entrance. (Courtesy of Lincoln County Historical Society.)

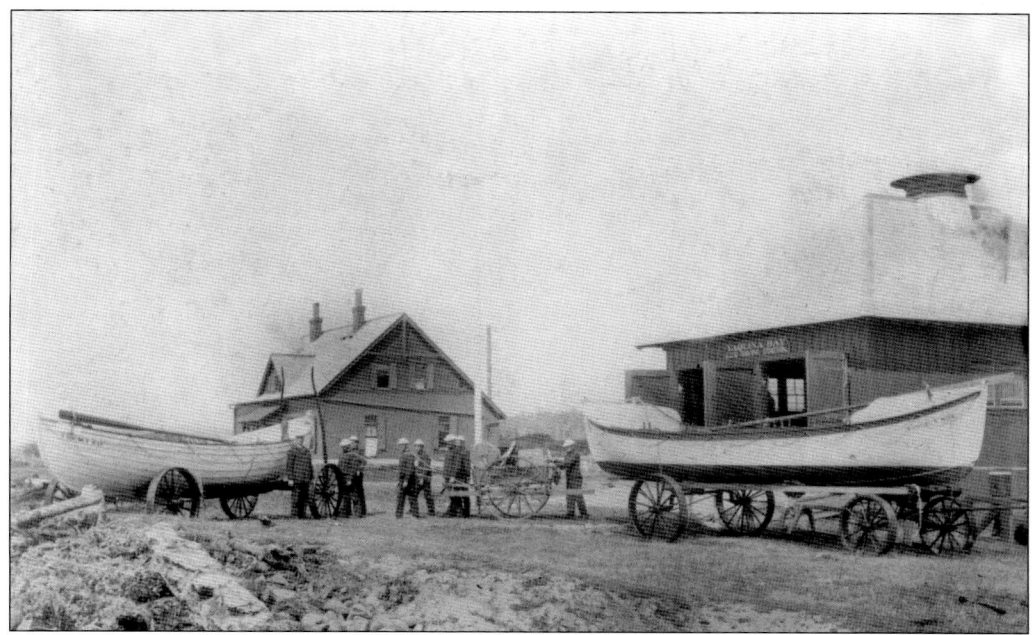

The life-saving station was positioned just above the high-tide line south of Yaquina Bay on South Beach and consisted of a station house, boathouse, barn, woodshed, and utility building. A drill field was created in front of the station between it and the water. The wreck pole was erected at the far north end of the field. (Courtesy of Lincoln County Historical Society.)

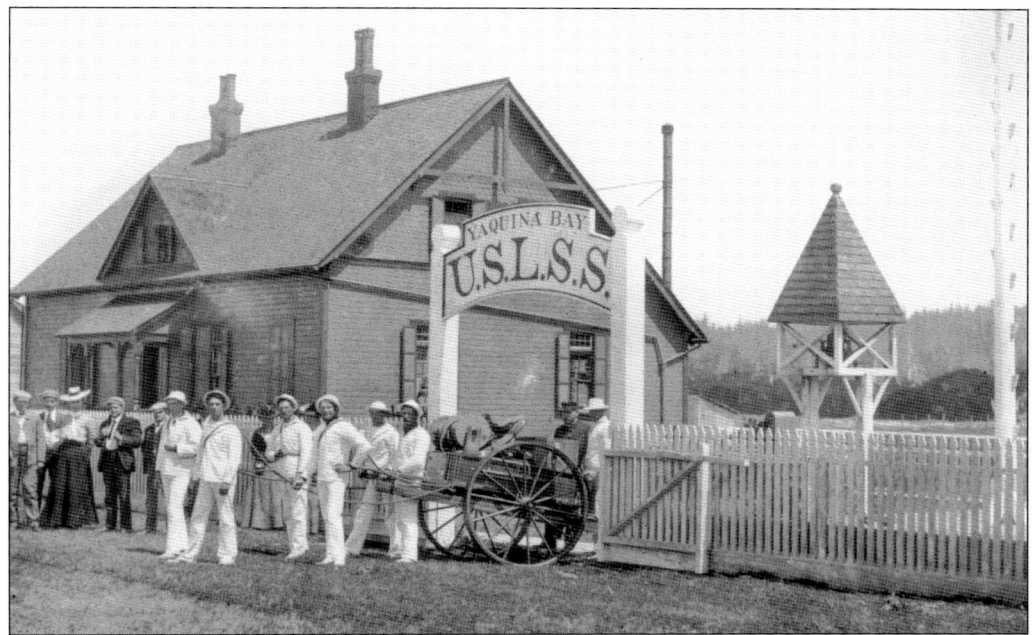

The U.S. Life-Saving Service employed a series of architects for their stations. This is a Marquette plan, the most common type built in Oregon, designed by Albert Bibb. Here the Yaquina Bay crew is hitched to the beach apparatus cart before hauling it down to the beach for breeches buoy drill, c. 1905. (Courtesy of Lincoln County Historical Society.)

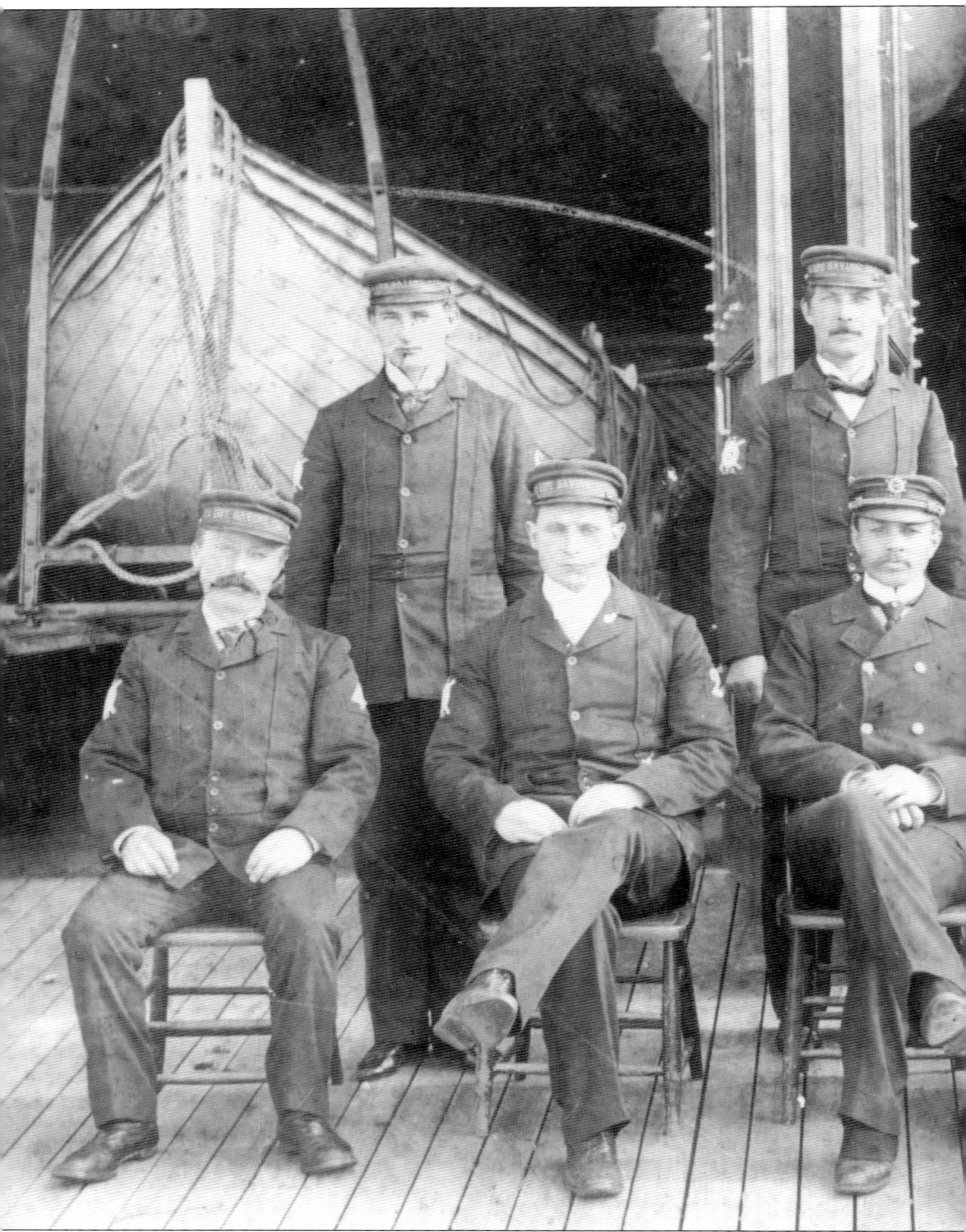

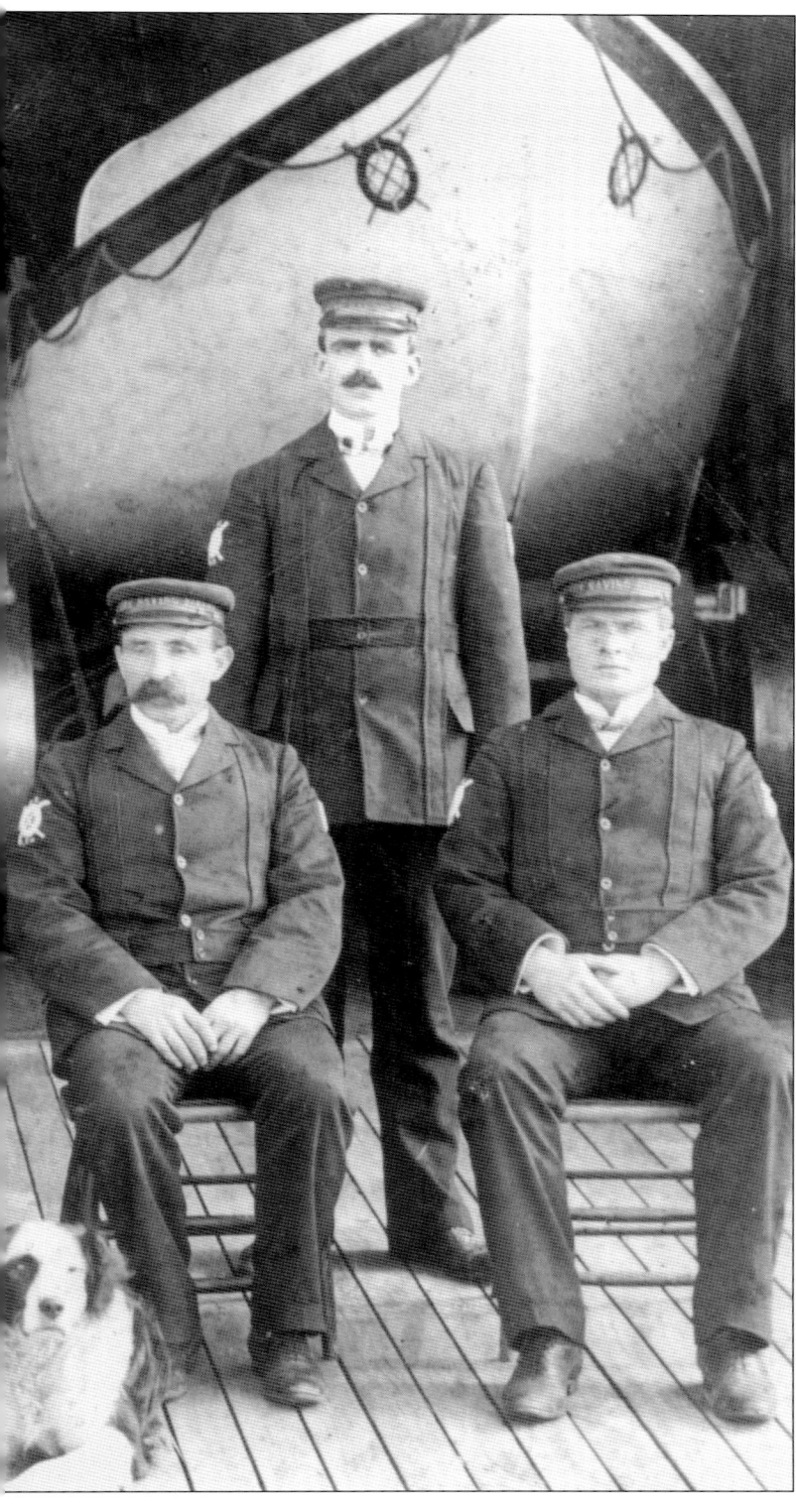

When not patrolling or attending to a wreck, there was a weekly routine to keep the surfmen fit and well practiced. Mondays were reserved for drill and practice with the beach apparatus, along with the overhauling of the boats and the rescue equipment. Tuesdays were designated for practice with the boats, which involved launching, rowing, and landing either a surfboat or lifeboat. The capsize drill was sometimes included at the discretion of the keeper since it was so hard on the equipment and crew. Wednesdays were signal practice with flags. On Thursdays, there was more drilling with the beach apparatus. Friday was reserved for practice of "restoring the apparently drowned" and training with the medical kit. Saturday was housecleaning day. By repeating the drills endlessly, the use of the equipment became automatic for the "storm warrior," allowing them to react mechanically in times of rescue. A surfman could visit his family on his one day off a week, "from sunrise to sunset." (Courtesy of Lincoln County Historical Society.)

55

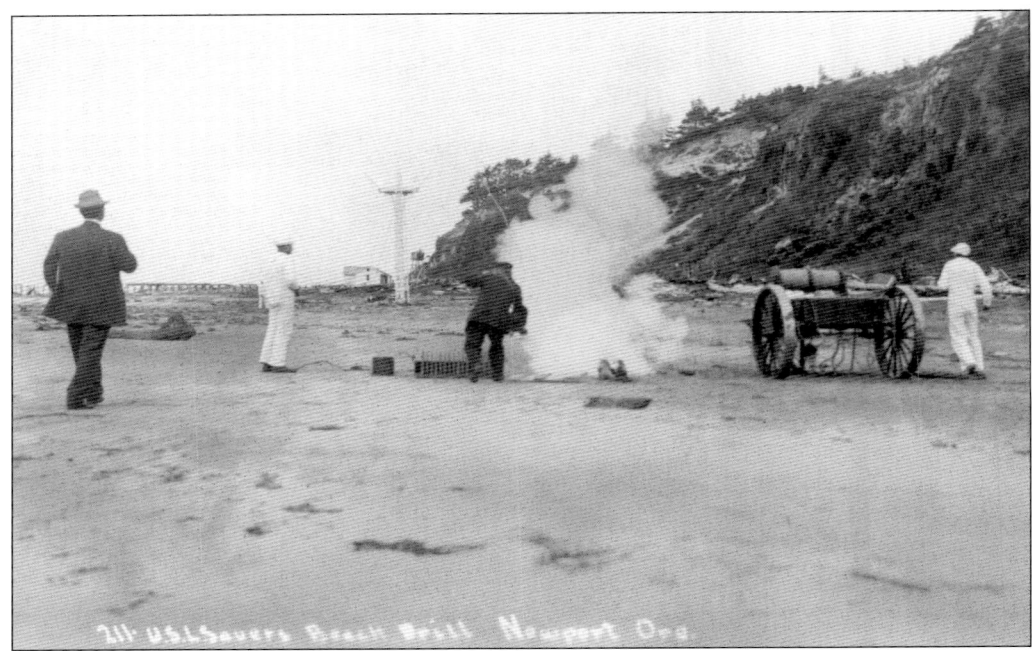

Mondays and Thursdays were reserved for beach apparatus drill. Here the crewmen are setting up a breeches buoy near the Yaquina Bay Life-Saving Station. The keeper is firing a line with a small cannon, called a Lyle gun, toward a pole representing a mast of a stranded vessel 75 yards away. The gun could fire the 17-pound projectile with accuracy up to an extreme range of 695 yards. The life-savers would then erect a series of lines and pulleys to rig the breeches buoy to rescue stranded mariners. A crew was expected to set up the breeches buoy in under 5 minutes and in the dark. A proficient crew could set it up in 2.5 minutes. (Author's collection, above; courtesy of Lincoln County Historical Society, below.)

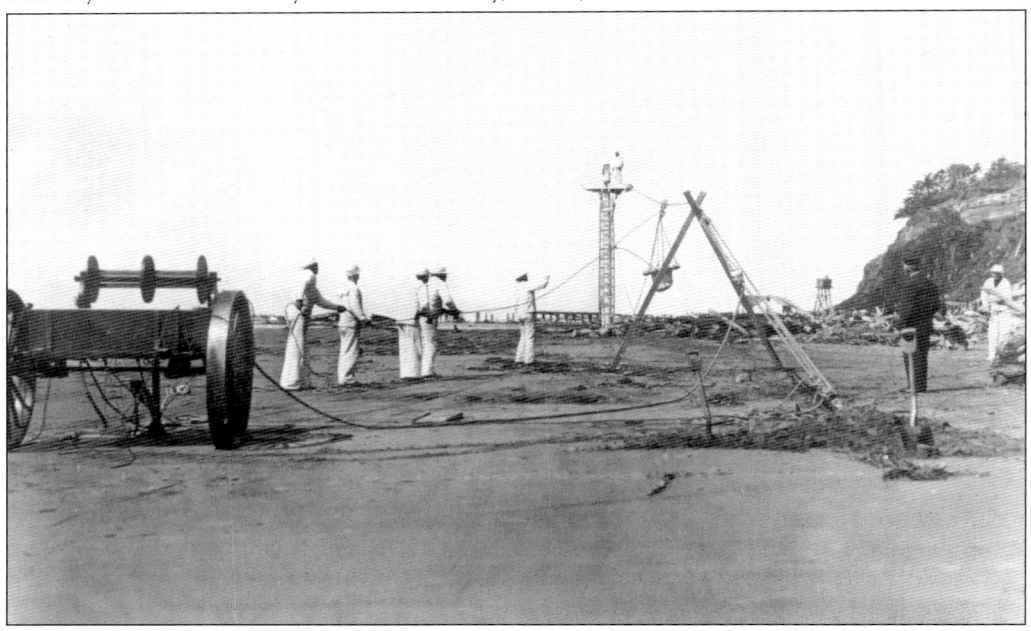

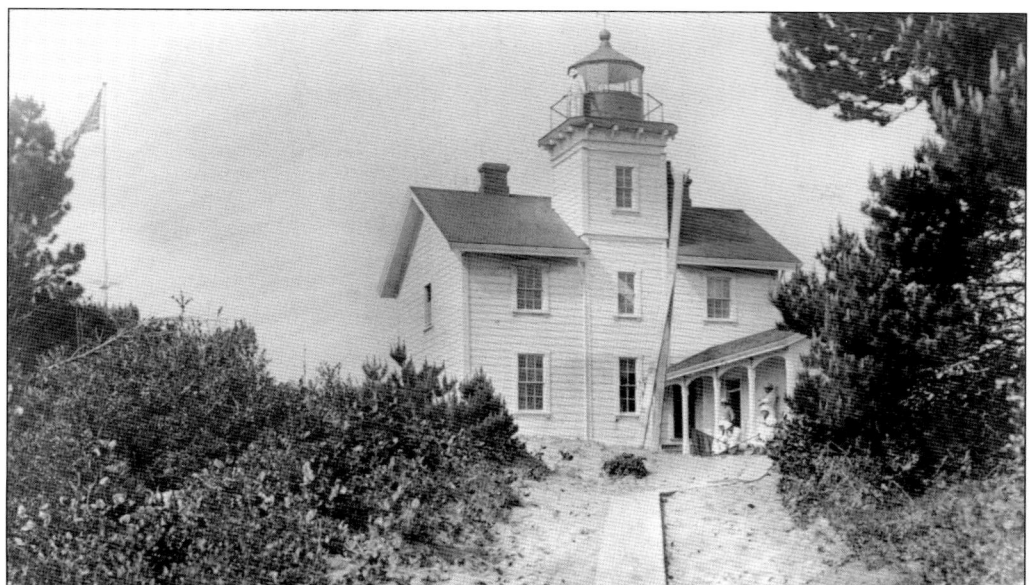

From 1906 to 1933, the Yaquina Bay Life-Saving Station was located at the Yaquina Bay Lighthouse. The lighthouse had been built in 1871, but was decommissioned in 1874. The Yaquina Bay lifesavers gladly moved in, as the lighthouse's location was far superior to their life-saving station on South Beach. This use of a lighthouse as a life-saving station is the only known instance in the United States. (Courtesy of U.S. Coast Guard.)

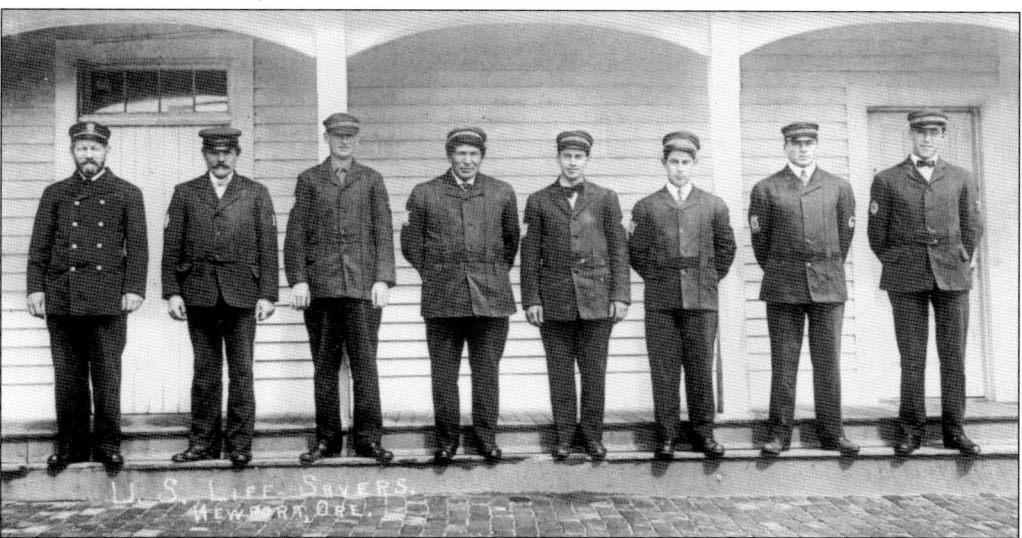

Life-savers did not get uniforms until 1889. Prior to that, surfmen would assemble anything they could that looked like a uniform. There were actual cases where stranded mariners thought pirates were attacking them. The U.S.L.S.S. finally designed a standardized uniform for the crew; however, the men were obligated to pay for their own. There were two sets of uniforms—formal dark blues and summer whites. The keeper can be distinguished in the formal blues by the double row of gilt buttons. The formal dark-blue uniform shows up in most posed portraits, while the summer whites appear in most action photographs. Here the Yaquina Bay crew is lined up behind the lighthouse in order of rank from left to right. (Courtesy of Lincoln County Historical Society.)

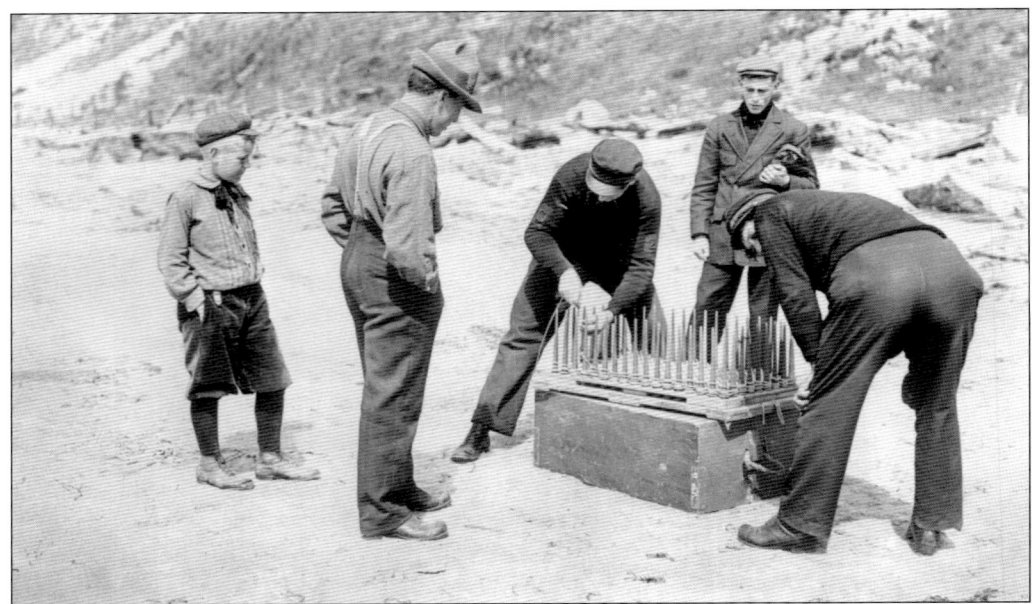

The key to firing the Lyle gun toward a ship was to have the line pay out smoothly behind the projectile. Here two Yaquina Bay crewmen "fake" a line so that the line won't entangle itself in flight. The line is fed between the pins and then the box set over the top. The box would then be turned over; the lid with the pins pulled out and the line would be ready to fly out unfettered from the box. (Courtesy of Lincoln County Historical Society.)

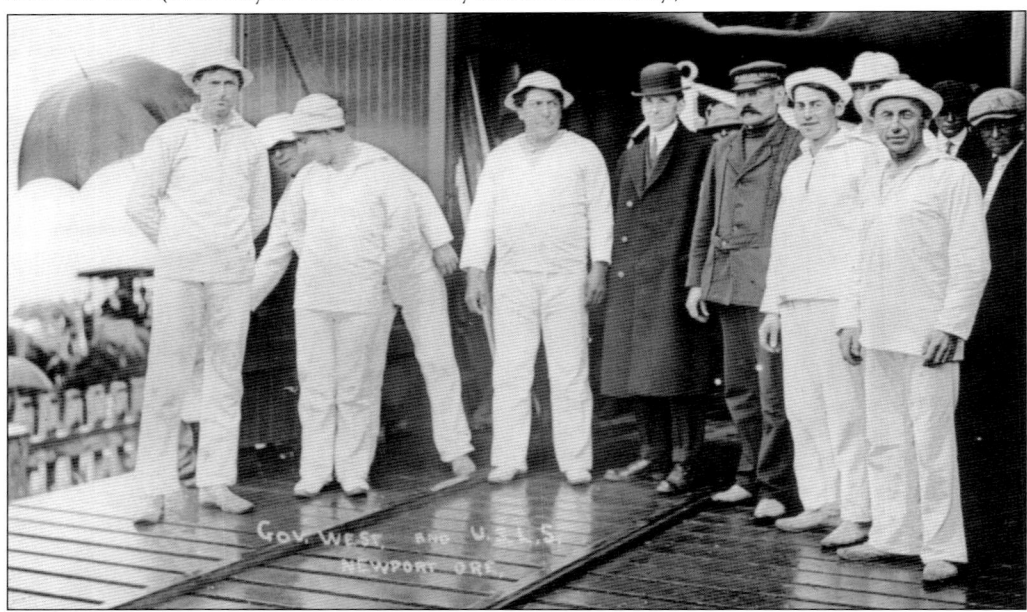

Promotion of the Life-Saving Service was a major component of U.S.L.S.S. superintendent Sumner Kimball's plan for the success of the service. Kimball was the only leader the Life-Saving Service had during its 44-year existence before it became the Coast Guard in 1915. Here Gov. Oswald West (in the derby) visits with the Yaquina Bay life-saving crew, *c.* 1912. (Courtesy of Lincoln County Historical Society.)

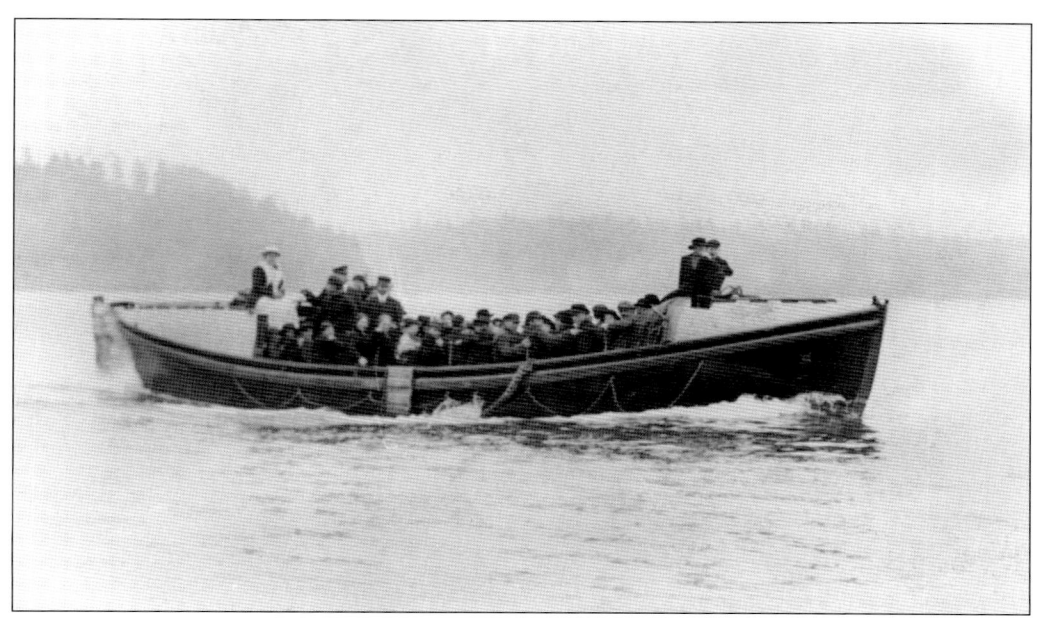

Life-saving service crews were a part of the community. Particularly on the West Coast, crews came from the local ranks. Everyone knew and associated with the life-savers. Even today, the Coast Guard continues with the tradition and often makes it possible for a "coastie" to serve with one station their entire career. In this picture, locals are taken for a ride aboard Yaquina Bay's new motor-driven, 36-foot lifeboat, *Undaunted*, c. 1914. (Courtesy of Lincoln County Historical Society.)

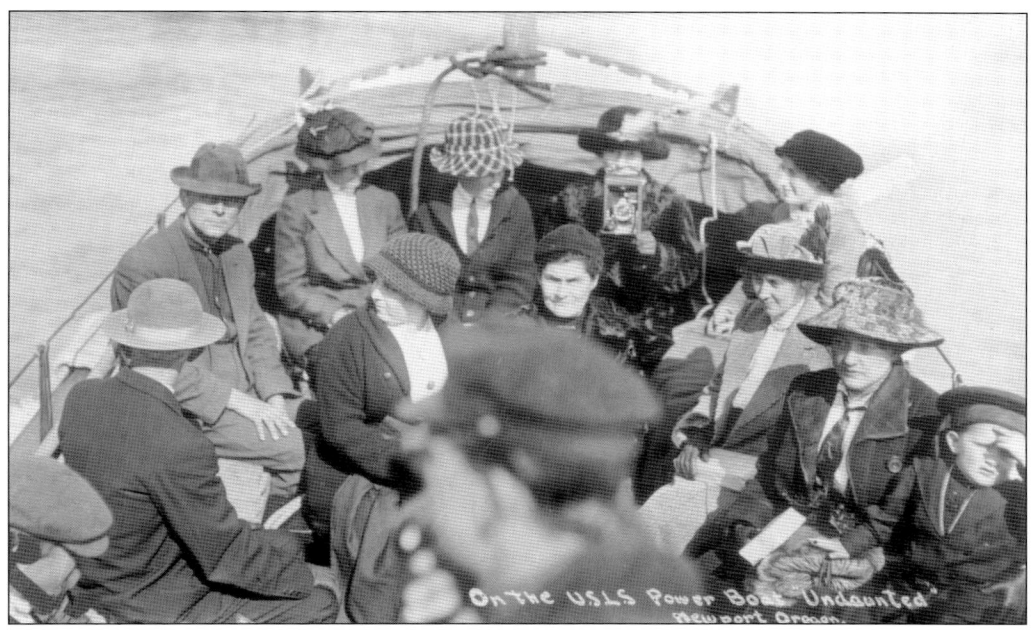

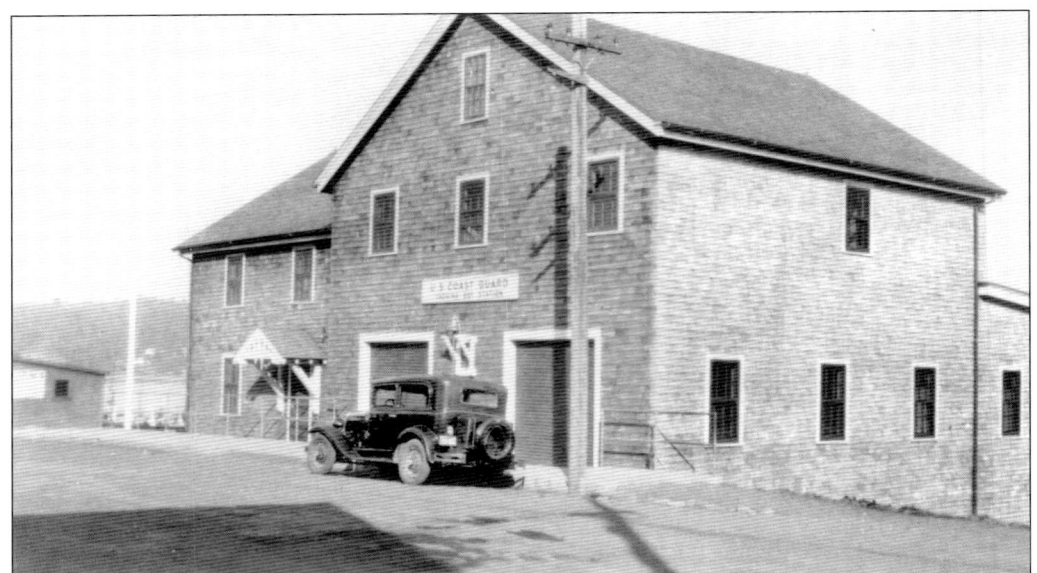

The Coast Guard took advantage of a boathouse fire to build what the locals had always wanted—a first class life-saving station. In September 1931, a contractor from Seattle, William Wills, began demolishing an old boathouse that was in the path of the new station. Construction went quickly, and on April 5, 1932, Capt. Anton Gustafson declared the new station open and ready for occupancy. The cost was $18,000 plus $6,000 for the furnishings. (Courtesy of Lincoln County Historical Society.)

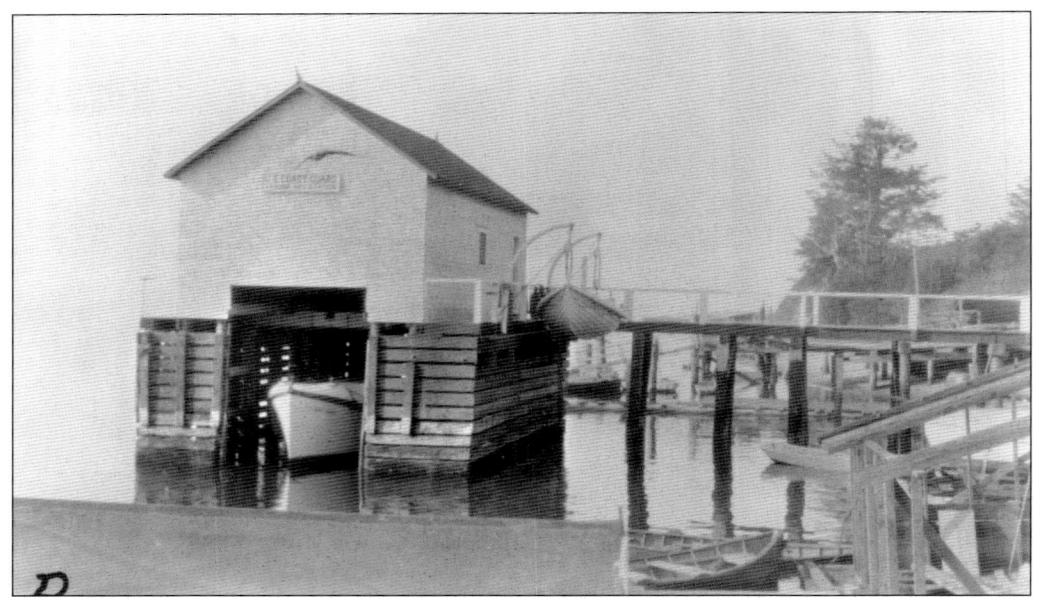

The Yaquina Bay Coast Guard had multiple boathouses during their history at Yaquina Bay for response in different situations. At the time this boathouse was photographed, they had one on the south side of the mouth of Yaquina Bay, one had just burned, and one was incorporated into the new station. Note the old surfboat on davits. (Courtesy of U.S. Coast Guard.)

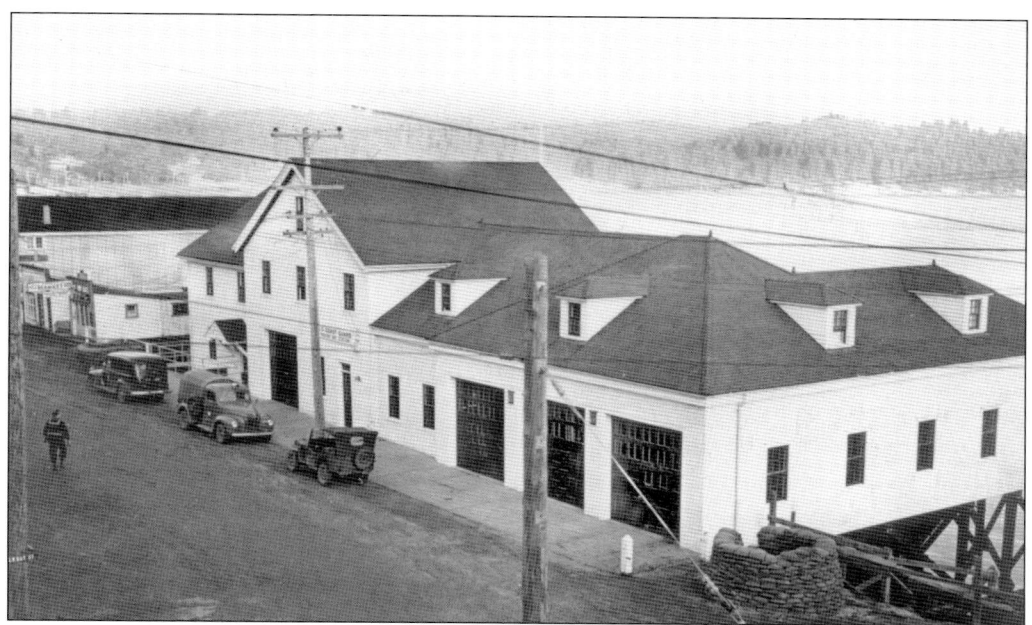

In 1941, the Yaquina Bay Station was expanded on its west side to accommodate the activities of the wartime beach patrol, making it one of the best equipped stations along the Oregon coast. On November 1, 1941, the Coast Guard was assigned to the U.S. Navy, which expanded the Coast Guard's duties to include beach patrol. As its name implies, the purpose of the beach patrol was to patrol the beach, watching for signs of enemy activity or invasion. Yaquina Bay was one hub of the beach patrol on the Oregon Coast. Richard Van Hine, the station keeper in 1943, was in charge of 500 navy personnel, most of whom were on beach patrol. (Courtesy of Lincoln County Historical Society, above; U.S. Coast Guard, below.)

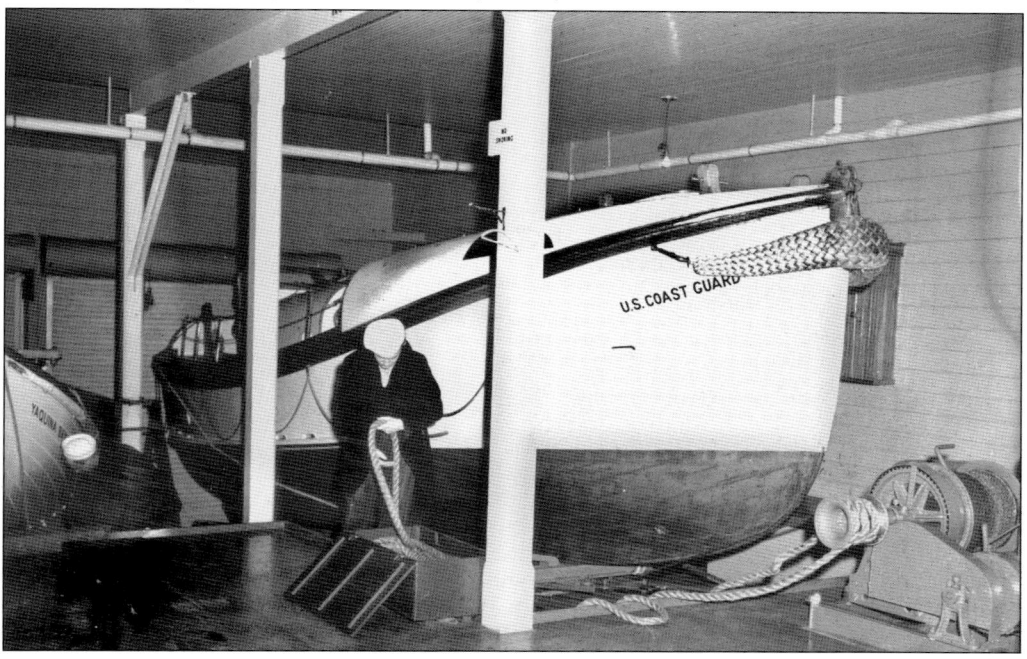

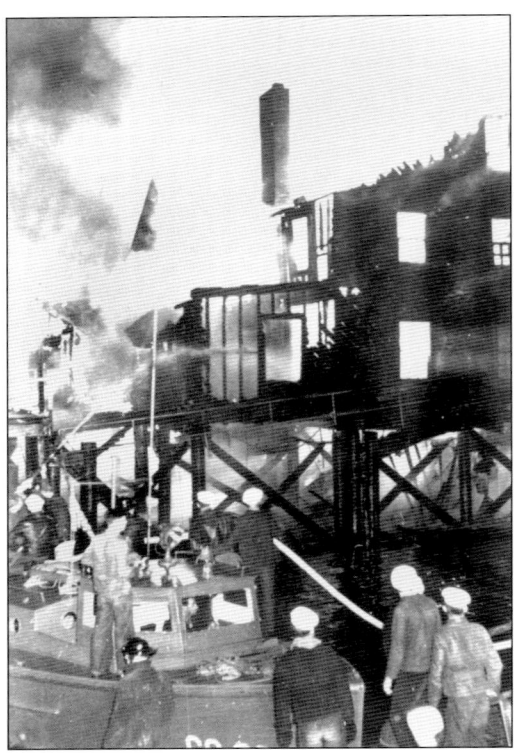

On January 2, 1944, the Yaquina Bay Station succumbed to a fire of "unknown origin." The fire departments from Newport and Toledo, plus coastguardsmen and army troops, could not contain the blaze. All motorized equipment was saved, though one pulling boat burned. After the fire, the crew lived at the Abbey Hotel for several months. (Courtesy of Lincoln County Historical Society.)

Due to postwar construction material shortages, it was not until 1948 that bids went out for the construction of a new station on a shelf of land east of the Yaquina Bay Bridge. The crew moved in on December 14, 1949. The new Yaquina Bay Station had accommodations for 22 men, consisting of a bunk room, recreation room, galley, and mess hall. The station building is still in use today by the Coast Guard. (Courtesy of U.S. Coast Guard.)

Five

Heceta Head

The economic potential of the Siuslaw River was overlooked in the 1850s. In fact, the Siuslaw River did not even appear on the 1851 federal coastal survey report. Shipping finally started to come to the Siuslaw when Duncan and Company located a salmon cannery and sawmill near the mouth of the river in 1876. However, not until the *Alexander Duncan* crossed the Siuslaw River bar in 1877, did the potential of the Siuslaw begin to be discussed outside of the immediate vicinity. In 1880, with pressure from the Oregon Congressional delegation, Congress authorized the first survey of the Siuslaw through the Rivers and Harbors Act. In 1883, a beacon was placed at the river's mouth.

In 1889, Congress appropriated $80,000 toward the construction of the Heceta Head Lighthouse, eight miles to the north of the Siuslaw River. However, Lighthouse Board member Vice Adm. S. C. Rowan expressed mixed feelings about the Siuslaw River area when he wrote, "It does not appear that a harbor light is needed by the sparse commerce of this river. But it is quite evident that a coast light is required to divide the dark space between Cape Arago and Cape Foulweather."

There is no doubt that Rowan's comments were unappreciated by the citizens of the small town of Florence at the mouth of the Siuslaw. The Siuslaw River did not support as many settlements as the Umpqua or Columbia, though the Siuslaw was the only other river to penetrate through the Coast Range. The first American settlers had arrived in the area in the 1850s, but Hudson Bay Company trappers had been in the region 30 years earlier. The first area residents were, of course, the Siuslaw Indians. Like other coastal settlements, the river was the road. Small coasting vessels brought supplies irregularly from San Francisco to the Siuslaw River towns of Florence, Cushman (formerly Acme), and Mapleton (formerly Seaton). Return cargoes were canned salmon, salt salmon, and miscellaneous produce from the farms of the region.

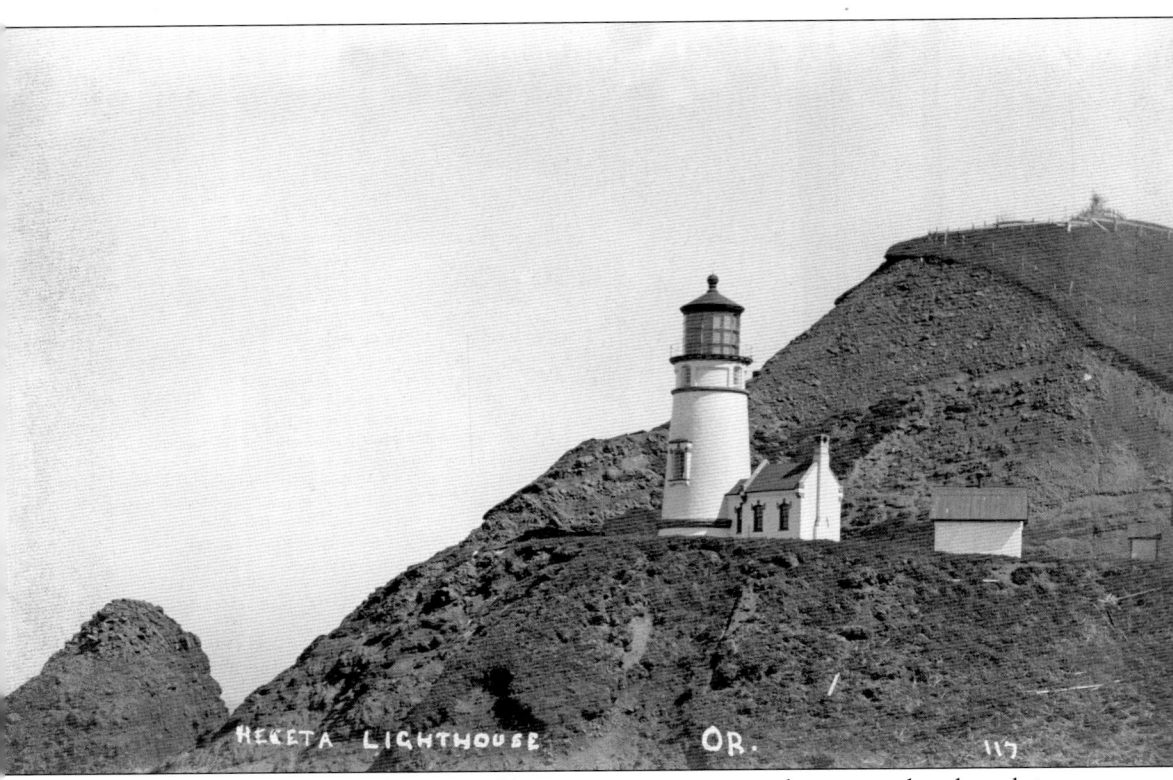

It was hoped that a lighthouse would improve navigation in the area and perhaps bring more vessels to the Siuslaw River. Property was acquired for the lighthouse and construction commenced in 1892. The building of the 56-foot tower was difficult because of its isolation. Construction materials came from San Francisco and Astoria, landed at Florence, and then came overland on a hastily built wagon road. The lens apparatus was brought in through the surf at Cape Cove below the construction site. Finally, on March 30, 1894, the lighthouse was lit. The first keeper at the lighthouse was Andrew P. C. Hald who was transferred south from Cape Meares. The assistant keepers were Eugene M. Walters and John M. Cowan. Annual salaries were $800 for the keeper, $600 for the first assistant keeper, and $550 for the second assistant keeper. (Courtesy of Mike Byrnes.)

This was a common photograph of Heceta Head taken in the late 1800s and early 1900s. Either the lighthouse or the keeper's residence would be lined up in the opening at Arrow Point. At some point after 1925, the rock formation eroded away, and this view no longer exists today. (Author's collection.)

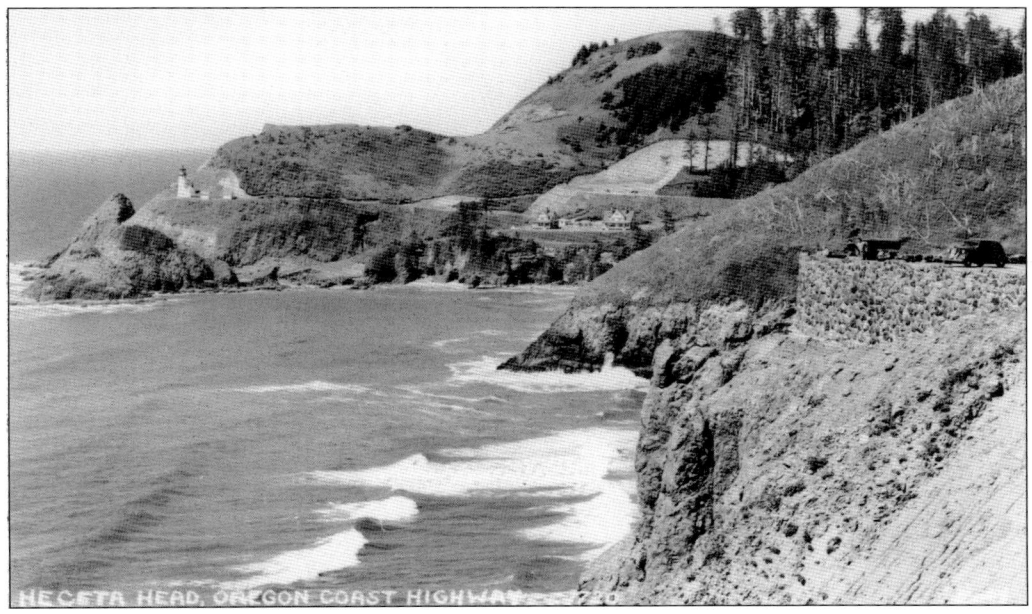

This view is one of the most popular scenes to photograph on the Oregon Coast. It is looking north from a highway turnout near Sea Lion Caves. The view's popularity was made possible by the Oregon Coast Highway. This stretch of the highway was opened in 1932, though the highway was not declared complete until 1936. (Author's collection.)

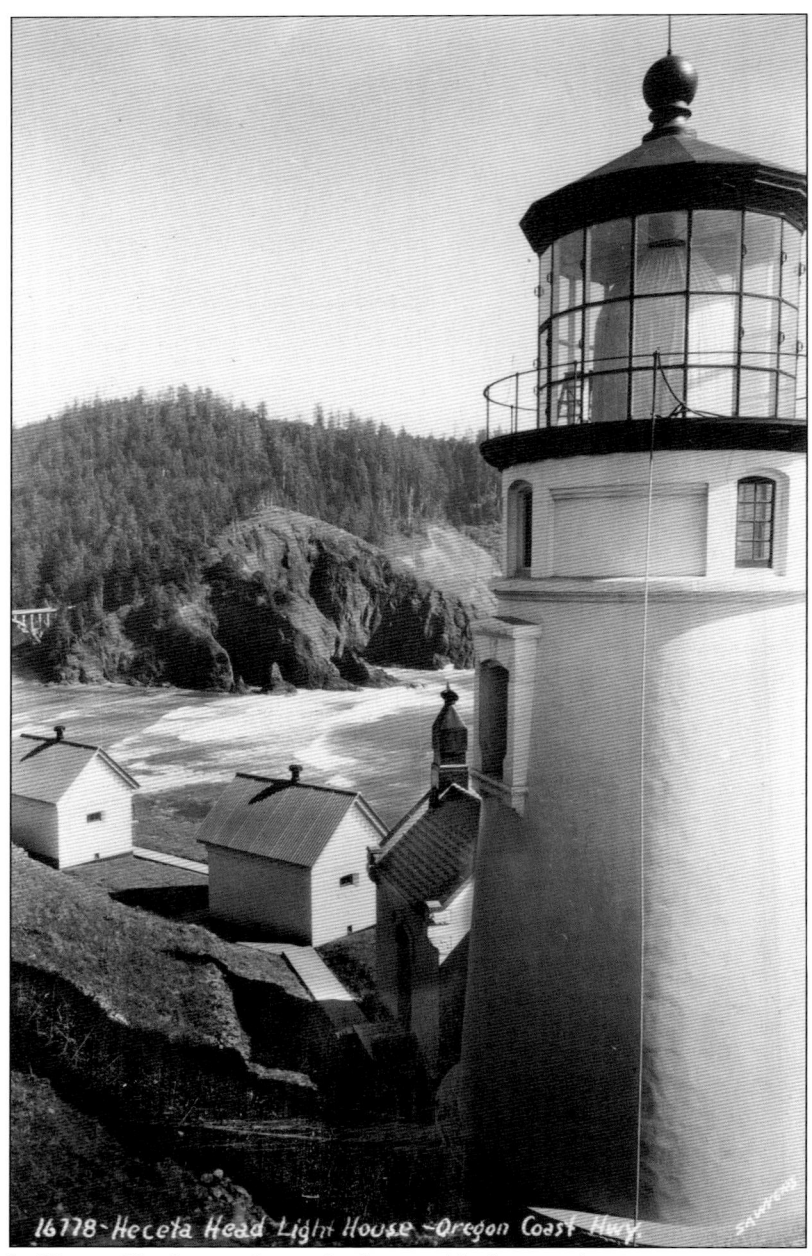

The light for Heceta Head was a first-order lens visible for 21 miles. However, its optics were not French made like most Oregon lights. This lens came instead from the Chance Brothers, a British firm. The principal duty of a keeper is to keep the light visible, and keeping the glass clean was key. The keepers would constantly clean the windows of the lantern room, both inside and out. The oil lamps produced smoke, most of which went out the round ventilator at the top of the lantern, but some was deposited on the glass optics. The keepers would clean and polish both the inside and outside of the glass optics in full-length aprons to protect the lens from dust, dirt, and lint from their clothes. The optics are kept shrouded during the day to protect the lens and lamp from the sun and to keep the glass as pristine as possible. (Author's collection.)

In 1934, the lighthouse was electrified. The oil lamps were retired and the keeper's role was lessened. The hand-cranked clockwork mechanism to turn the lens carriage was replaced by a small motor, further reducing the keeper's work role and causing one of the three keeper positions to be eliminated. (Author's collection.)

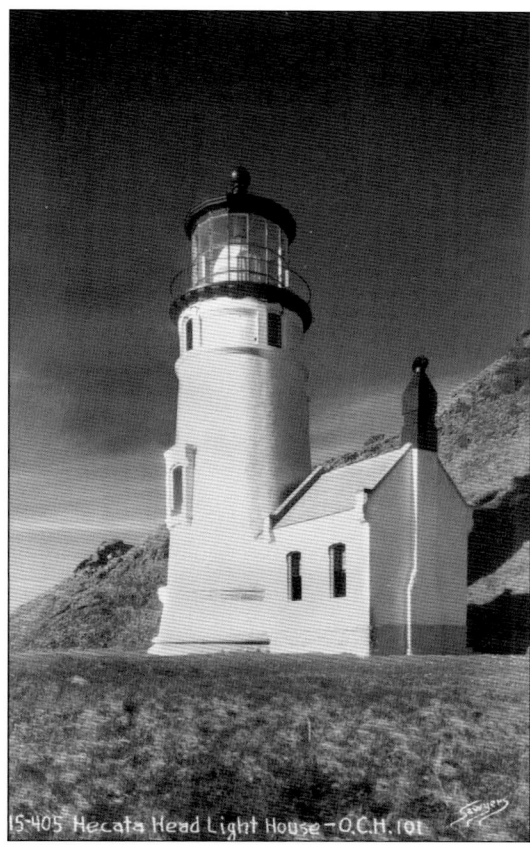

In 1940, Rufus Johnson, a contractor from Mapleton, was hired to demolish the keeper's dwelling. The two remaining keepers moved into the assistant keepers' duplex, which still stands today and is operated as a bed and breakfast. This photograph was taken just a few years prior to the demolition, with the keeper's dwelling on the right still standing. In the background on the next headland is the visitors' center for Sea Lion Caves. (Author's collection.)

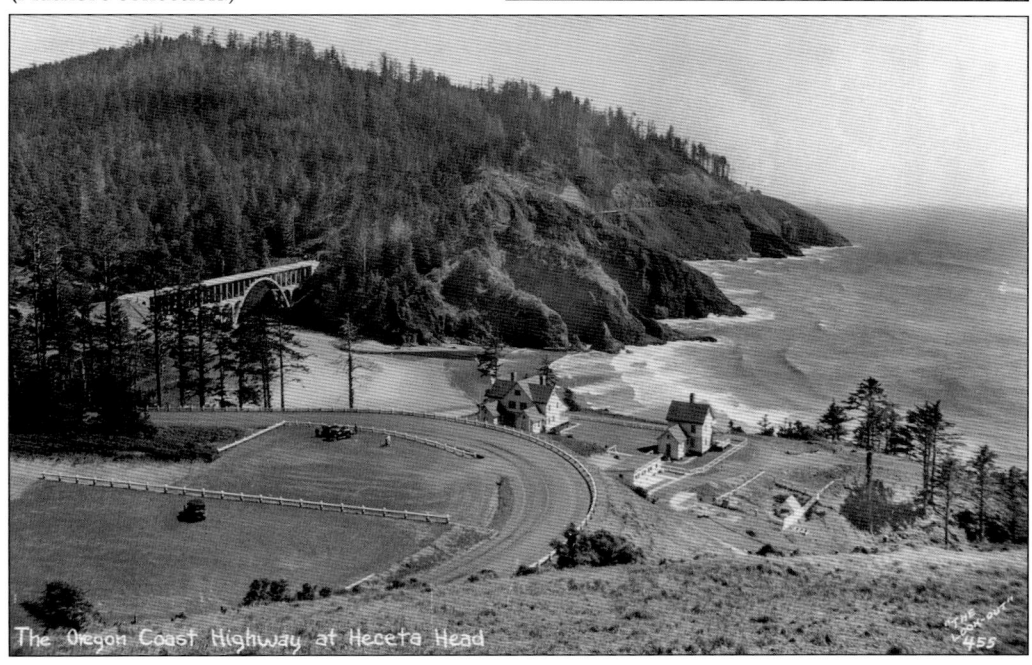

When the lighthouse was completed in 1894, the compound consisted of the lighthouse with attached workroom, oil house, and storage building, while below the lighthouse to the south sat the keeper's dwelling and the assistant keepers' dwelling about 500 yards away. (Courtesy of U.S. Coast Guard.)

In the background is Cape Creek Bridge, opened in 1932. It was designed by Conde B. McCullough, a pioneering bridge engineer who was responsible for designing hundreds of Oregon bridges during his 25-year career with the State Highway Department. The beach at the center is Cape Creek beach where the lens was landed and hauled up to the lighthouse. (Courtesy of U.S. Coast Guard.)

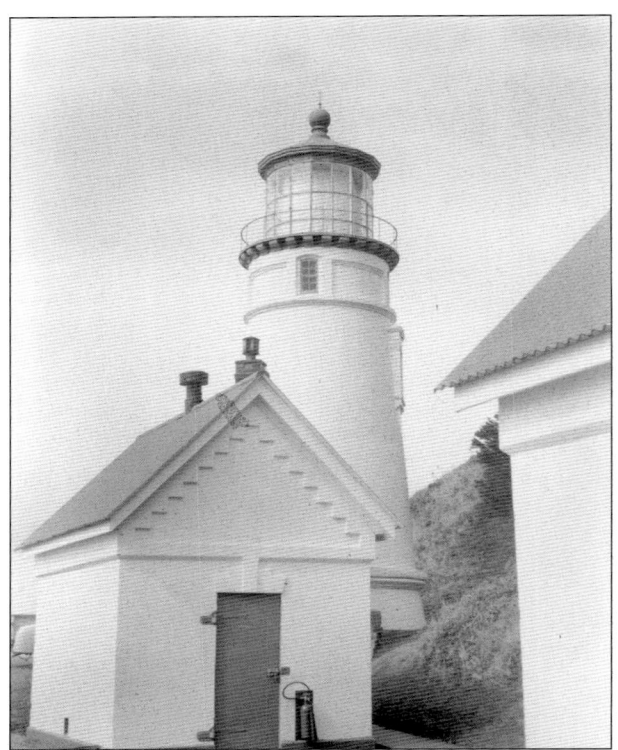

As early as 1889, Congress had been solicited for a life-saving station at the mouth of the Siuslaw. However, not enough shipwrecks had yet occurred to warrant it. After another request in 1893, Superintendent Kimball still did not back the proposal, as there had only been two accidents at the Siuslaw in 28 years of recorded shipping. However, two more wrecks suddenly occurred, one in 1894 and another in 1895. At those disasters, the Umpqua River crew had rowed 25 miles to render assistance. Still there was not enough support. Finally, a month after the Life-Saving Service became the Coast Guard; a House resolution was passed on March 4, 1915, to establish a life-saving station at the mouth of the Siuslaw. It took several years to buy property and get the station built, but finally, it was reported on September 21, 1917, that the station would be opening. (Courtesy of U.S. Coast Guard.)

Florence's paper, *The West*, reported, "It has been some twenty-five years since it was first suggested that a life-saving station should be established at the mouth of the Siuslaw river." Only Port Orford worked longer to get a station. Capt. Theodore Roberge came down from Cape Disappointment and was appointed keeper. The crew was "shipped" in March 1918, five men from the Florence area and three from other locations. (Courtesy of U.S. Coast Guard.)

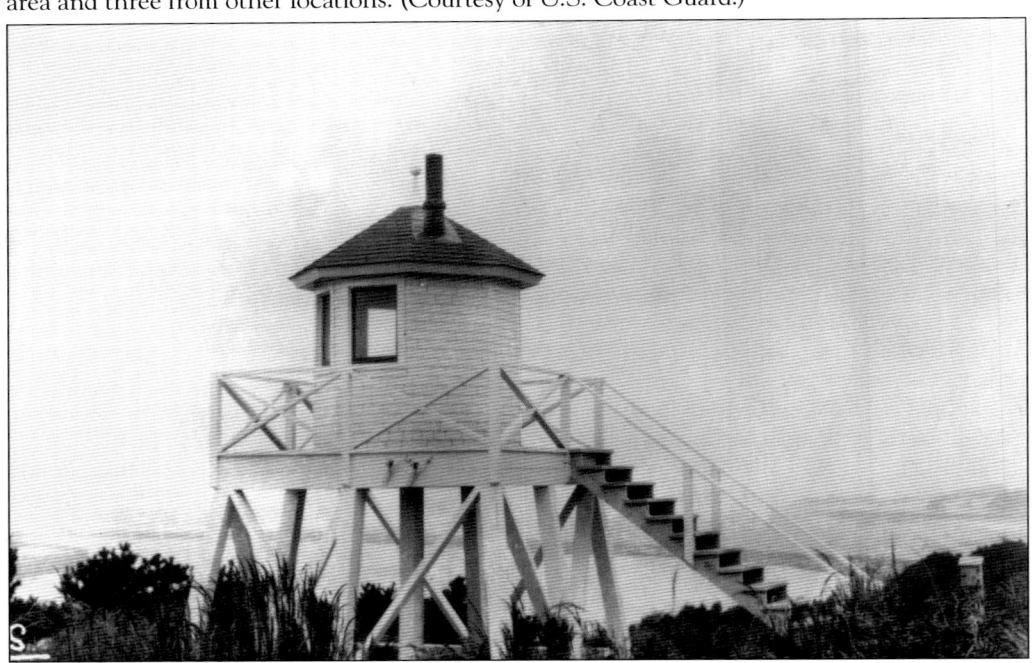

Northwest of the station house was a lookout tower on Cannery Hill built around 1918. The eight-sided tower was raised only about 8 feet above the ground, as Cannery Hill offered sufficient elevation. Shingle-clad with an eight-sided roof, it is the earliest lookout in Oregon known to have a stove for heat. The diminutive tower has disappeared over time, made obsolete by a metal-framed lookout tower on the north jetty to the northwest. (Courtesy of U.S. Coast Guard.)

Six

Umpqua River

European settlement on the Umpqua River was solidified in 1836 when representatives of the Hudson's Bay Company built Fort Umpqua near the site of present-day Elkton. The presence of the fort encouraged settlement of the area by non-natives. The fort was abandoned in 1852 but not before the area began to be populated by Americans. In the late 1840s and early 1850s, the settlements along the Umpqua River became major trading partners with the gold fields of California and Southern Oregon. The settlers knew there was a fortune to be made in supplying the miners with food and timber. The town of Scottsburg, about 30 miles up the Umpqua, thrived during the gold rush in California in 1849 and then again in 1852 with the gold rush in Southern Oregon. Only two navigable rivers, the Columbia and the Umpqua, cut through the Coast Range and connect the Pacific to the Willamette Valley. Being the farther south, the Umpqua was the quickest water route to the Southern Oregon mines from San Francisco or Portland. When the Pacific Coast was first surveyed for aids to navigation, the only lighthouse recommended for Oregon was one for the Umpqua River.

The entrance to the Umpqua River is twisted by an enormous sand spit dangling from the north side of the mouth and projecting southward. This "North Spit" forces the river southward in an attempt to find an outlet to the ocean. At least eight major shipwrecks occurred at the mouth of the Umpqua River between 1850 and 1857, several coming to rest on North Spit. On March 3, 1851, Congress appropriated $15,000 toward the construction of a light at the Umpqua River. Funds continued to be appropriated over the years until enough was collected for construction to begin in 1855. Due to construction difficulties on the isolated Oregon coast, the lighthouse was not illuminated until the fall of 1857. Unfortunately, the lighthouse was built too close to the south side of the river's mouth. In February 1861, the structure was undermined by a winter storm and the tower became unstable. The lighthouse was abandoned in December 1863, and soon after the tower collapsed into the Umpqua.

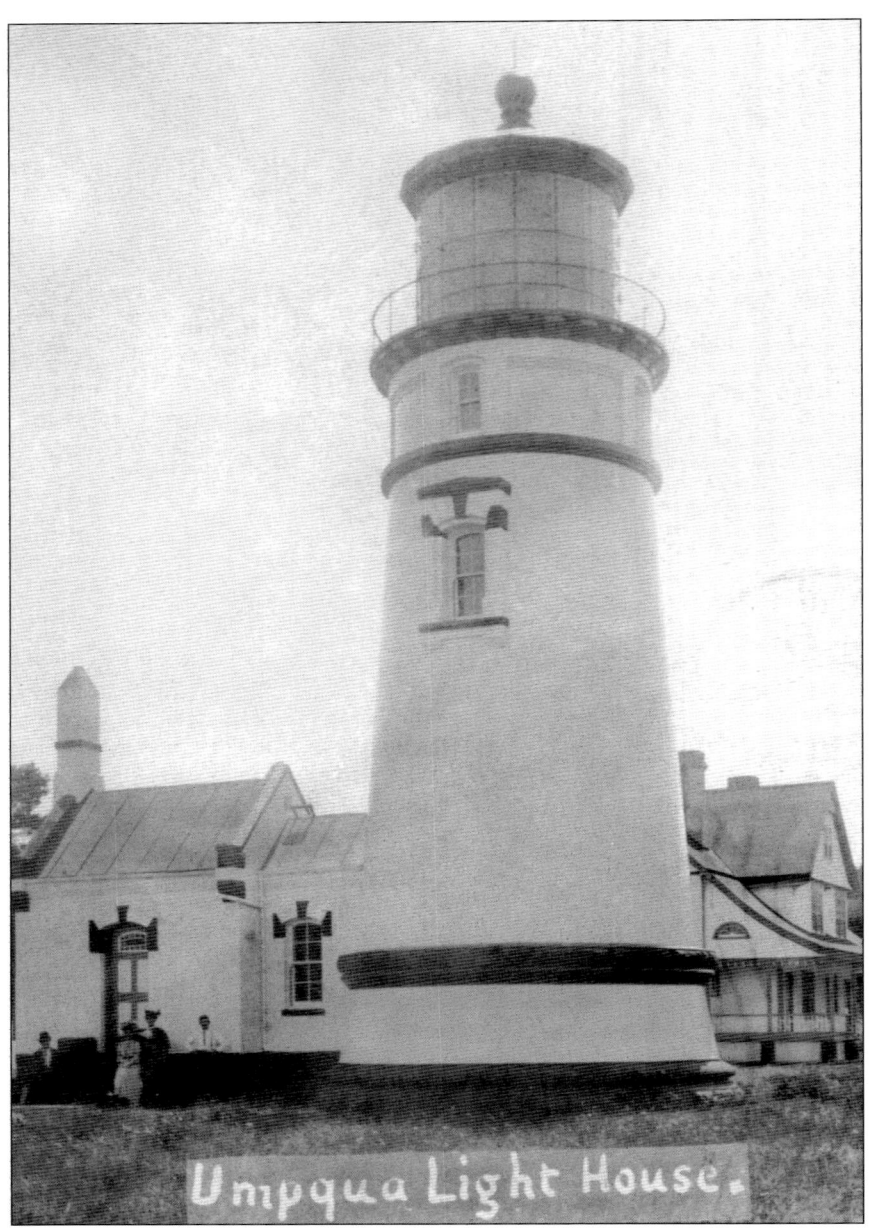

For more than 30 years, pilots made do without a lighthouse at the mouth of the Umpqua. The Lighthouse Board argued in 1864 that a lighthouse 21 miles south at Cape Arago would serve the region better. This, of course, helped the economic situation of Coos Bay while hurting the economy of the Umpqua River Valley. Finally, Congress acted in October 1888 by purchasing a large amount of stable land on the south side of the Umpqua on a low headland, far back from the ocean and river. Construction began in 1891. Problems with contractors, cost overruns, and construction errors kept the light from being illuminated until December 31, 1894. In the background is the assistant keepers' dwelling. The keeper's dwelling is out of the picture to the left. Each dwelling flanked the lighthouse, and all three structures were built in a line parallel to the ocean. (Courtesy of Michel Forand.)

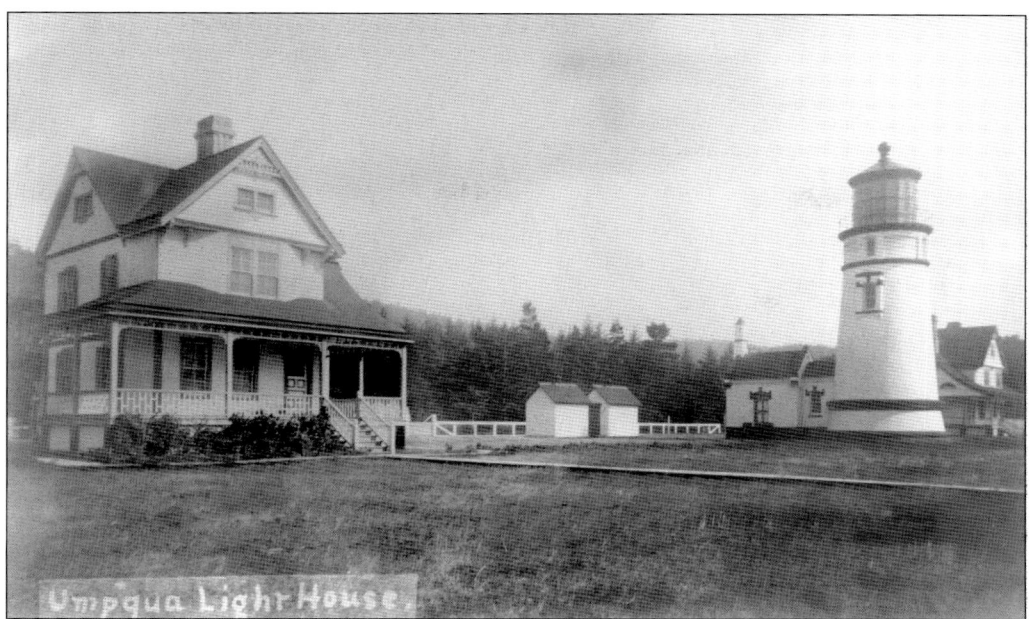

The keeper's dwelling is in the foreground, while the assistant keepers' dwelling is on the far side of the lighthouse. At first glance, the dwellings appear similar, but upon closer inspection, the keeper's dwelling is a single-family home, while the assistant keepers' house is a duplex built for two families. (Courtesy of Mike Byrnes.)

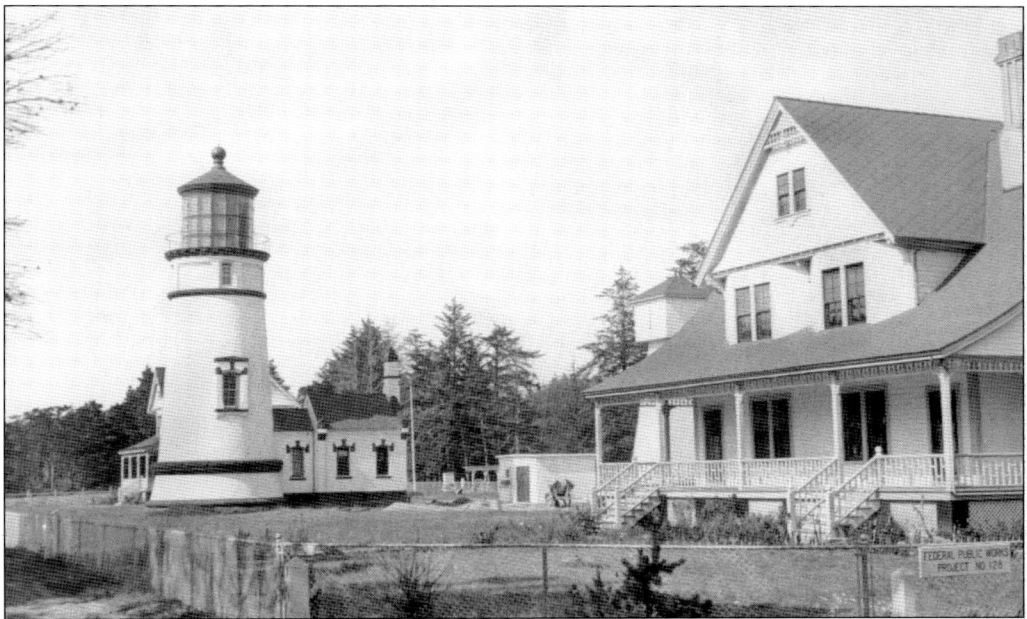

This photograph was taken at Umpqua in 1935. Note the sign in the lower-right corner displaying "Federal Public Works Project No. 128." Several Oregon stations were built under President Roosevelt's New Deal Public Works Administration. This station was already built before the Great Depression, so presumably a small construction project by the PWA was undertaken at Umpqua. (Courtesy of U.S. Coast Guard.)

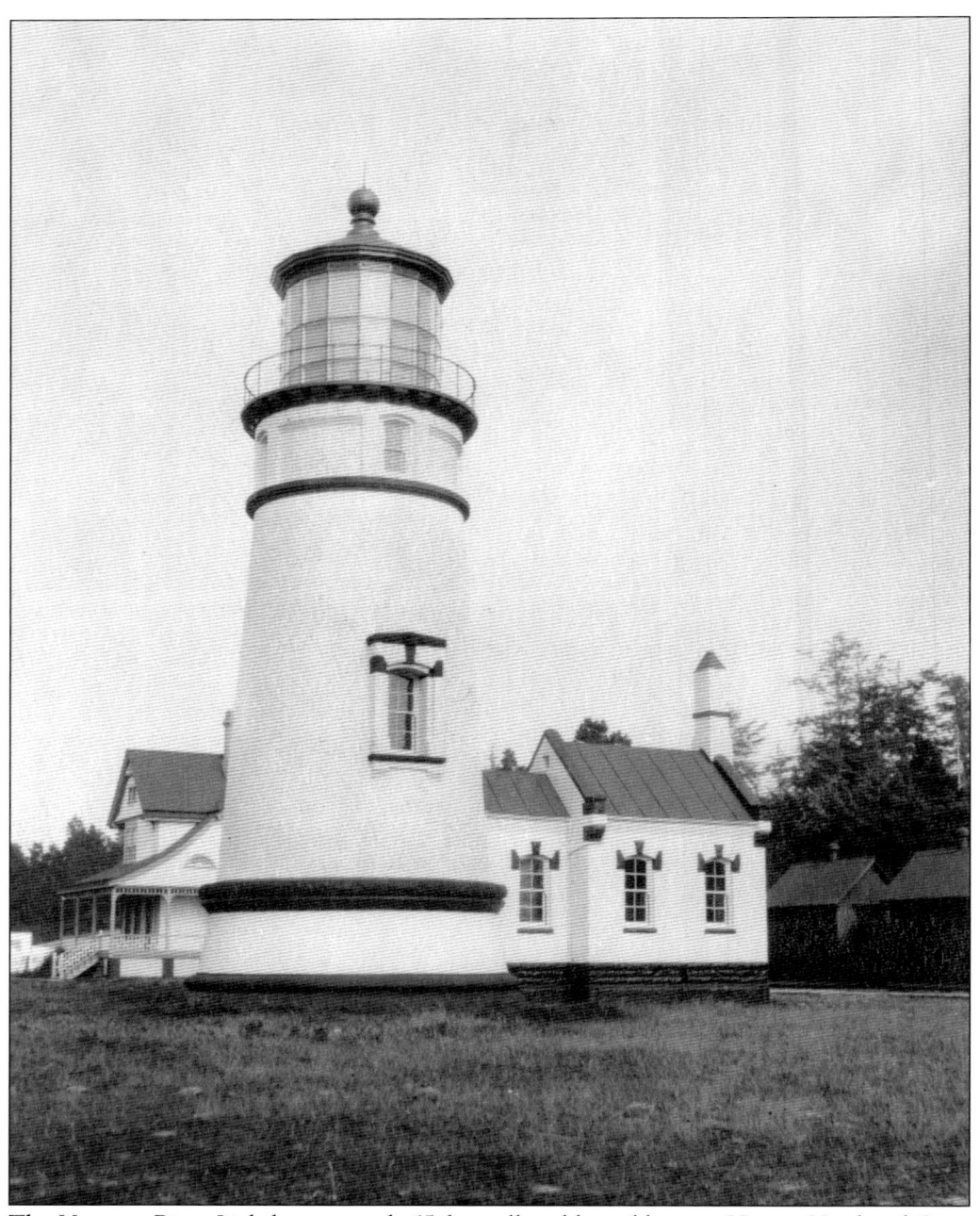

The Umpqua River Lighthouse stands 65 feet tall and has siblings at Heceta Head and Cape Blanco. The brick tower is parged and is 5 feet thick at the base and tapers to 21 inches at the lantern room. It has an attached workroom at the base. The light is a first-order Fresnel lens, manufactured in 1890 by Barbier and Cie of Paris and used a Funck mineral oil lamp. The Umpqua River Lighthouse is typical of Oregon lighthouses except for one unusual feature: its signal. Its signature is two white flashes followed by a red flash. At night, visitors come from around the world to watch the carousel of red and white beams on the surrounding trees. (Courtesy of U.S. Coast Guard.)

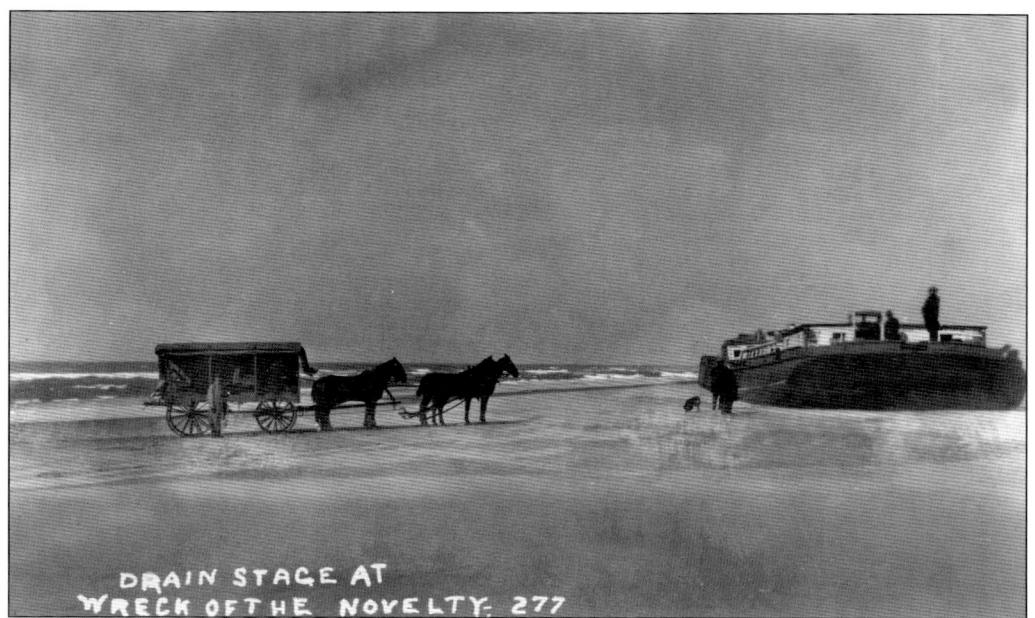

The unusual four-masted schooner *Novelty* was launched in 1886. The ship was the world's first four-masted, bald-headed schooner and the first of her rig to circumnavigate the globe. In 1907, while coming down the West Coast, the San Francisco–based *Novelty* ran aground on the sand dunes south of the Umpqua River. The crew, captain, and his family all walked ashore. (Courtesy of Mike Byrnes.)

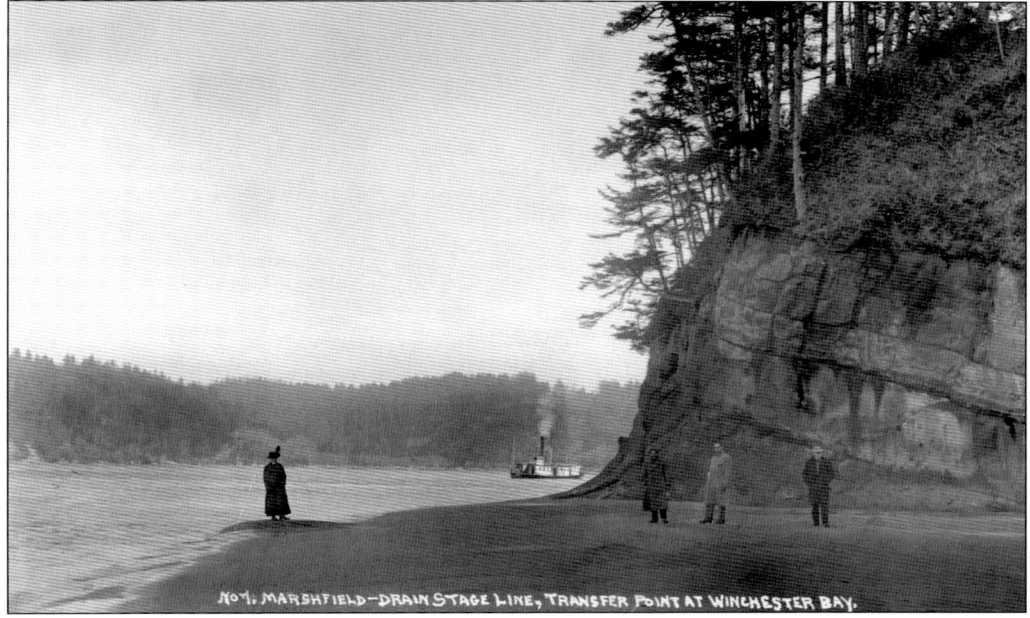

The Marshfield-to-Drain stage traveled the best road available: the beach. The horse-drawn stage would run along the beach from Coos Bay to Winchester Bay, where passengers would disembark to wait for a ferry to take them from Winchester Bay up the Umpqua River toward the town of Drain. (Author's collection.)

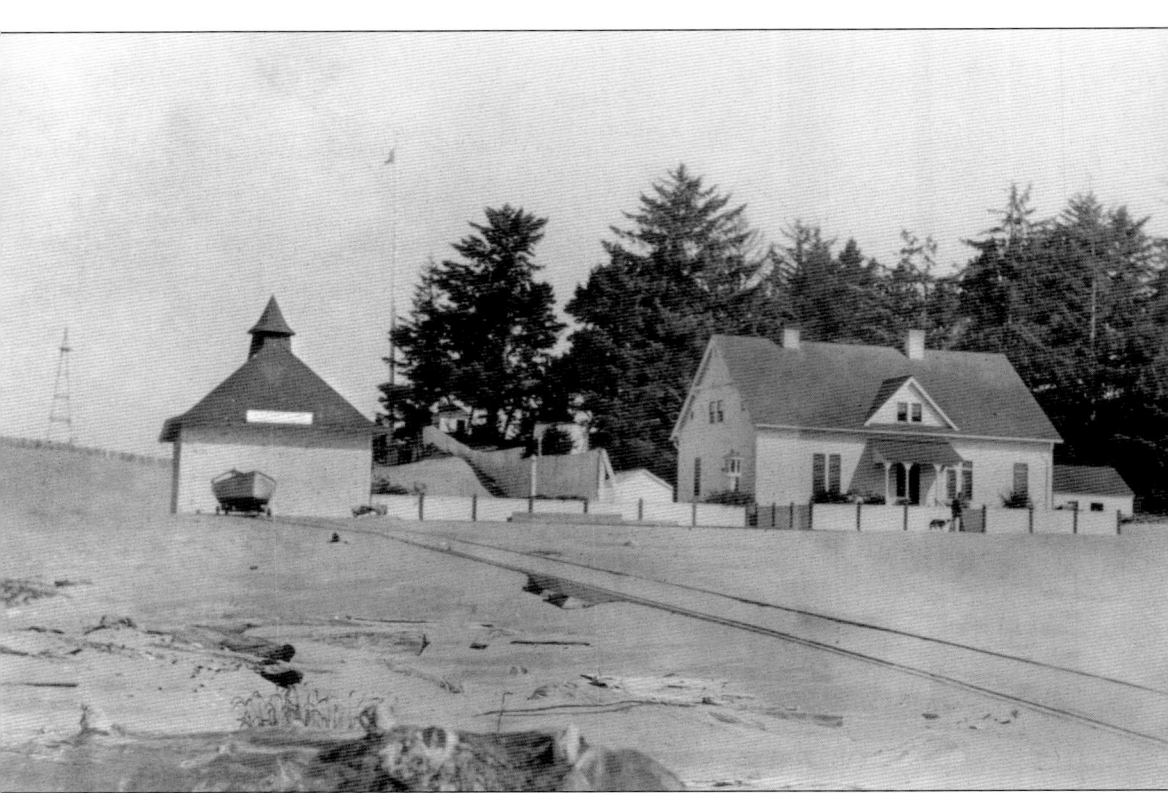

After the first Umpqua River Lighthouse collapsed in 1864, shipwrecks began to occur with increasing frequency. The 1870s saw a long string of tragic disasters. Besides pushing for a new lighthouse, the local populace also requested a life-saving station. Oregon representative Binger Hermann requested an appropriation of $8,000 in early 1888 to establish a life-saving station near the mouth of the Umpqua River. The proposed station was rolled into House Resolution 8181, along with 10 other life-saving stations, and approved on July 17, 1888; however, a limit of $5,000 was set per station. A site for the station was selected to the southwest of Fort Umpqua (1856–1862) on Army Hill, northeast of the 1857 lighthouse. Conveniently it was located on land owned by the federal government since the 1850s. The Umpqua River Life-Saving Station opened in September 1891, with a full-time crew of seven. (Courtesy of U.S. Coast Guard.)

The Umpqua River Life-Saving Station was quite isolated on the North Spit across the Umpqua River from the small community of Winchester Bay. To help supply themselves with food, the crewmen planted a garden between the station and the boathouse, as shown in this 1923 photograph. (Courtesy of U.S. Coast Guard.)

Horses were often used to help move surfboats and lifeboats overland. This allowed the surfmen to arrive somewhat fresh to launch the heavy wooden boats into the water. Here are two horses corralled behind the station next to the wood house in 1923. (Courtesy of U.S. Coast Guard.)

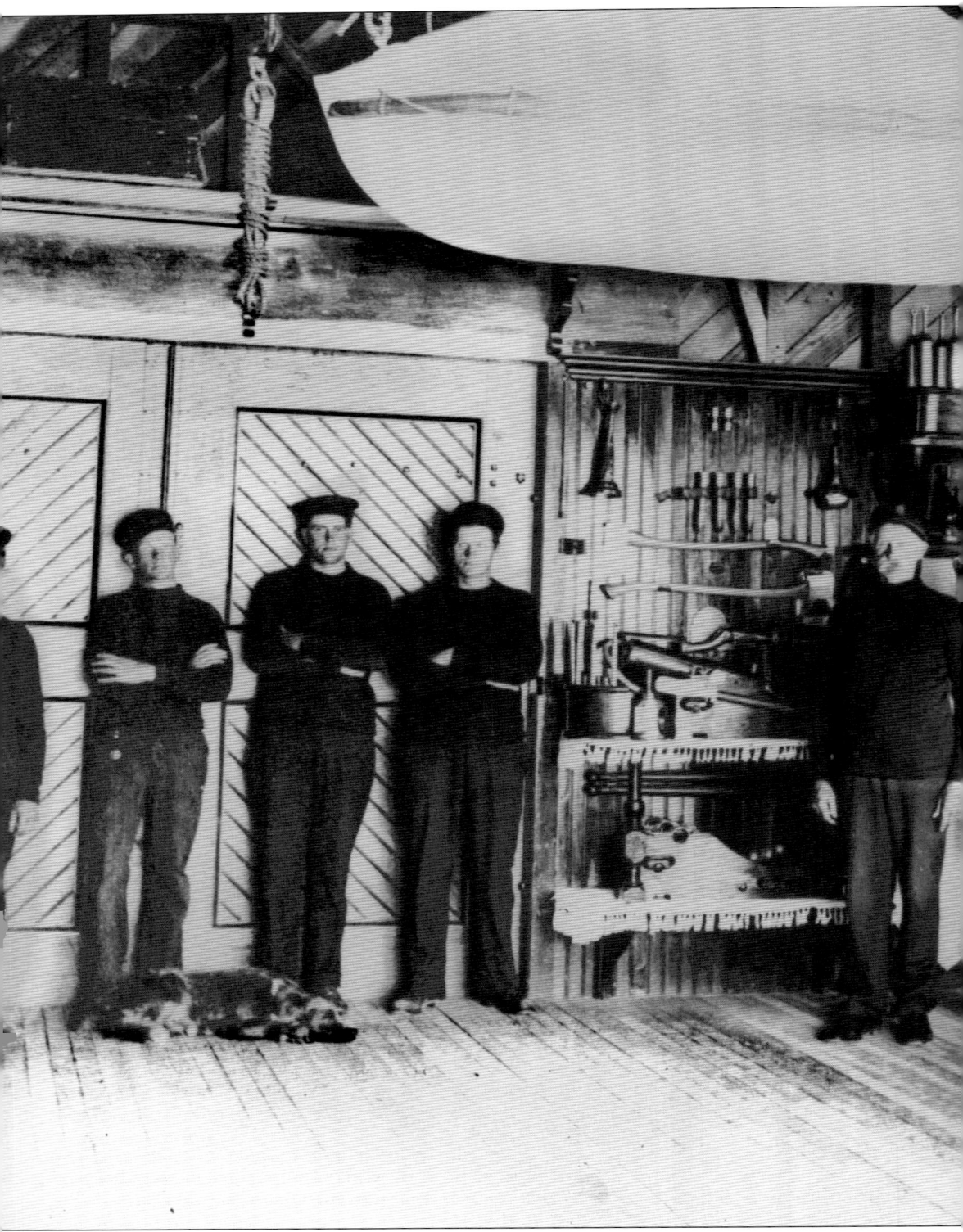

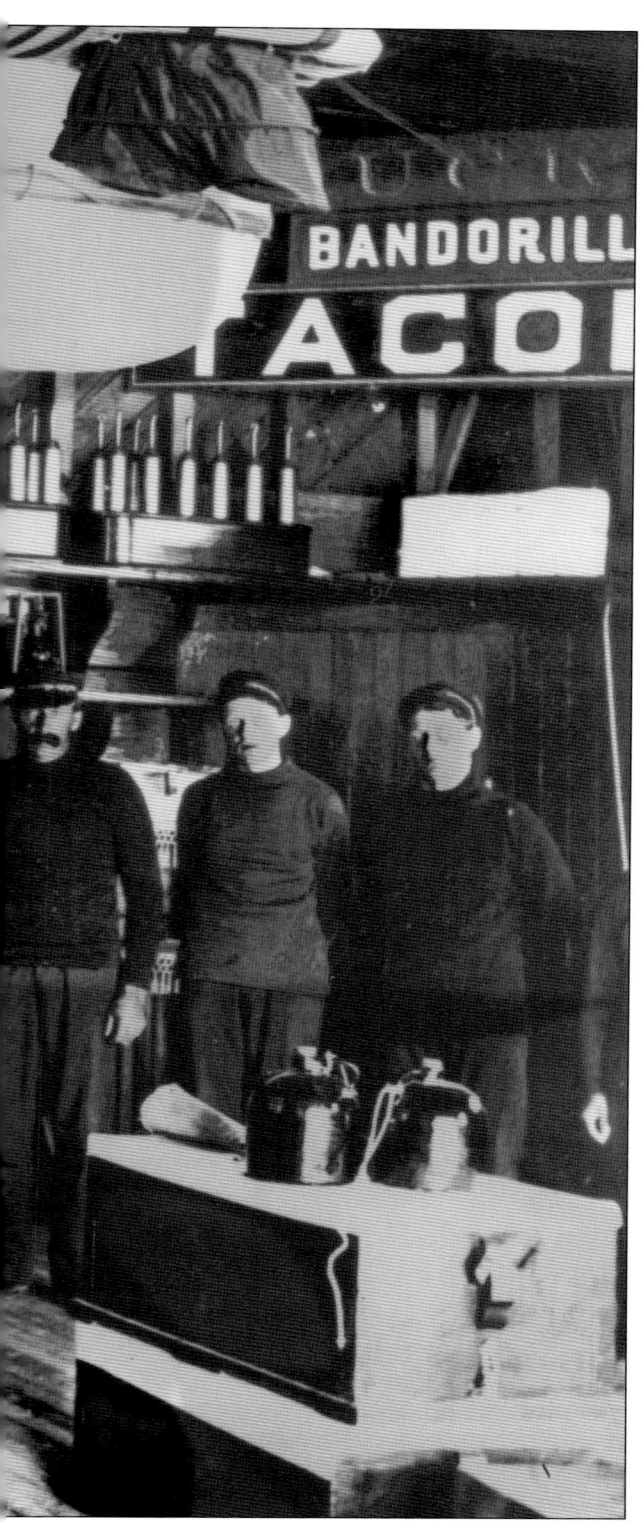

An interior photograph of a life-saving station's boathouse is fairly rare in Oregon. This is the boathouse interior at Umpqua River, c. 1908. Almost all of the equipment life-savers used is visible in this photograph. On the front of the boathouse, a pair of double doors each led to a bay on the inside, one bay containing a surfboat and the other a lifeboat. The rafters were used to hang equipment such as the life car and breeches buoy. A small workbench was situated at the back, next to the rear doors. On the back wall, megaphones, Lyle gun projectiles, the Lyle gun itself, flares, flare holders, axes, and lanterns are all visible. In the upper right-hand corner are name boards from shipwrecks that the crew had responded to: *Tacoma* (1883), *Bandorille* (1895), and *Truckee* (1897). The lifeboat and surfboat both have been wheeled out along with the beach apparatus cart, so that the entire crew could fit in the picture. (Courtesy of U.S. Coast Guard.)

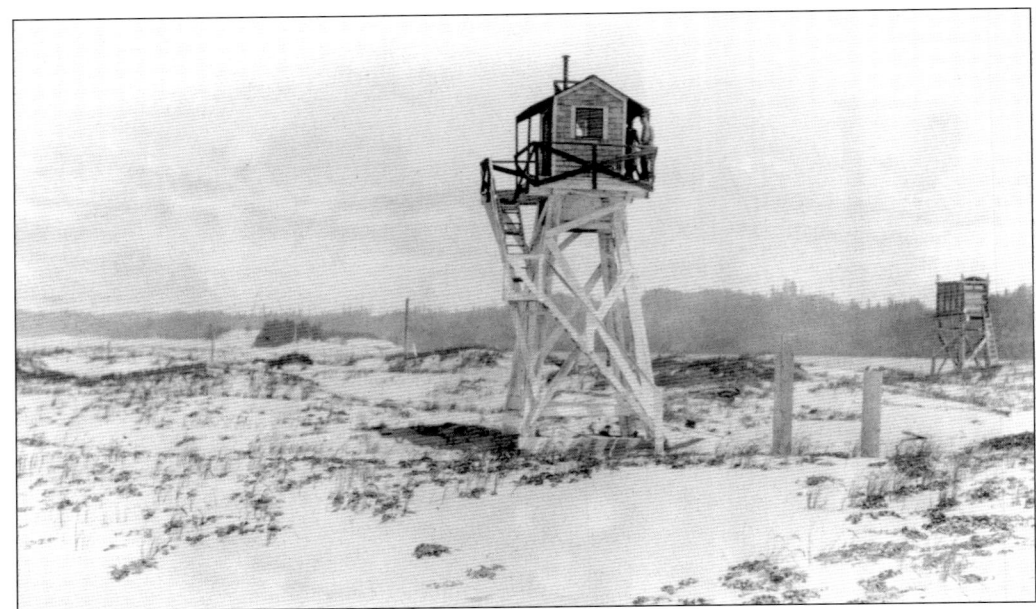

This small lookout tower was located close to the mouth of the Umpqua River, about a mile away from the station house. A watch was maintained from dawn to dusk. To prevent the man on watch from dozing, no seats were provided. (Courtesy of U.S. Coast Guard.)

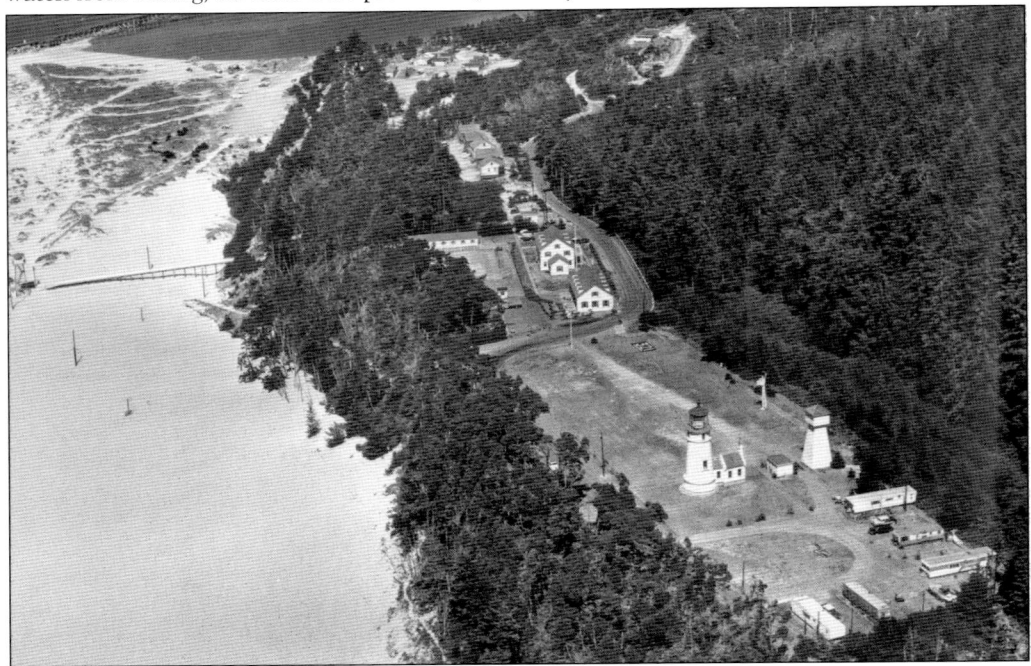

This aerial, taken in 1959, shows the location of the Umpqua River Coast Guard Station on a stable shelf of land off the beach. In the foreground is the Umpqua River Lighthouse. The keeper's dwelling and assistant keepers' dwelling on either side of the lighthouse were razed in the 1950s. Farther north on the bluff is the new Umpqua River Lifeboat Station, built in 1939 to replace the life-saving station on North Spit. (Courtesy of U.S. Coast Guard.)

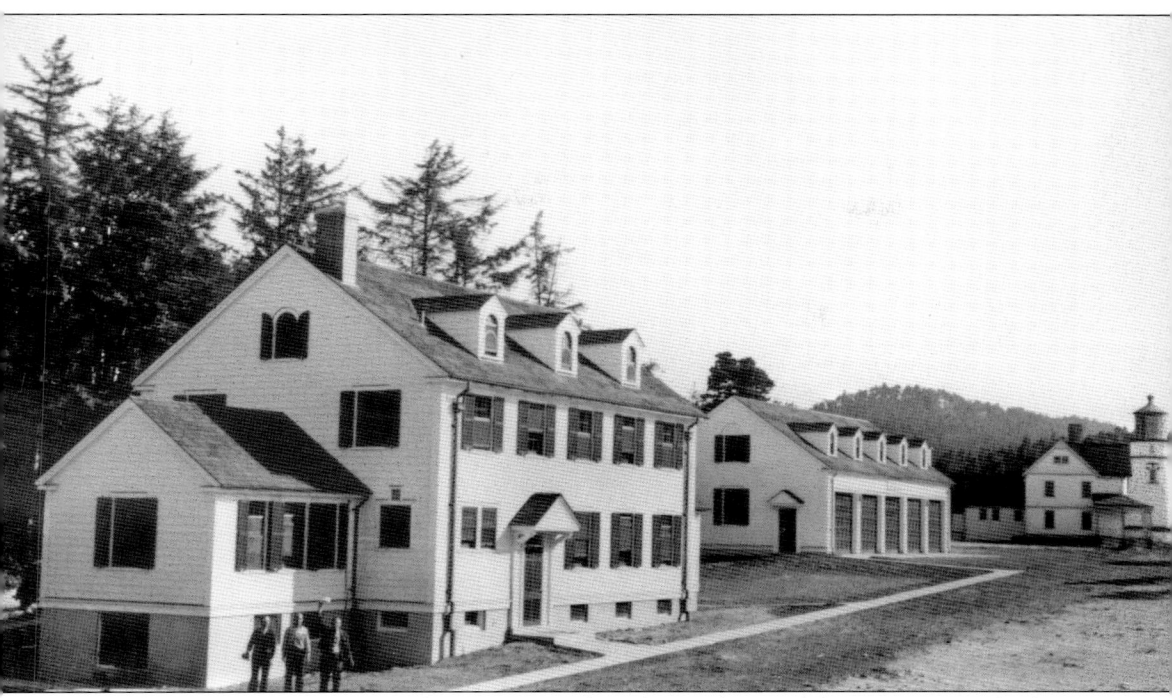

A new lifeboat station was erected in 1939 to replace the inadequate life-saving station built on North Spit nearly 50 years earlier in 1891. The general contractor, Lillebo Construction Company, began work on the Umpqua River Lifeboat Station in early 1939. It was decided to locate the station next to the Umpqua River Lighthouse. The new station was the second of the four Roosevelt-type stations to be built on the Oregon Coast. In the foreground is the just-completed station house. Next to the station house is a five-bay garage to serve all of the station's equipment needs. In the background are the old keeper's dwelling and the lighthouse. Today the former Coast Guard station serves as the Umpqua River Lighthouse museum. (Courtesy of U.S. Coast Guard.)

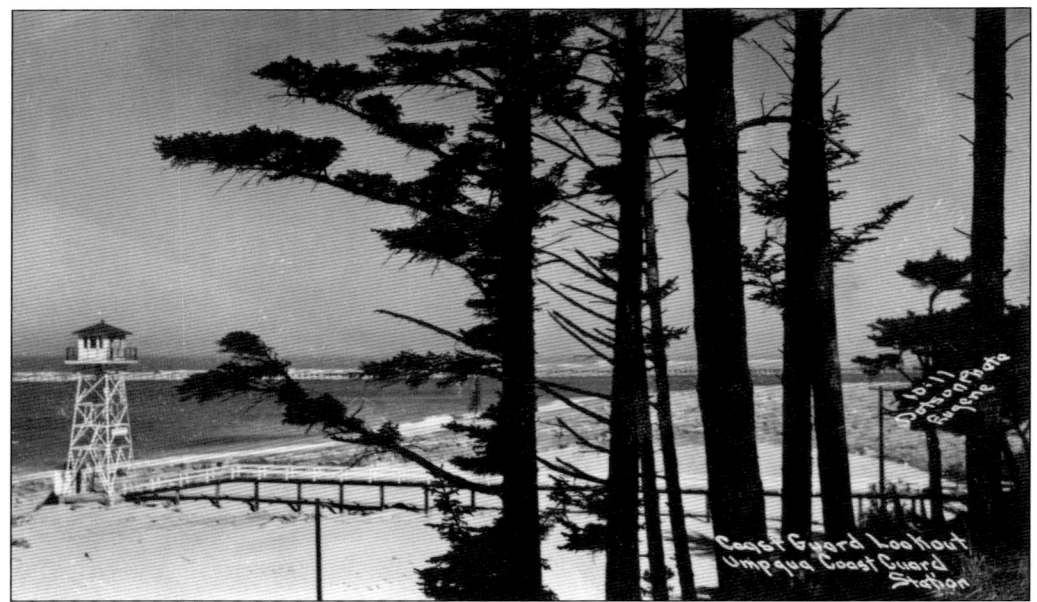

A standard, 50-foot lookout tower was erected at the edge of the dunes, northwest of the station house in 1939. The tower had a metal frame with a wooden watchhouse capped by a pyramidal roof. The tower was demolished and a new one erected closer to the jetty; however, remains of the wooden walkway still protrude from the dunes. (Author's collection.)

During World War II, the Coast Guard protected America's ports and coastlines from attack, sabotage, and accident. Beach patrols were augmented soon after Roosevelt declared a state of emergency in September 1939. Blackouts were enforced up and down the coast. Mounted patrols, Jeeps, and war dogs were brought in to bolster the beach patrols, such as these two near Tahkenitch Lake. (Courtesy of Lincoln County Historical Society.)

Seven

COOS BAY

Mariners consider Coos Bay the best natural harbor between San Francisco and the Puget Sound. The area still claims to be the largest port in the world for shipping forest-products. The bay has forged the history of the region and was the most important factor in its development. Coos Bay is located two-thirds of the way down the Oregon Coast and is the economic focus for the towns of Coos Bay (formerly Marshfield), North Bend, and Empire.

For many years, Oregon representatives to Congress had been fighting for federal money to enhance the entrance to the bay. Lumber and coal drove the economy of the area, and if the ships could not reach the goods, there was no money to be made. In June 1861, the U.S. Coast and Geodetic Survey began the formal charting of Coos Bay, finishing in 1866. However, the harbor improvements suggested in that survey did not get underway until 1879. The first stone was laid for a jetty across the South Slough on April 6, 1880. The Army Corps of Engineers thought that blocking the South Slough would stop sediments from entering the mouth of Coos Bay. Unfortunately, the construction project went on for 10 years before it was abandoned in 1890 as too impractical to justify the costs. Standard jetties were then designed to jut out 1,800 feet on either side of the harbor entrance.

At this time, the Columbia River and Yaquina Bay already had their first jetties, so the designer of those breakwaters, James Polhemus, was brought in to supervise the construction of jetties at Coos Bay. The north jetty was started in 1890 and finally completed in 1901. The directed flow of water out of Coos Bay scoured out the bar crossing, deepening the channel from an average of 11 feet to 17 feet. Later dredging further deepened the channel. A south jetty was not completed until 1928.

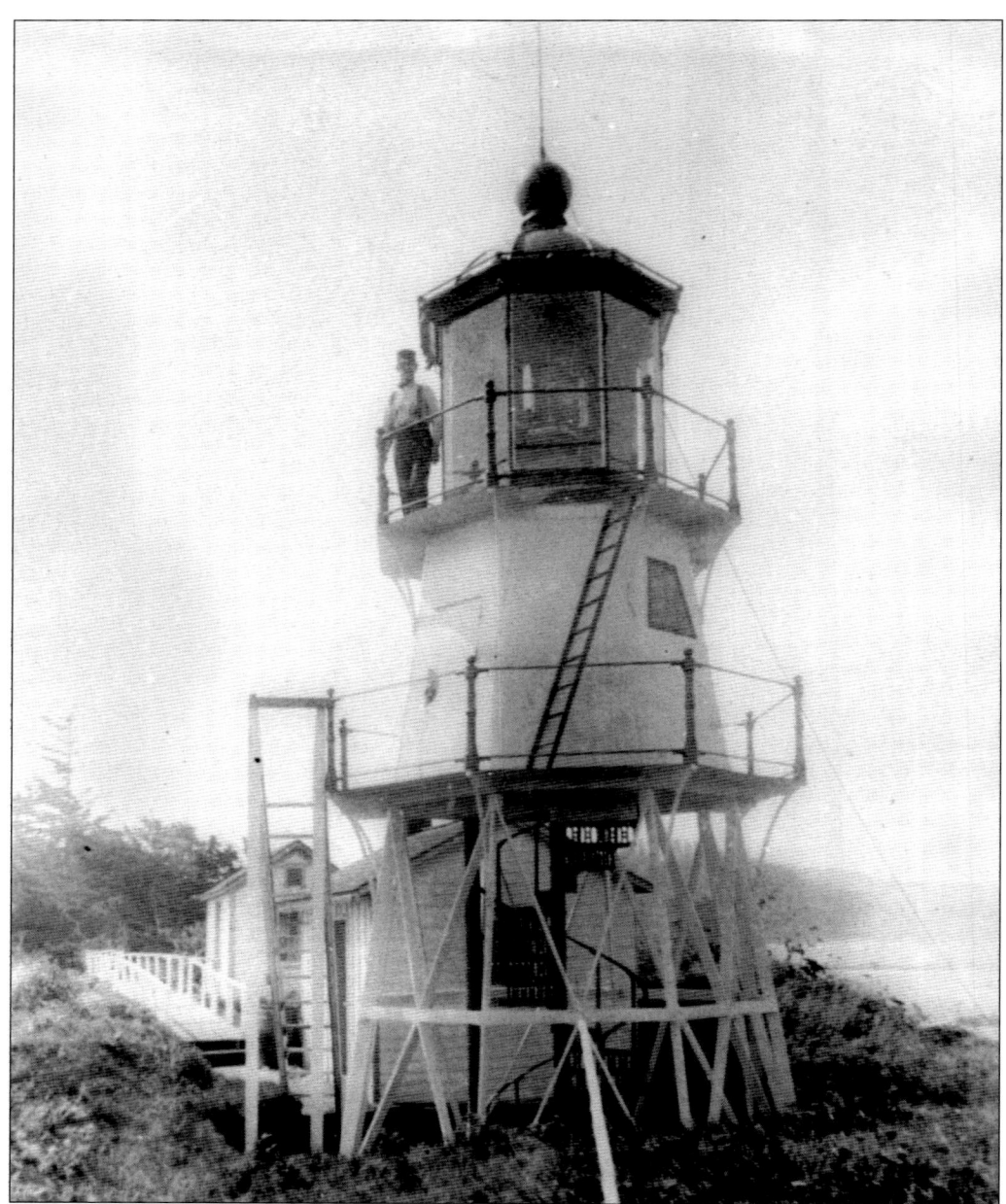

The Cape Arago Lighthouse (sometimes referred to as the Cape Gregory Lighthouse) was the first of three lighthouses to be built at Cape Arago, a fractured headland south of Coos Bay. The light was built by a cash-strapped federal government in 1866. The lighthouse was a diminutive 25-foot-tall iron skeleton placed at the farthest reaches of Gregory Point. The fourth-order lens was lit by Keeper L. C. Hall on November 1, 1866, becoming the second lighthouse on the Oregon Coast, though the only one still standing at the time. The keeper's dwelling was built 1,050 feet away on a wider portion of the island. The Cape Arago Lighthouse was replaced by another lighthouse structure in 1908, and yet another in 1933, yet the original spindly lighthouse survived until it was dynamited in 1936. (Courtesy of U.S. Coast Guard.)

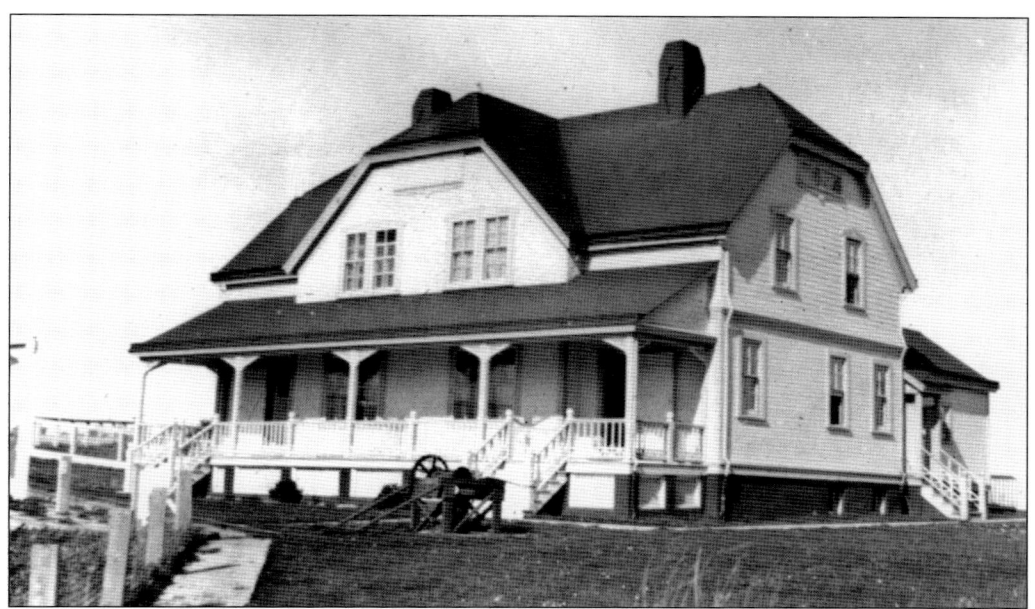

In 1896, the Cape Arago Station received several improvements. The 1866 lighthouse was encased in bricks and covered with stucco. A brick fog signal building housing a Daboll trumpet was attached to the tower. And a new keepers' duplex was built to replace the 30-year-old dwelling. The duplex was identical to that built at Coquille River in the same year. (Courtesy of U.S. Coast Guard.)

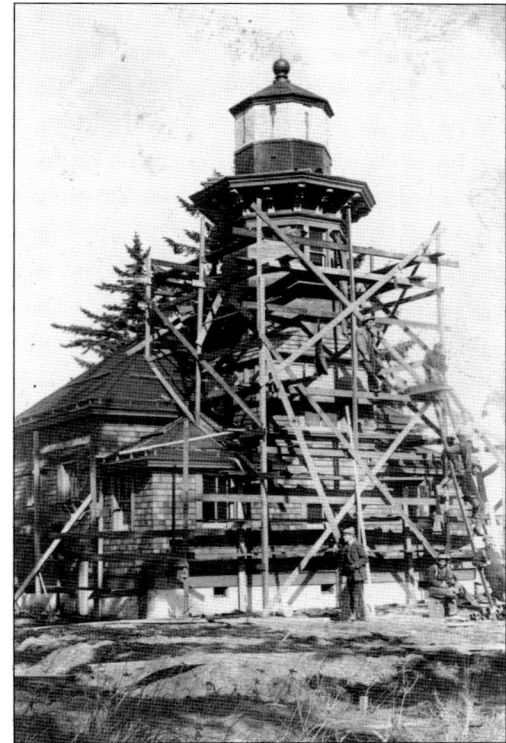

In 1908, after years of requests, a new lighthouse was built on the main part of the island back from the finger of land on which the 1866 lighthouse stood. Here construction workers can be seen taking a break from the scaffold while the photographer takes a picture in 1908. (Courtesy of Mike Byrnes.)

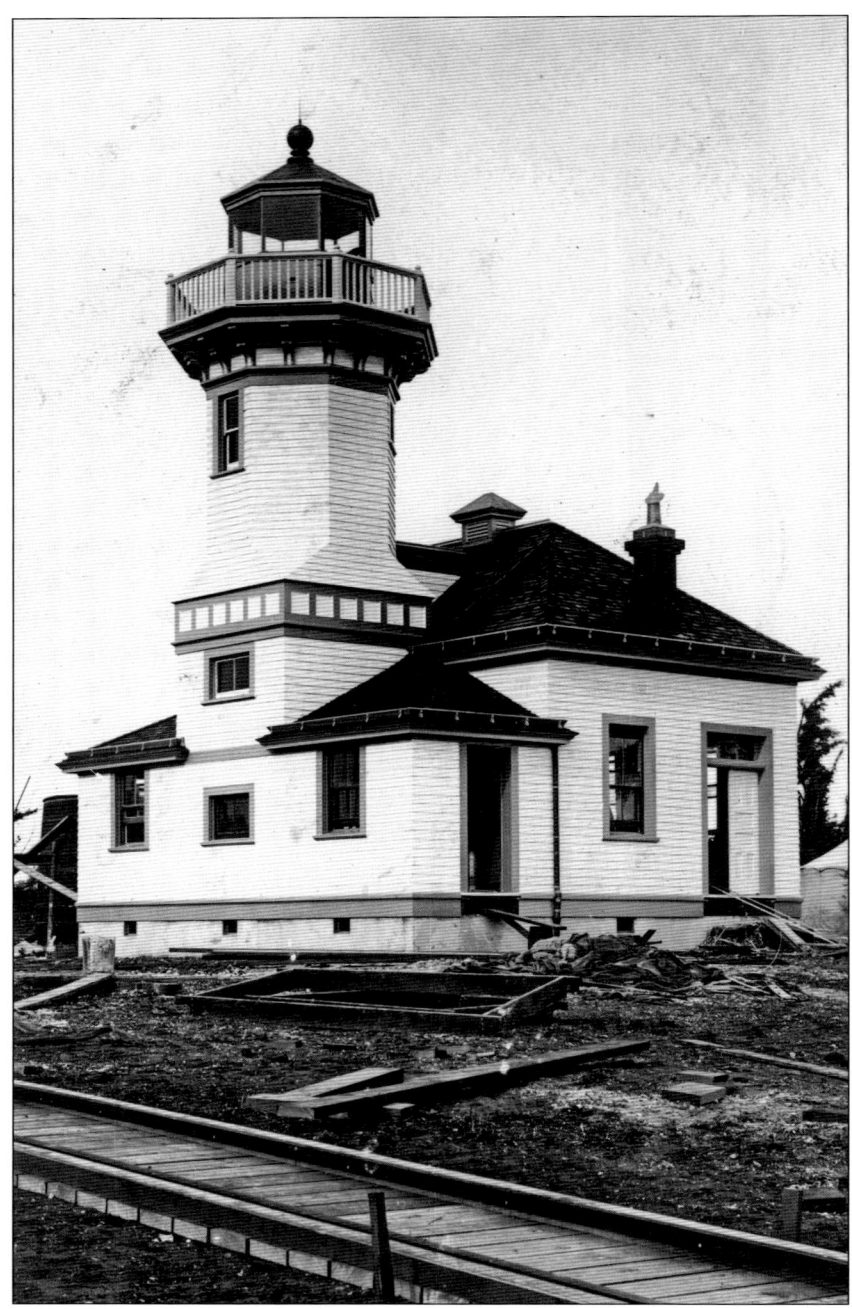

The new lighthouse received a new fourth-order Fresnel lens from Barbier, Benard and Turenne of Paris. A first-class compressed air siren took its place in the fog signal room. The wood-framed structure was clad in wood shingles and topped with a wood shingle roof. The foundation was parged brick. Gutters were not practical in such a windy environment, so water diverter boards are used instead on the roof to direct the rainwater away from the openings. In this November 1908 photograph, the building is enclosed but the finish work remains, including the installation of the Fresnel lens. The light was lit on July 1, 1909. (Courtesy of Mike Byrnes.)

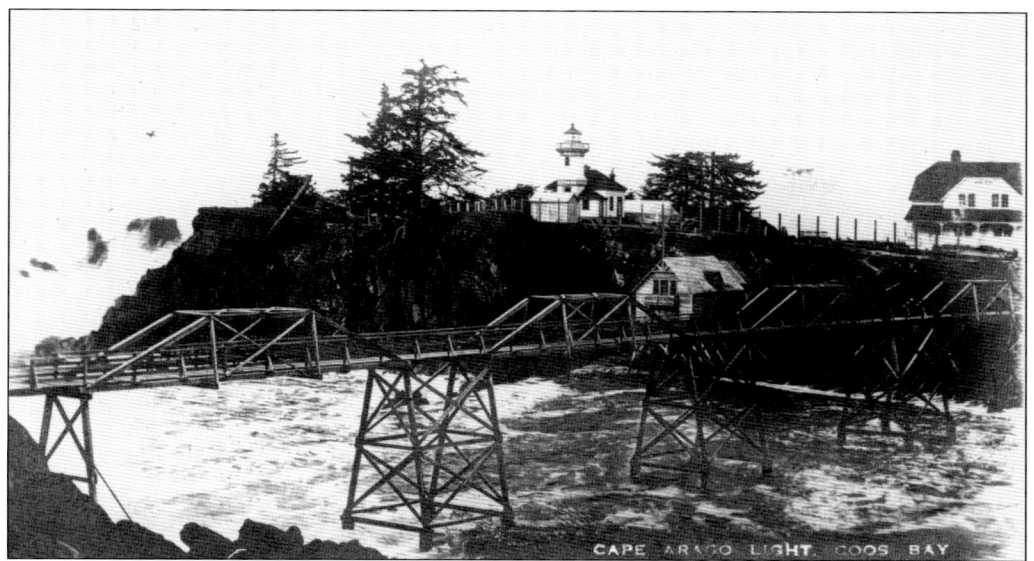

The bridge from Lighthouse Island to the mainland has been replaced several times throughout its history. A bridge low to the water was washed away on November 24, 1885. It was rebuilt and washed away again in November 1888. It was again rebuilt in 1898, this time higher above the water. Maintenance on the structure was such a headache that keepers referred to it as the "Bridge of Sighs." (Author's collection.)

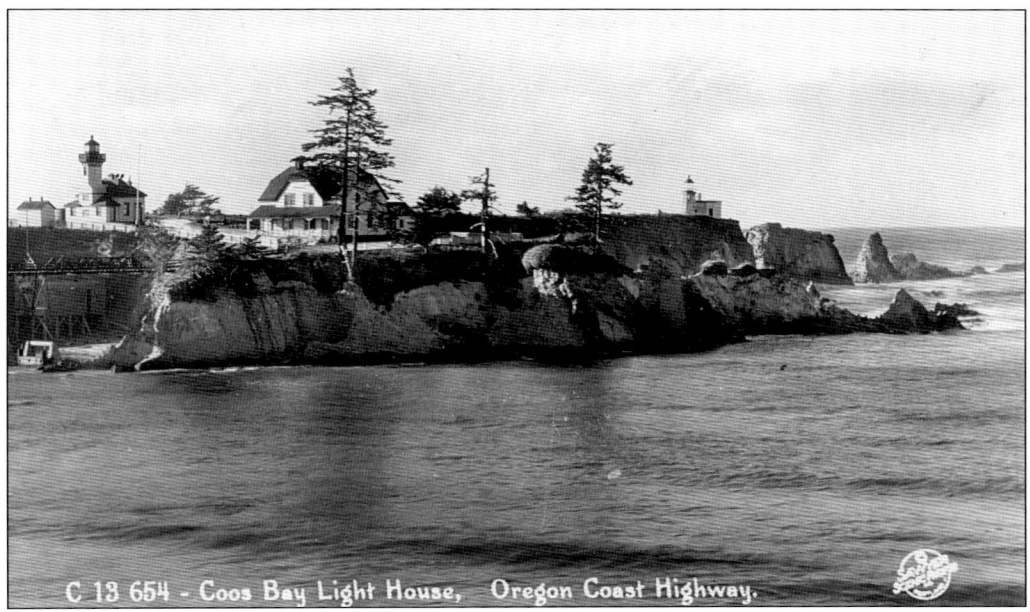

The 1866 lighthouse can be seen right of center with its attached fog signal building. The old lighthouse was perceived as a danger to visitors, so it was obliterated with dynamite in 1936, just a few years after this photograph was taken. (Author's collection.)

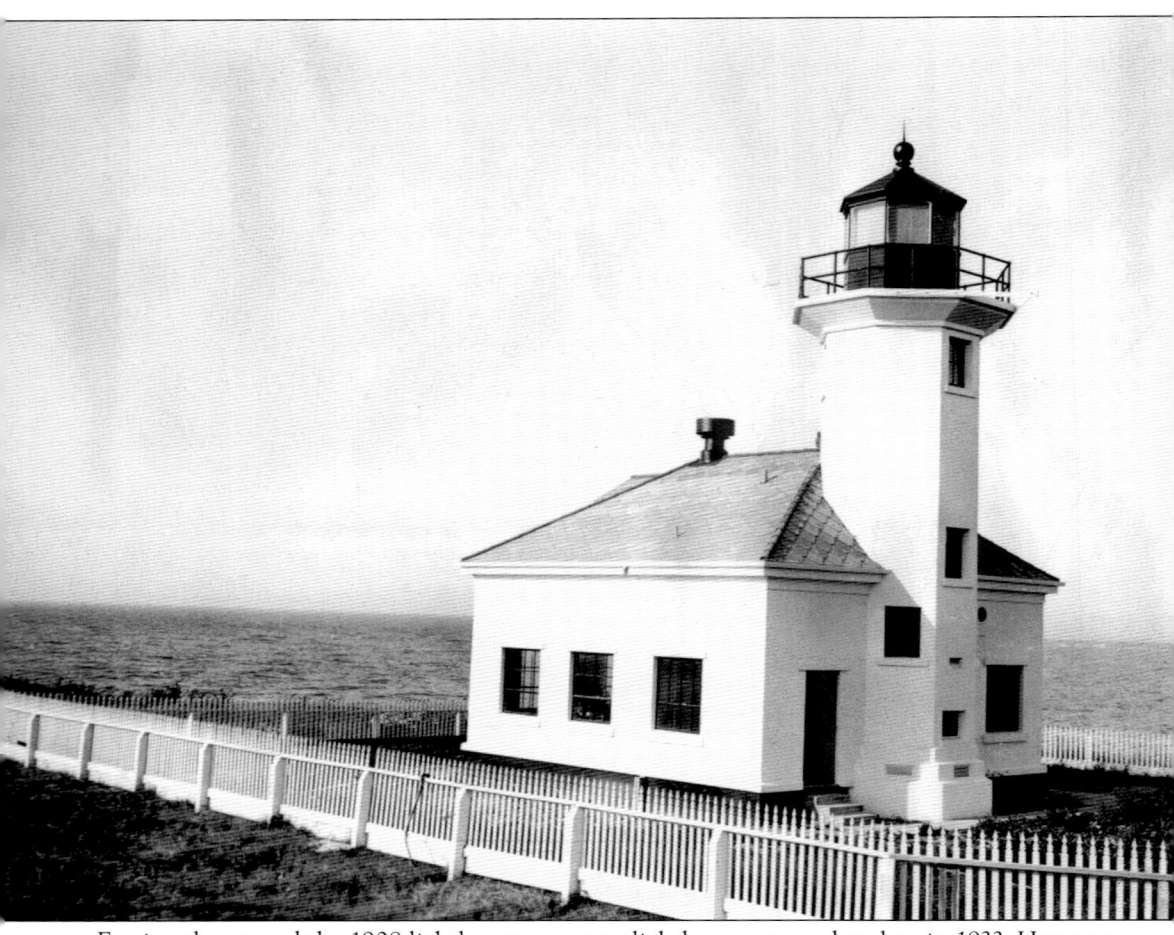

Erosion threatened the 1908 lighthouse, so a new lighthouse was undertaken in 1933. However, instead of iron or wood, this one was to be built of concrete to withstand the elements. Local contractor R. J. Hillstrom was hired to build the new concrete lighthouse with plans from Washington's Point Robinson Lighthouse. The lighthouse was positioned closer to the center of what remained of the island. The fourth-order optics were removed from the 1908 lighthouse, electrified, reinstalled in the new lighthouse, and lit in 1934. Hillstrom chopped off the tower of the 1908 lighthouse and made it into an office for the keeper. (Courtesy of U.S. Coast Guard.)

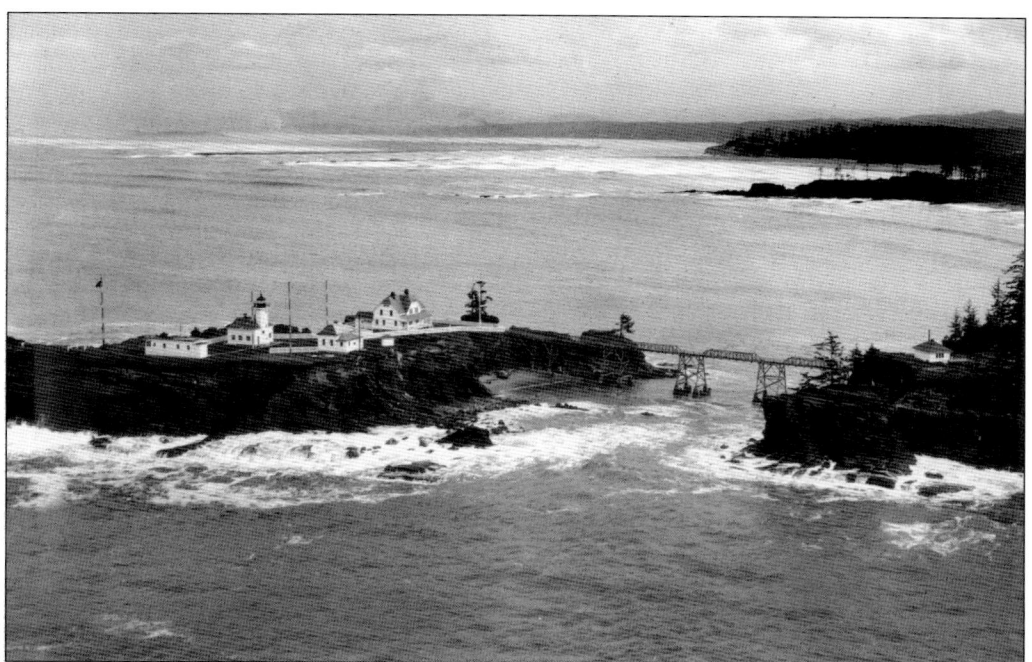

In 1953, the keeper's dwelling still stood along with the remains of the 1908 lighthouse, albeit without its tower. The jetties for the Coos Bay entrance can be seen in the background. (Courtesy of U.S. Coast Guard.)

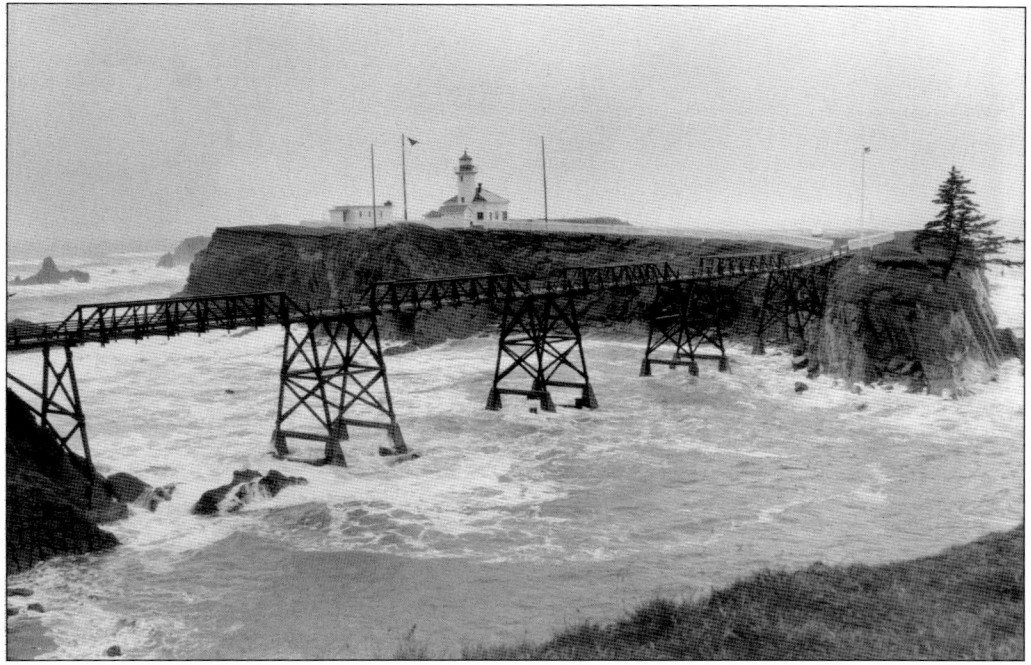

By 1956, much of Lighthouse Island had been worn away by the waves. The lighthouse was automated in 1966. All the buildings except for the lighthouse were razed over time. The fourth-order Fresnel lens was removed in 1993. (Courtesy of U.S. Coast Guard.)

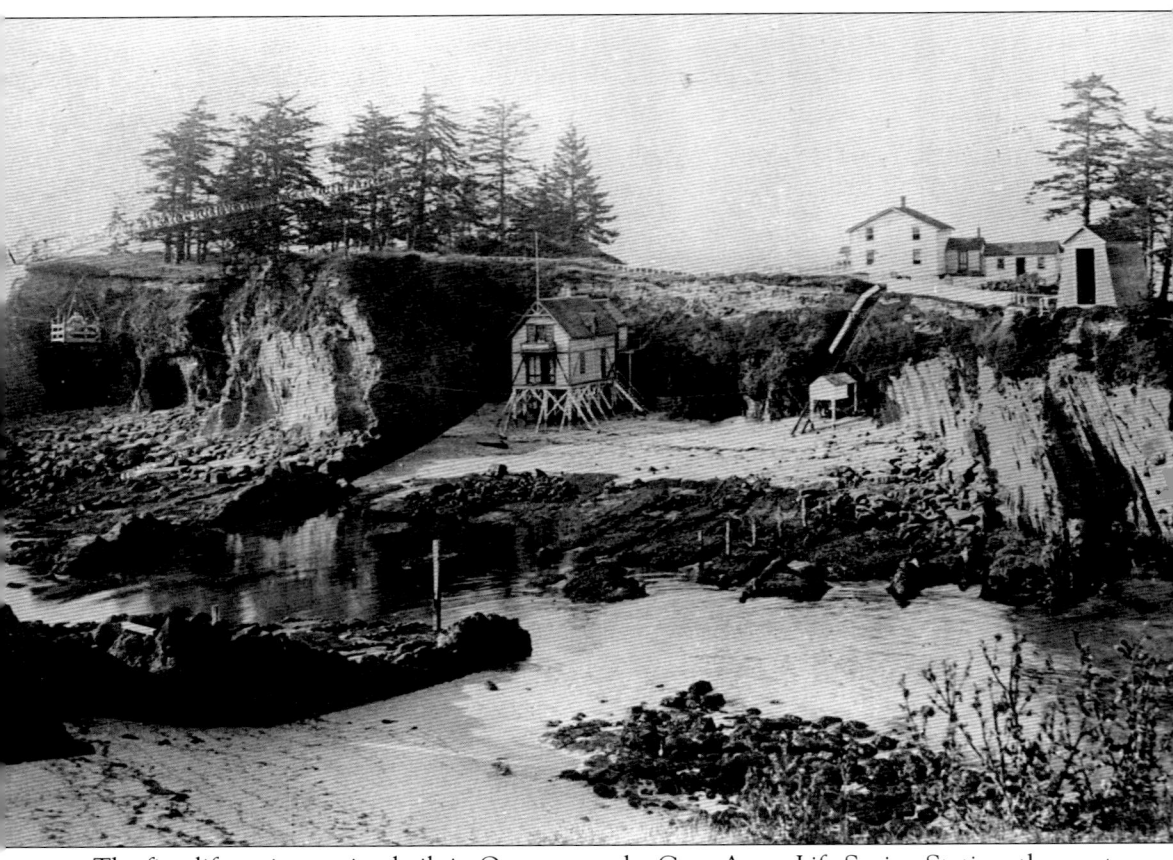
The first life-saving station built in Oregon was the Cape Arago Life-Saving Station, the most impractically sited station erected on the Oregon Coast. It was built in 1878 on pilings in a small cove on Lighthouse Island. At this point in time, there were no permanent life-saving crews, just a full-time keeper. If there was a need to perform some kind of water rescue activity, the keeper would first have to be informed of the wreck, as the station was not in a location from which to watch for trouble. The keeper would then have to travel to the nearby town of Empire to find volunteers. He would round them up and bring them back to the life-saving station to launch the boat with the volunteer crew. This photograph was taken around 1891 after a 400-foot-long cable tram was built to cross the gap instead of a bridge. Its basket is just visible at the left edge of the photograph. (Courtesy of U.S. Coast Guard.)

The U.S. Life-Saving Service moved the operations of the Cape Arago Life-Saving Station from Lighthouse Island to the North Spit of Coos Bay in July 1891. As early as September 1890, Keeper Joseph Hodgson had been assisting in locating a site for a new station. According to the daily logbooks, by March 1891, a building contractor was involved in the project. Keeper Hodgson moved the boats and gear on July 8, 1891, to the new station on North Spit. On August 1, 1891, Hodgson "shipped" a crew of eight surfmen, and the station began patrols for the first time in its history. Keeper Hodgson oversaw the transition from a poorly located station with no crew to an infinitely better-situated station with a full compliment of eight paid surfmen. (Courtesy of Mike Byrnes, above; U.S. Coast Guard, below.)

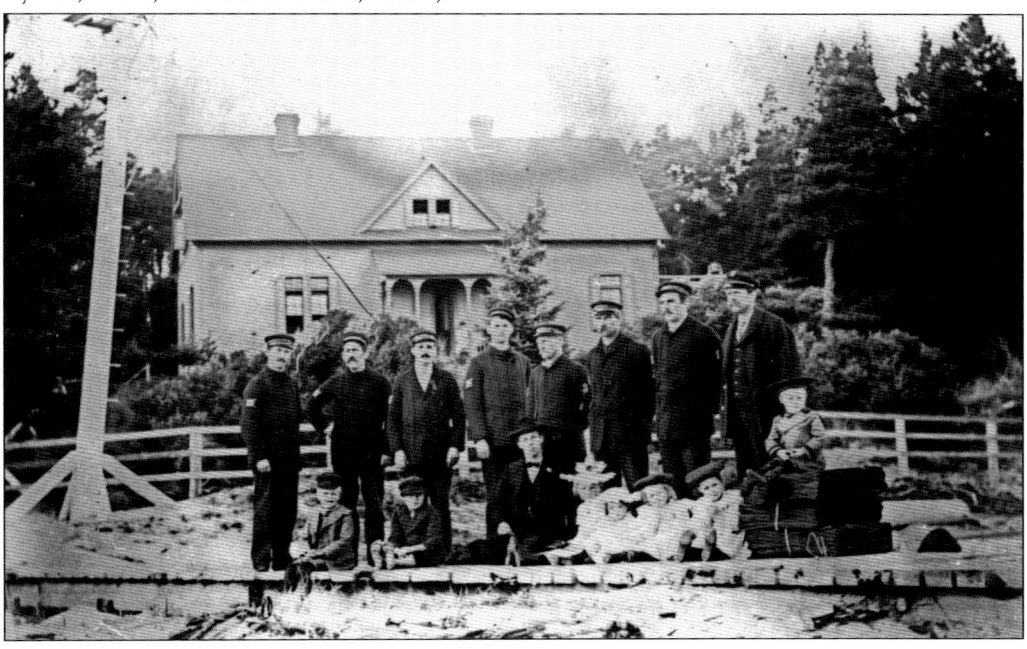

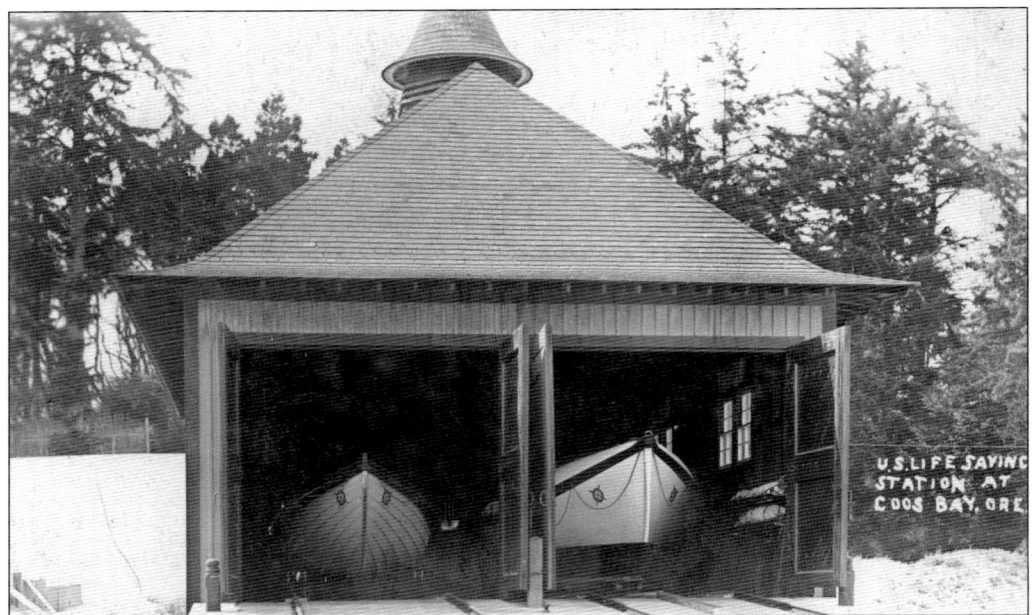

The boathouse was a standard Fort Point–type boathouse measuring 24 feet wide by 40 feet deep. The left bay held a surfboat and the right bay a Dobbins lifeboat. The Dobbins lifeboat was a lightweight lifeboat developed in 1881. It was 24 feet long, weighing from 1,600 to 2,000 pounds. It was self-righting and self-bailing and could carry up to 33 people safely. It was rowed by eight surfmen and steered by the keeper with a tiller. A Dobbins lifeboat appears in many photographs on the Oregon Coast, and it is believed that every Oregon station had one in addition to their surfboat by 1900. (Courtesy of Mike Byrnes, above; U.S. Coast Guard, below.)

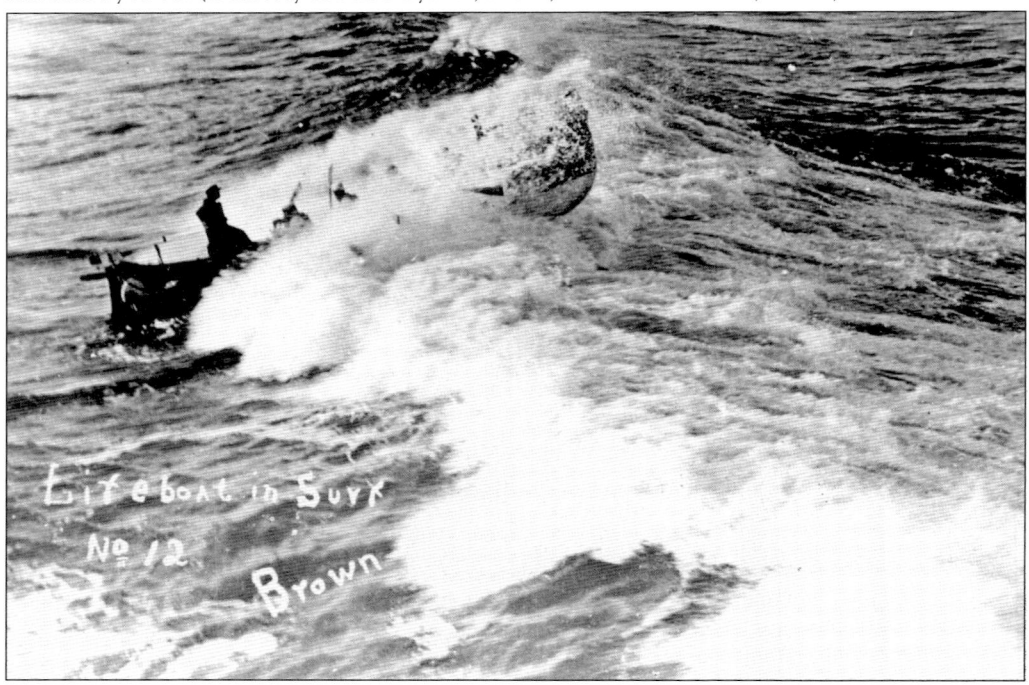

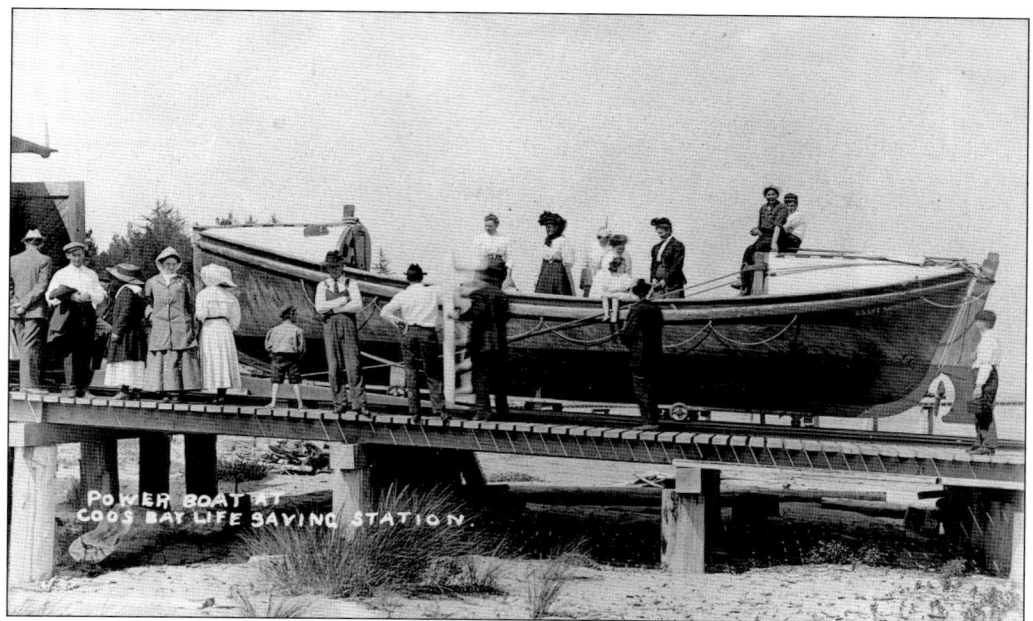

The arrival of the new motor lifeboats was a godsend to the surfmen. They more than doubled the range of the life-savers and allowed them to arrive fresh at the scene. The 36-foot motor lifeboat went through many incarnations throughout its long history. They continued to be produced as late as 1956. The last active 36-footer in America was retired from Depoe Bay in 1987. (Courtesy of Mike Byrnes.)

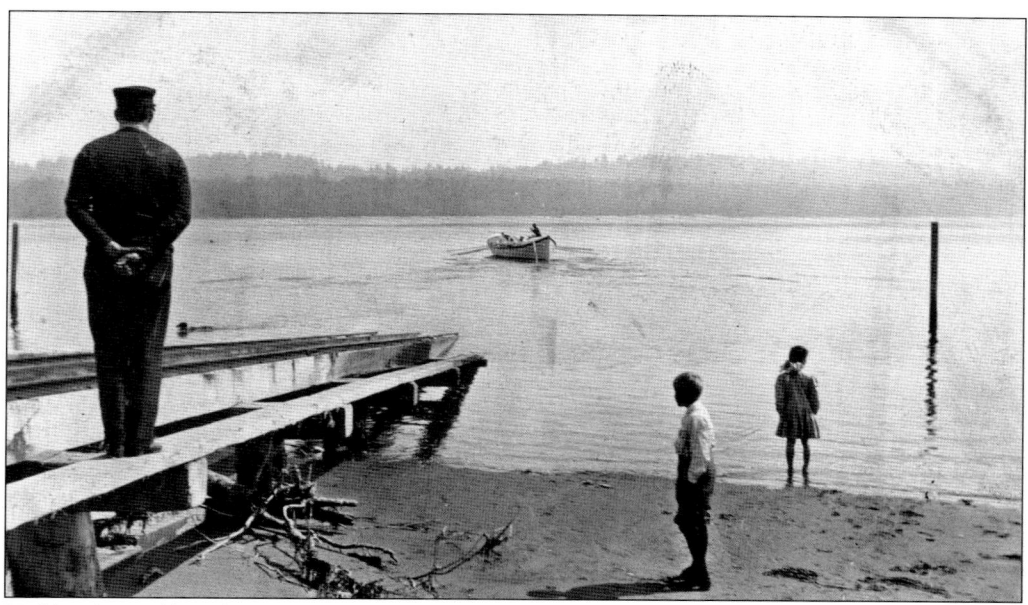

Unlike the Dobbins lifeboat (shown here) that could be launched from a marine railway or from a beach, the 19,000-pound, 36-foot motor lifeboat had to be launched from a ramp due to its weight. Tillamook Bay, Yaquina Bay, Umpqua River, and Port Orford all have their old 36-foot motor lifeboats on display near their respective stations. (Courtesy of Mike Byrnes.)

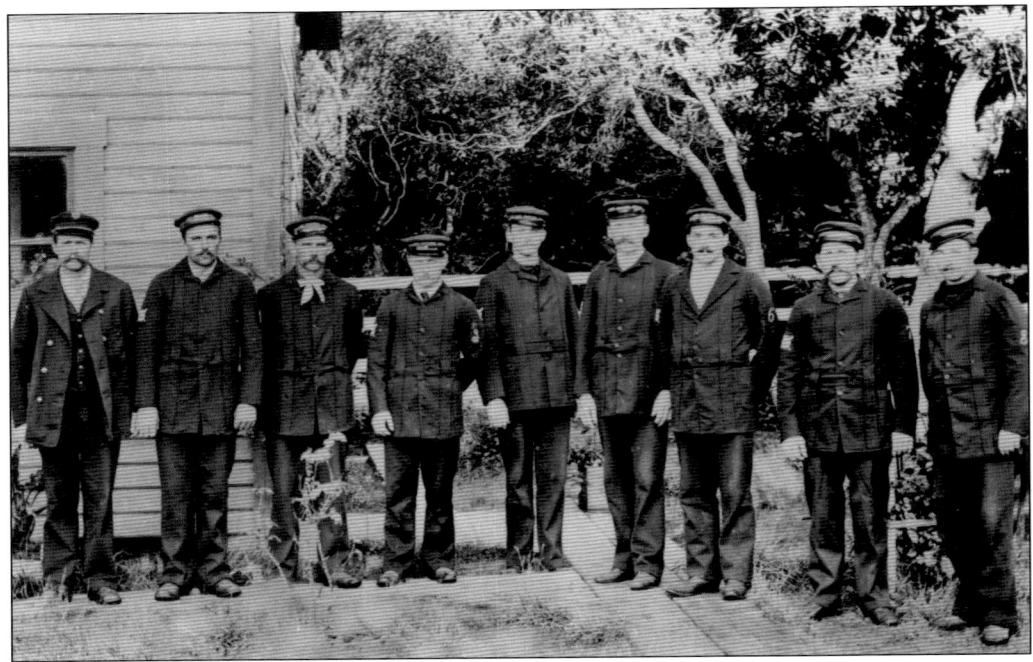

Each crewman was provided quarters with a bed and a locker. He was housed at the station and fed, at least until it was his turn to cook. Some stations pooled their money and hired a cook. Pay was considered fairly low for the era, though a meager pension was enacted in 1882. Here the Coos Bay crew lines up at the corner of their station house in rank order from left to right in 1898. (Courtesy of U.S. Coast Guard.)

Most breeches buoy training used a wreck pole on a beach or grassy practice field. Coos Bay occasionally did a more realistic drill by setting up the breeches buoy from a ship's mast to shore, as this 1901 photograph attests. (Courtesy of Mike Byrnes.)

The *Marconi* was built by A. M. Simpson in North Bend and used for hauling lumber. The ship was being towed out of Coos Bay on March 23, 1909, laden with lumber for Valparaiso, Chili, when the hawser parted midway over the bar. The ship was driven onto the south spit, eventually coming ashore at Bastendorff Beach. The ship's crew was fortunately rescued by breeches buoy. (Courtesy of Mike Byrnes, above; author's collection, below.)

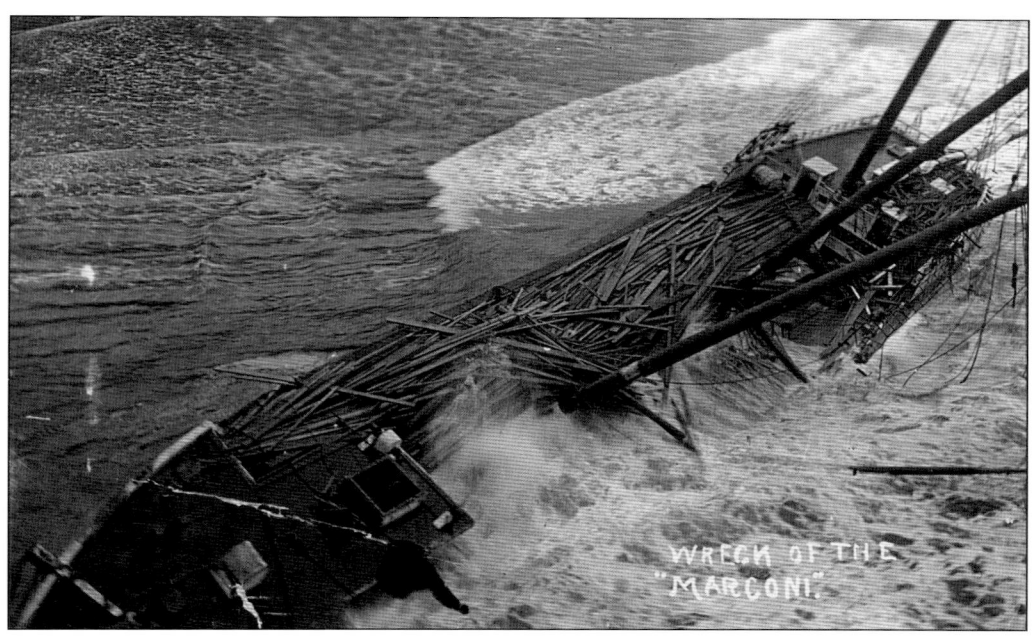

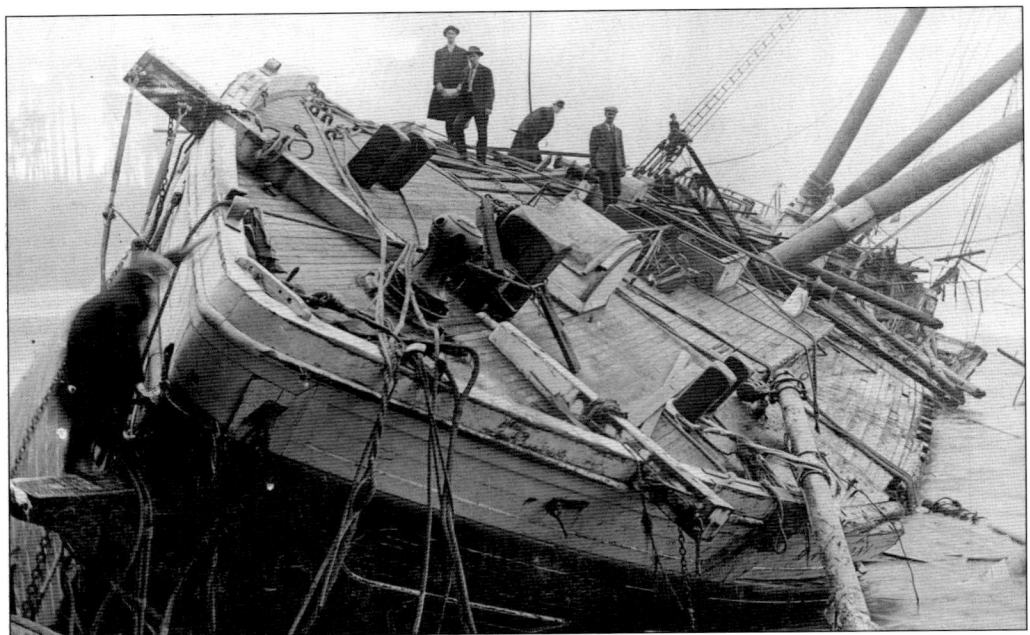

Cargo ships were dangerous when they wrecked, particularly when some of the cargo was secured to the deck. Especially dangerous were the heavily laden lumber schooners because their cargo floated easily, becoming lethal objects in the surf for both mariners and life-savers. (Courtesy of Mike Byrnes.)

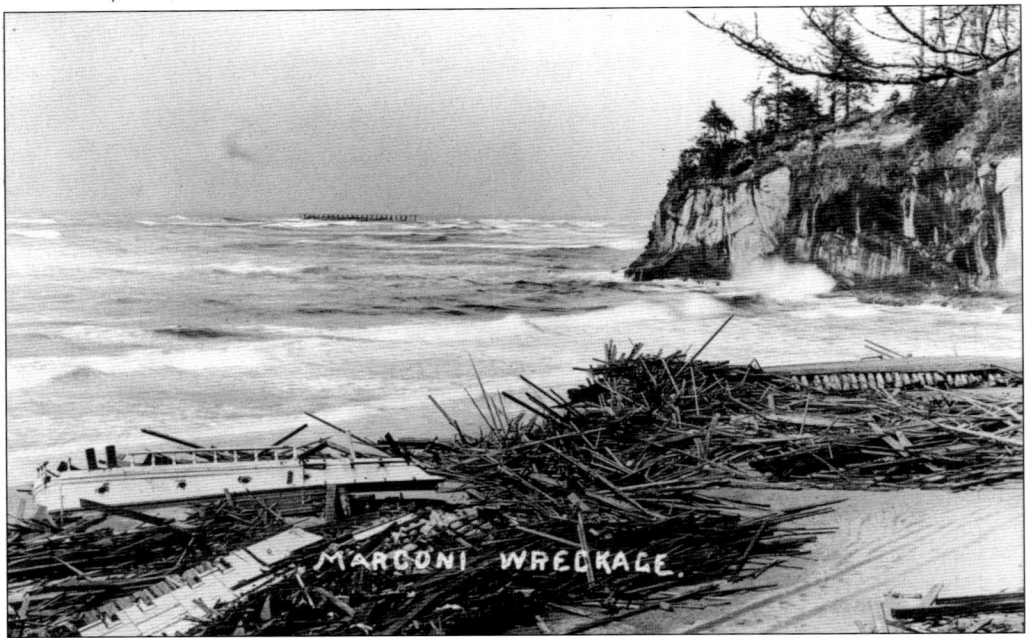

The creation of the Life-Saving Service in 1871 was meant not only to save lives, but also to save property. Often the life-savers were tasked with rescuing foundering ships, securing cargo, and left to guard goods that washed ashore. Superintendent Kimball frequently cited that the service saved many more times in property than the service cost to operate. (Courtesy of Mike Byrnes.)

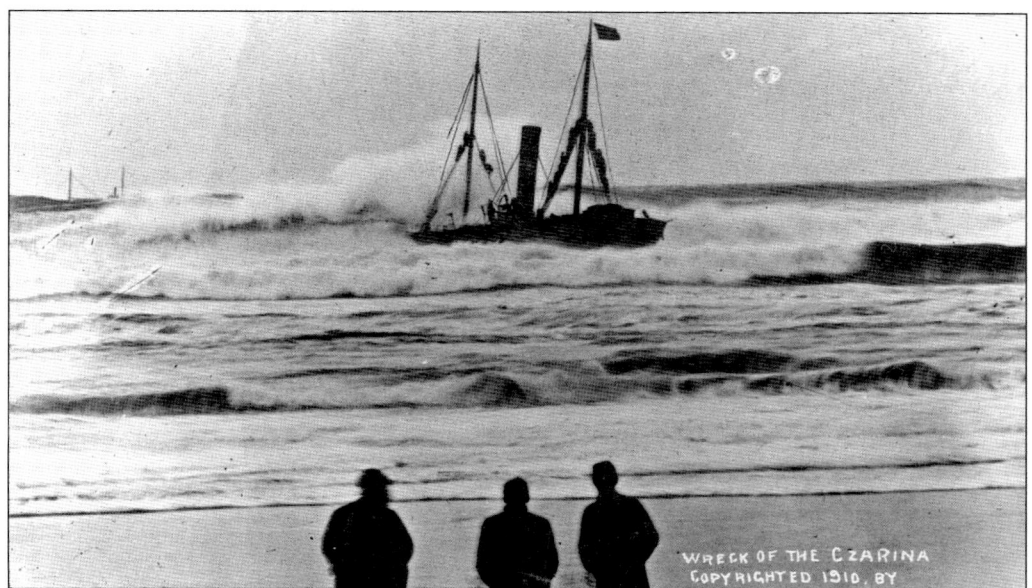

On January 12, 1910, Capt. Charles Dugan and his crew of 22 on the *Czarina* ran into trouble on the Coos Bay bar. A heavy sea struck the vessel as she crossed, flooding her engine room and putting out her fires. She floated helplessly, so the desperate crew set the anchor. The anchor ended up pinning the *Czarina* in the breakers, dooming the vessel. The crew and one passenger took to the rigging where, numbed by freezing winds, they dropped one by one into the surf over a 24-hour period. Only one survived. (Author's collection.)

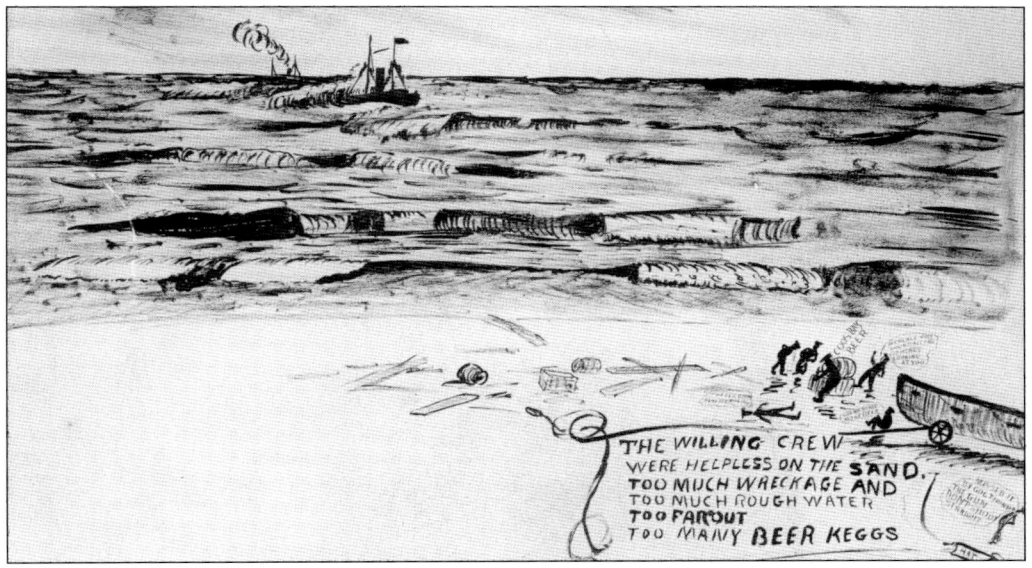

The *Czarina* was the most tragic wreck ever to occur at Coos Bay. It took 23 lives, sparing only engineer Harry Kintzel, and was described as the worst disaster in 25 years in the United States. An inquiry held Keeper Charles W. Boice responsible for not doing enough to save the crew of the *Czarina*, though some felt he had done all he could do, many didn't. He was demoted to surfman and returned to the Coquille River Life-Saving Station to finish out his career. (Courtesy of Mike Byrnes.)

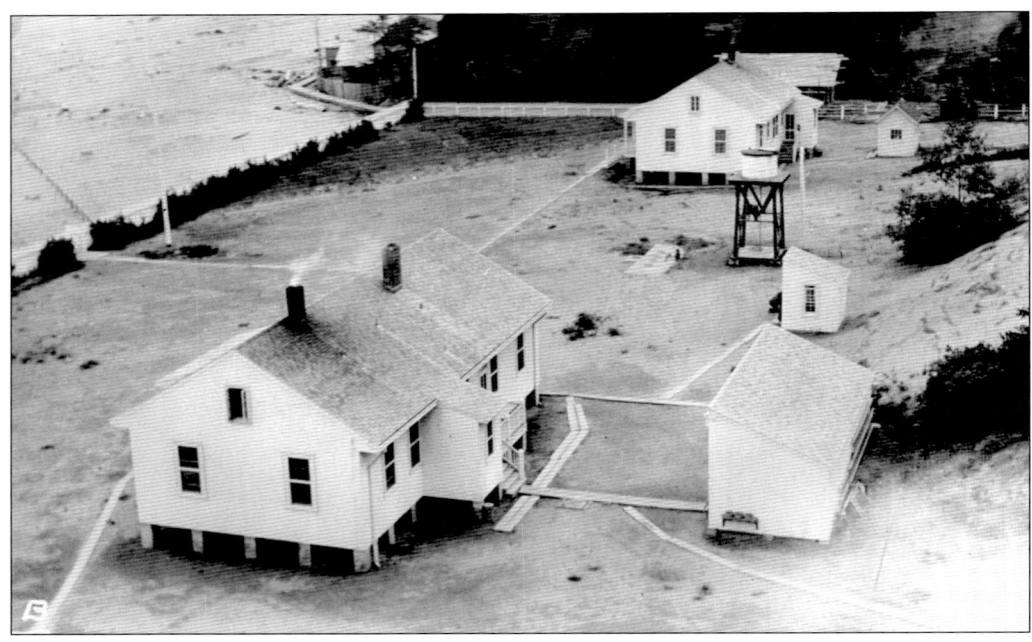

In what may have been one of the first stations built by the new Coast Guard in the United States, construction began in 1915 in Charleston to replace the life-saving station at North Spit. The new location was situated quite close to the entrance to Coos Bay and was near a high promontory ideal for a lookout tower, two essential features the old station lacked. In September 1916, the crew moved across the bay to the new Charleston location. (Courtesy of U.S. Coast Guard.)

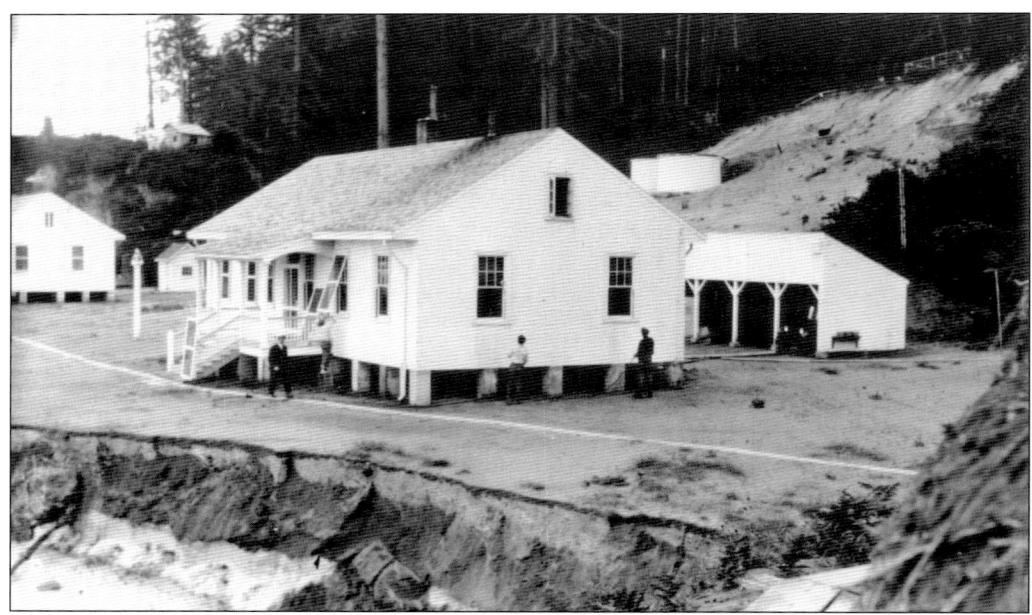

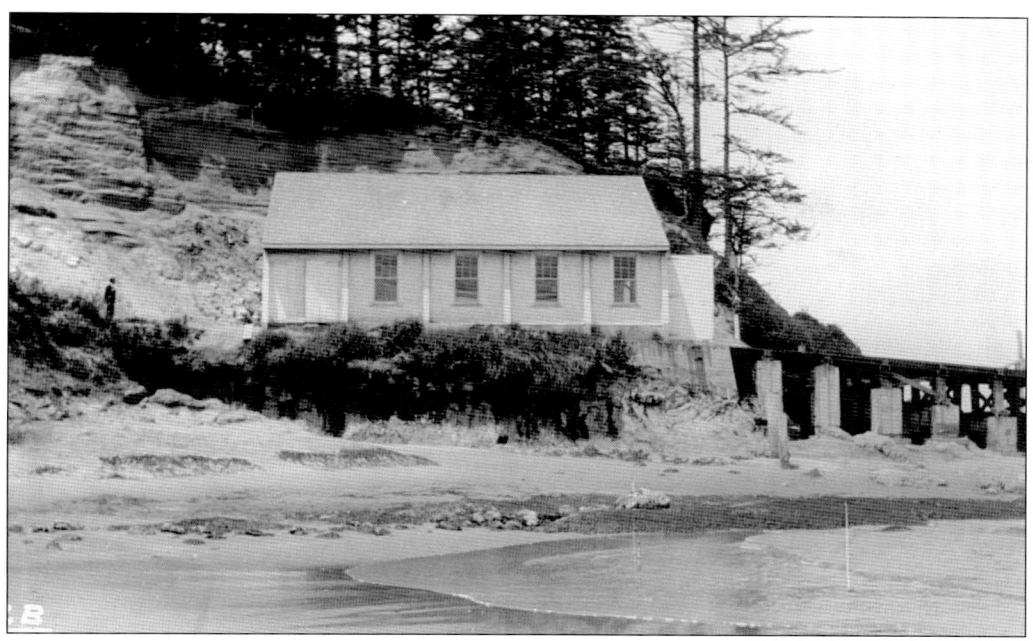

The Coos Bay Lifeboat Station received the largest and finest Coast Guard boathouse in Oregon. The building measured 40 feet wide by 50 feet deep and was three bays wide. In 1915, the bays stored one 36-foot motor lifeboat, one Dobbins lifeboat, one Monomoy surfboat, and one Beebe-McLellan surfboat. Extending from the front of the boathouse was a 338-foot launchway. A large concrete jetty was built to the west of the boathouse and launchway to protect them from the onslaught of storms and surf. (Courtesy of U.S. Coast Guard.)

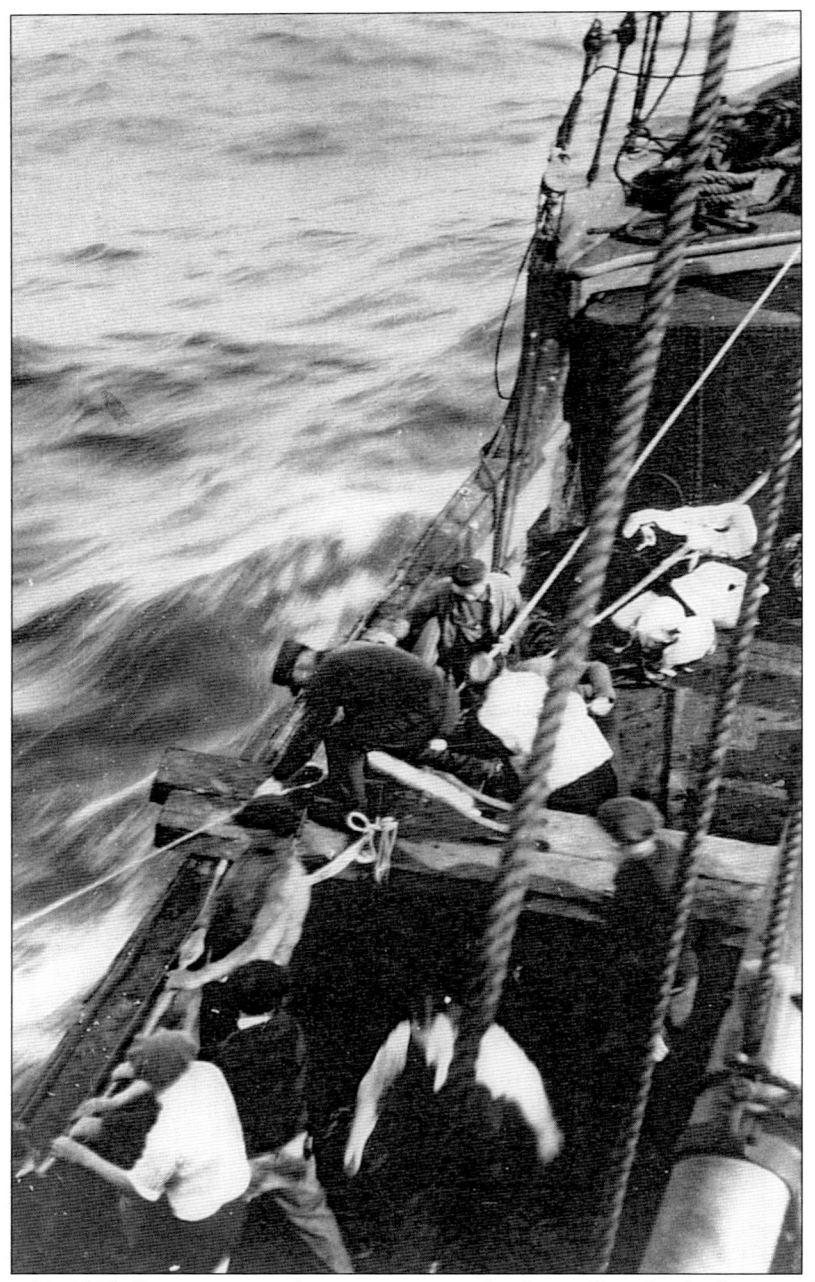

On January 20, 1915, Congress passed an act creating the Coast Guard, which merged the Life-Saving Service with the Revenue Cutter Service. The new military organization was called the United States Coast Guard. Maritime safety, law enforcement, and military readiness were instantly rolled into one group and remain the three principles of the Coast Guard today. With the change over, little changed in the day-to-day lives of the surfman. In this photograph from February 17, 1924, Capt. Robert Johnson took the Lyle gun onto the steam schooner *Cleone* to fire towards the *Columbia*, stranded on the north jetty. The shot was good, and the passengers and crew of the *Columbia* were rescued. (Courtesy of Bandon Historical Society Museum.)

Eight

COQUILLE RIVER

The Coquille River serves principally the town of Bandon located on the south side of the river's mouth. The first settlers in the area arrived in 1853, though Hudson Bay Company trappers had been in the area as early as 1826. The native Coquille Indians had, of course, lived in the area long before that. The river was the highway for such settlements as Coquille, Myrtle Point, Prosper, and Powers farther upriver. Bandon received a post office in 1877 and quickly formed into a community based on lumber, salmon, and dairy products. Bandon was located only 20 miles from Empire City on Coos Bay, yet almost all of the traffic went by water; as late as 1886, there was not even a wagon road between the two areas.

The Coquille River entrance was recognized early on as being extremely dangerous. The first schooner to finally make it across the bar came down from the Umpqua River on August 25, 1859. Reportedly the locals lined the banks to greet their economic salvation.

During a 20-year period from 1891 through 1910, the U.S.L.S.S. *Annual Reports* recorded 55 strandings at the mouth of the Coquille River. In comparison, the Coos Bay area reported only 41, the Umpqua River 14, and the Tillamook Bar 11. In fact, the Coquille River was second only to the San Francisco Bay area (with 71 groundings) on the entire Pacific Coast during this same time period, and the Coquille River's shipping volume was far less. Part of the difficulty at Coquille River is that the distance between its two jetties is only 500 feet with the channel itself narrowing to 100 feet. However, prior to the construction of the jetties in the 1890s, the bar was even more dangerous. The only deaths of Oregon life-savers before 1915 occurred during a boat drill on the Coquille Bar in 1892. Groundings occurred constantly due to shifting winds, cross currents, engine breakdown, steering failure, and broken towlines. The life of a surfman at Bandon was a busy and risky one.

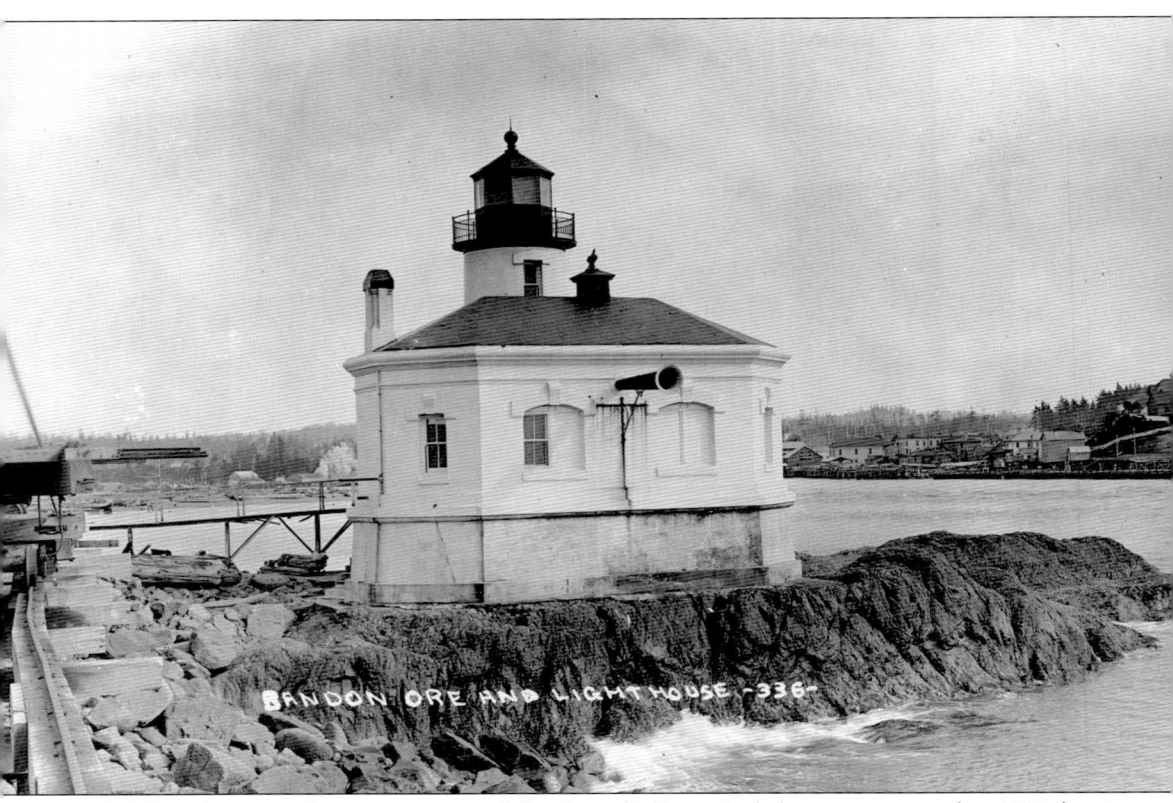

A bill authorizing the construction of the Coquille River Lighthouse was passed in 1891, but it was four years before land was purchased, plans were solidified, and construction began. Workers started by leveling the top of Rackleff Rock to provide a base for the lighthouse. Local stone was cut to form the structure's foundation, while the lighthouse itself was built of brick and covered in stucco. The design was unique with a cylindrical tower attached to the east side of an elongated, octagonal room, which housed the fog-signal equipment and had a large trumpet projecting from its western wall. The fourth-order Fresnel lens was lit on February 29, 1896. (Courtesy of Mike Byrnes.)

In 1939, after the Lighthouse Service was folded into the Coast Guard, the Coquille River Lighthouse was one of the first lighthouses to be decommissioned when its light was replaced with an unmanned light at the end of the jetty. This photograph, from 1932, shows the construction of a new oil storage building. (Courtesy of U.S. Coast Guard.)

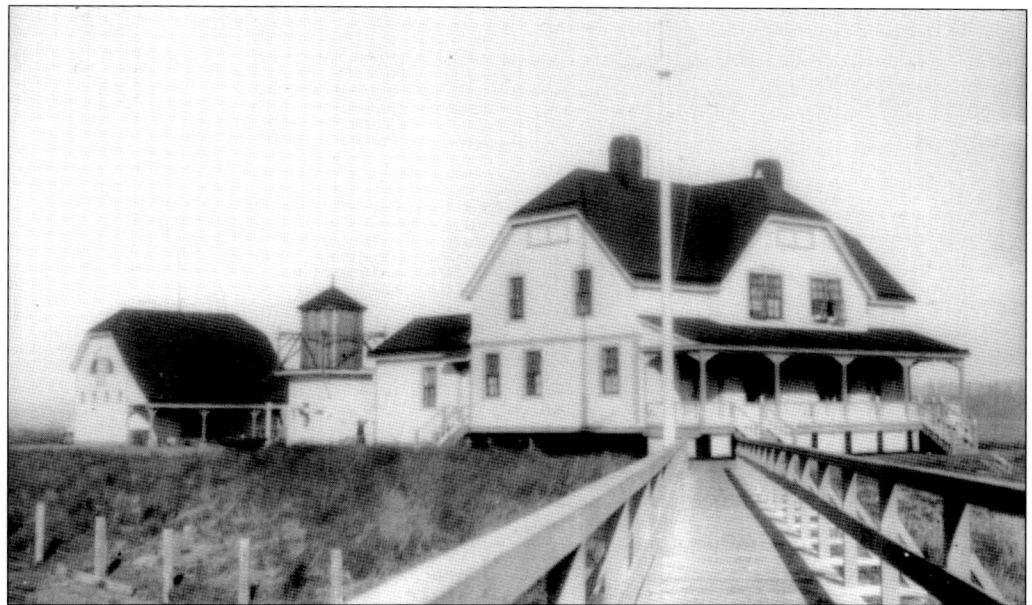

A long, wooden walkway connected the lighthouse to the keepers' dwelling. The large structure was a duplex with a complementary barn behind and a water tower in between. Two keepers, both transferred in from Heceta Head, took up residence at the new station in early 1896. By the time this photograph was taken in 1932, time was running out for the station. (Courtesy of U.S. Coast Guard.)

The original fog signal was a third-class Daboll trumpet, which blasted for 5 seconds and then was silent for 25 seconds. In 1910, a first-class siren was installed, "Much to the satisfaction of fog-bound mariners but to the dismay of near neighbors," according to Jim Gibbs, Oregon's lighthouse historian. Here are "the neighbors" across the river at the Bandon waterfront in 1913. (Author's collection.)

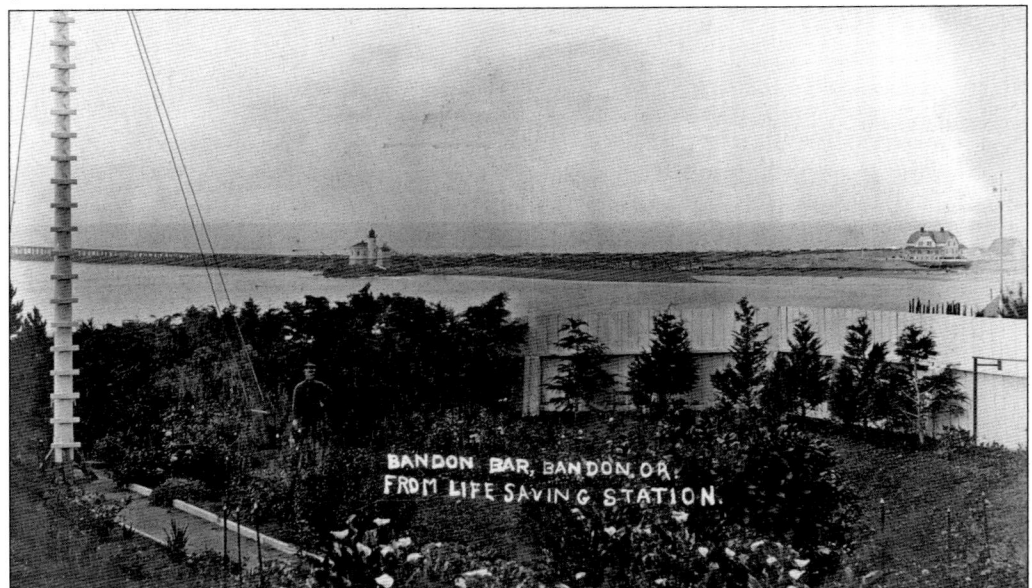

In 1939, when the Lighthouse Service was folded into the Coast Guard, it was decided the lighthouse was no longer needed. An automated beacon was placed at the end of the south jetty, the dwelling was disassembled, and the lighthouse abandoned. The Bandon Lighthouse stood neglected for 24 years until Bullards Beach State Park was created on the north side of the river enveloping the lighthouse. The badly damaged lighthouse was restored and opened to the public in 1976. The restoration efforts continue. (Courtesy of Mike Byrnes.)

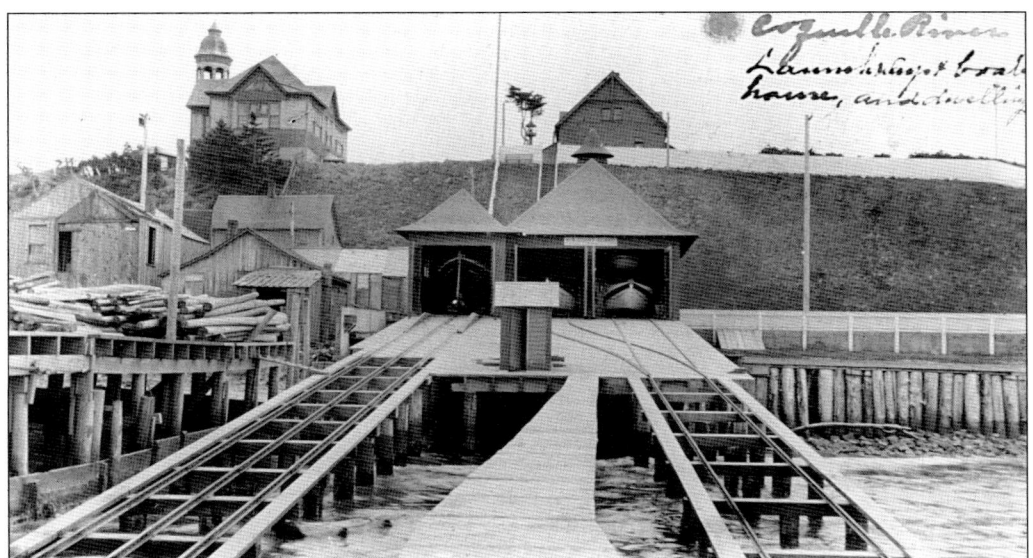

At about the same time as the lighthouse was being discussed for the Coquille River, a lifesaving station was proposed for Bandon. Oregon representative Binger Hermann requested the establishment of a life-saving station in 1889. The argument must have been persuasive and the facts clear, as a station with crew was approved on February 20, 1889. Construction on the station was well underway by June 1890, and it was activated in early 1891. (Courtesy of U.S. Coast Guard.)

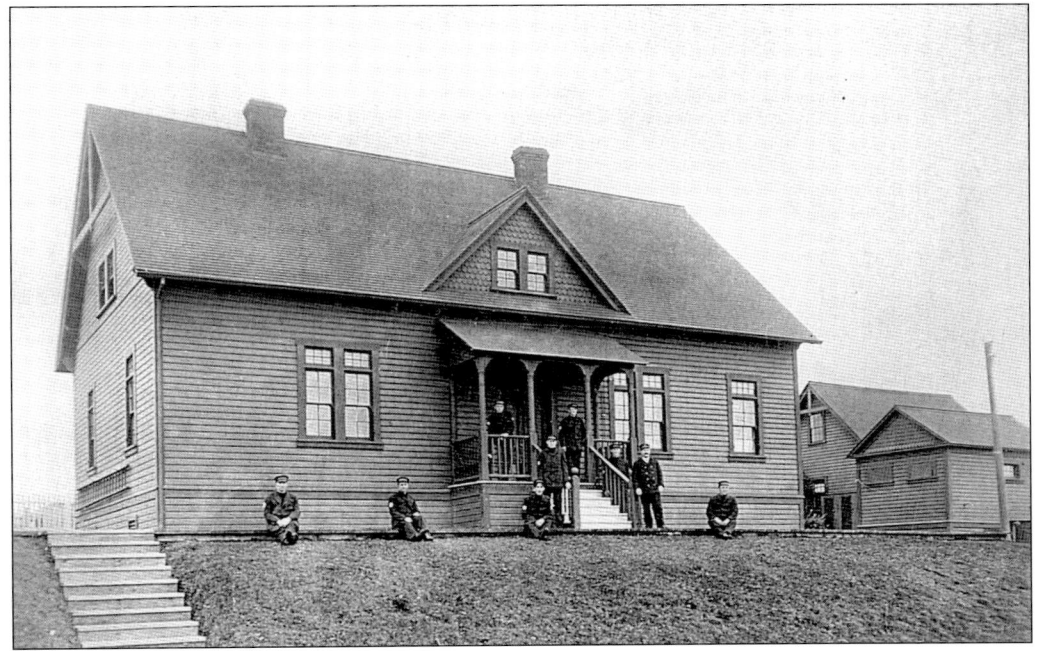

Apparently, the station house at Coquille River was used by the keeper and his family only, while the crewmen bunked in the building at the right. From left to right are Clarence Boice, Harry Armstrong, Hans Olsen, Oscar Langlois, Lester Kranick, Soldier Demmick, Victor Brewer, Capt. Robert Johnson, and Howard Culver. (Courtesy of Bandon Historical Society Museum.)

Once motorized tugs took over at Bandon, sailing vessels were typically towed over the Coquille River bar, as shown in this photograph from around 1914. Prior to engines, groundings occurred frequently due to capricious winds. Still, even with motors, ships ran aground continually because of shifting winds, cross currents, engine breakdown, steering failure, and broken tow lines. (Author's collection.)

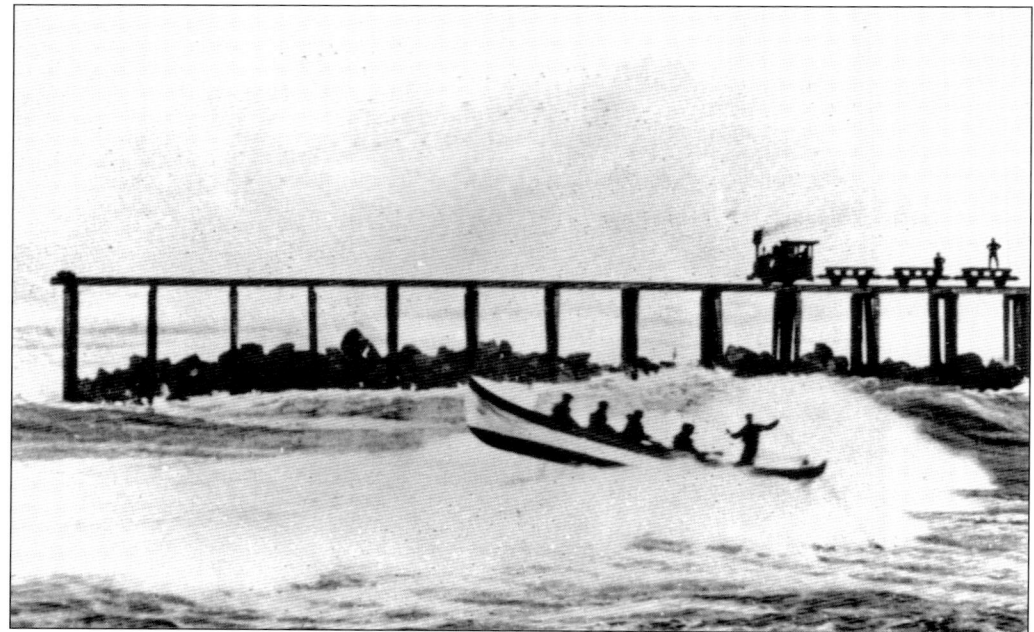

Life-savers trained in all types of conditions, though it was left up to the discretion of the keeper to determine if conditions were too rough to go out. The Coquille River crew was particularly bold on this day as they rowed over the river bar. In the background is the small steam engine working on the construction of the north jetty. (Courtesy of U.S. Coast Guard.)

While training at the Coquille River bar on April 12, 1892, the boat unintentionally capsized, resulting in the deaths of Capt. Edward Nelson, James K. Sumner, and William A. Greene. Accidents would occur, but this was the only loss of Oregon surfmen during the existence of the Life-Saving Service. This photograph of their flag-draped coffins was taken in the boathouse. (Courtesy of Bandon Historical Society Museum.)

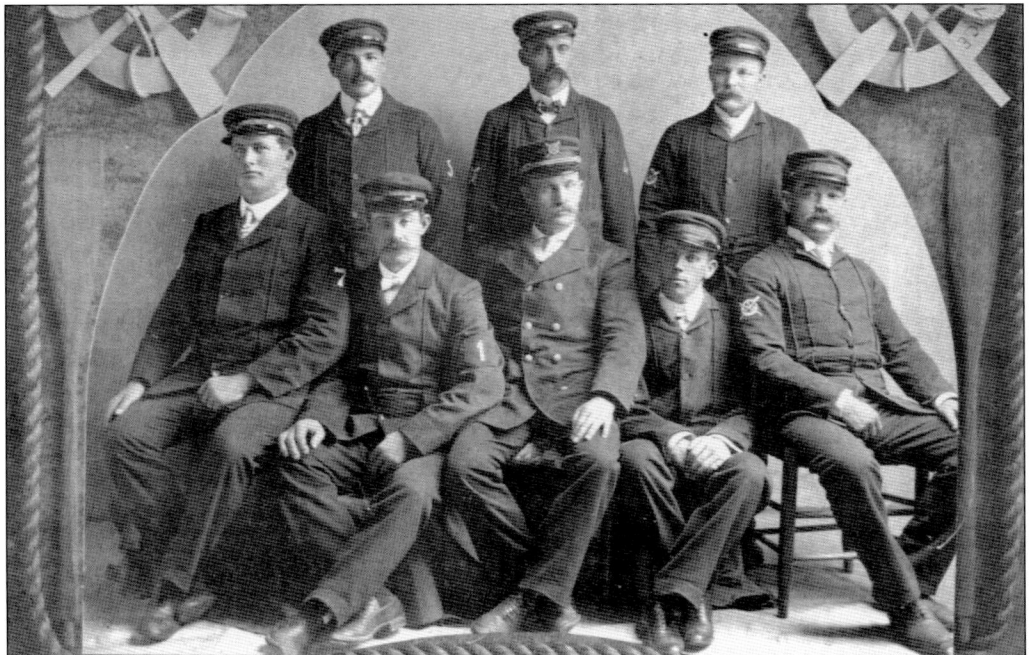

Group photographs of life-saving crews are fairly common. Here is the Coquille River Life-Saving Station crew in 1899. The number on their left shoulders signifies their position in the crew and their responsibilities. No. 1 was the keeper's right-hand man (Fred Mehl); no. 7 was the most inexperienced (Clarence Boice). (Courtesy of Bandon Historical Society Museum.)

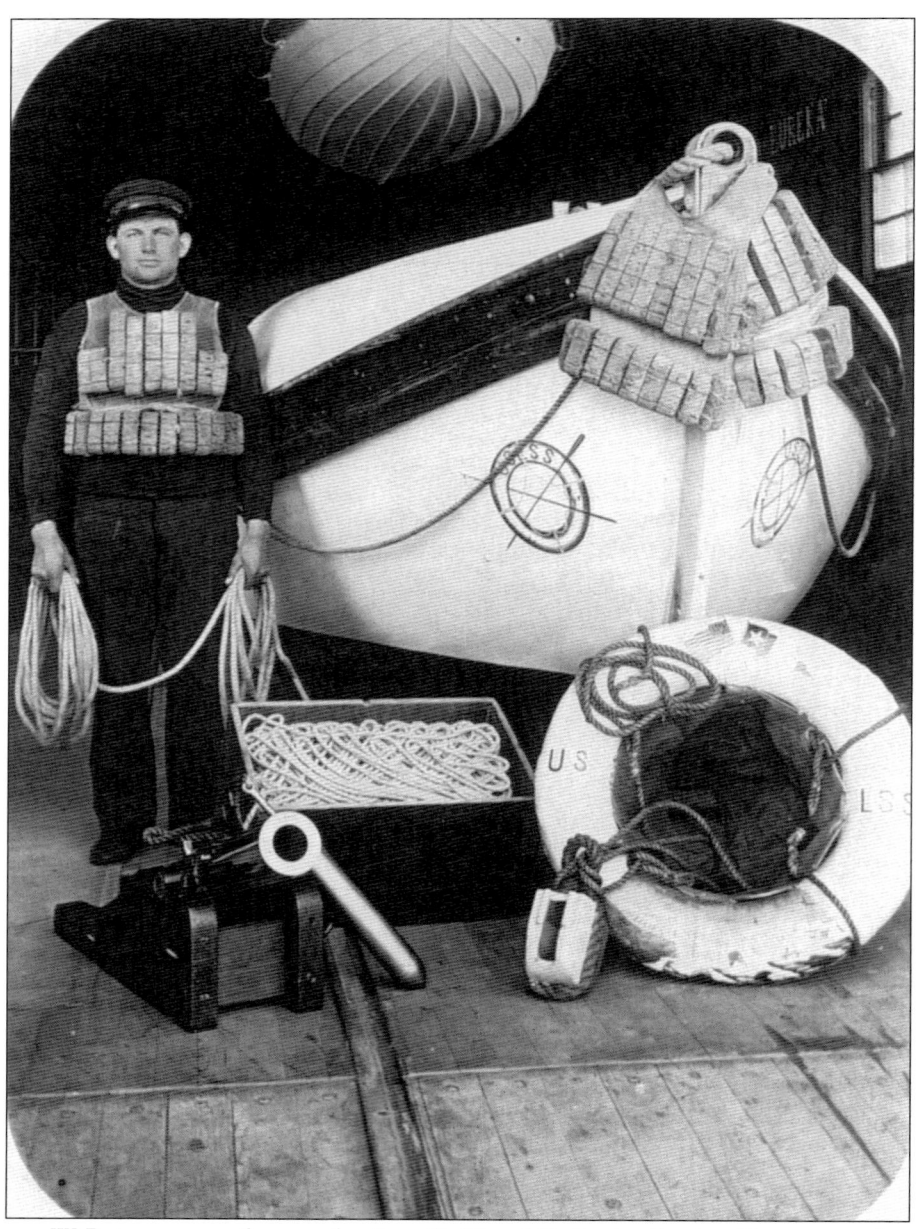

Clarence W. Boice was a surfman at the Coquille River Life-Saving Station. He is pictured wearing his cork life vest. In front of him is the station's Lyle gun with projectile, faked line in faking box, and a breeches buoy with block. Behind him is the station's Dobbins lifeboat. Above him is the life car hooked to the rafters of the boathouse. Boice eventually rose to the No. 1 position at Coquille and then accepted the duty of keeper at the Coos Bay Life-Saving Station 18 miles north up the coast. Unfortunately, the wreck of the *Czarina* in 1910 intervened in his career. He was held responsible for not doing enough to save the crew of the *Czarina*, resulting in the deaths of 23 men. (The wreck is detailed in Chapter 7, Coos Bay.) He was demoted to surfman and returned to the Coquille River Life-Saving Station to finish out his career. (Courtesy of Bandon Historical Society Museum.)

The station was located on a hill with a commanding view of the Coquille River, the Bandon waterfront, and the lighthouse across the river. The station was approximately 70 feet above the boathouse. Note the elegant gothic entry at the top of the stairs into the yard and the bell stand to its left. (Courtesy of Bandon Historical Society Museum.)

Saturday was "maintenance day" in the regimented week of the surfman. Here is the crew all pitching in to paint the roof of the boathouse in red lead, the common roof paint in 1900. The red lead paint held up well to the elements. The "red roof, white body" paint scheme is continued today as a Coast Guard tradition, but without the lead. (Courtesy of Bandon Historical Society Museum.)

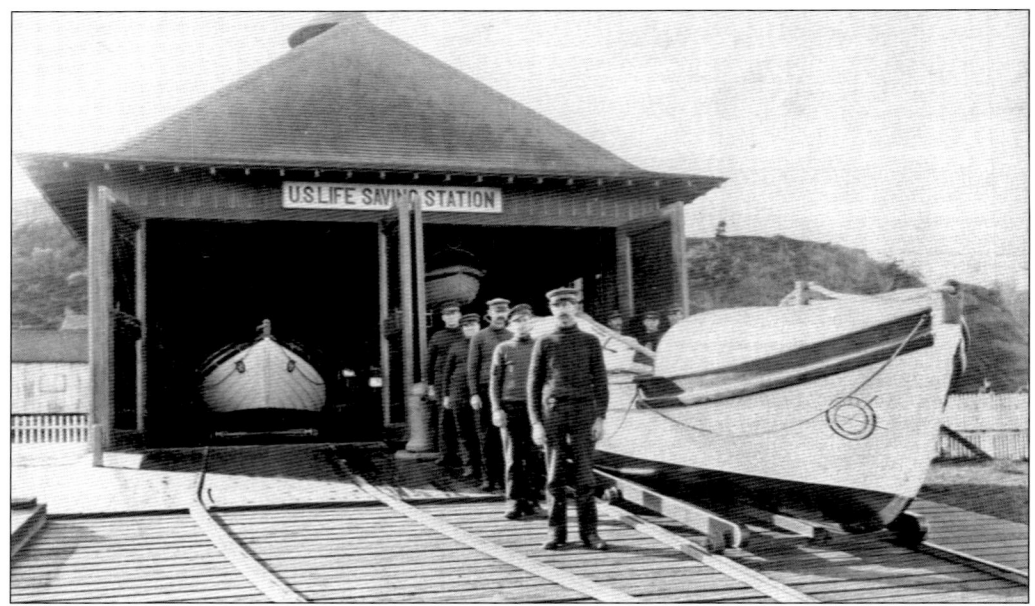

The Coquille River Life-Saving Station boathouse was a typical Fort Point–type boathouse with witch's hat ventilator. The Coquille River boathouse was located on the waterfront below the station complex. The building was one-story with two bays and measured 24 feet wide by 40 feet deep. The left bay held a surfboat and the right bay a lifeboat. A launchway led from the building directly into the Coquille River. (Courtesy of Bandon Historical Society Museum.)

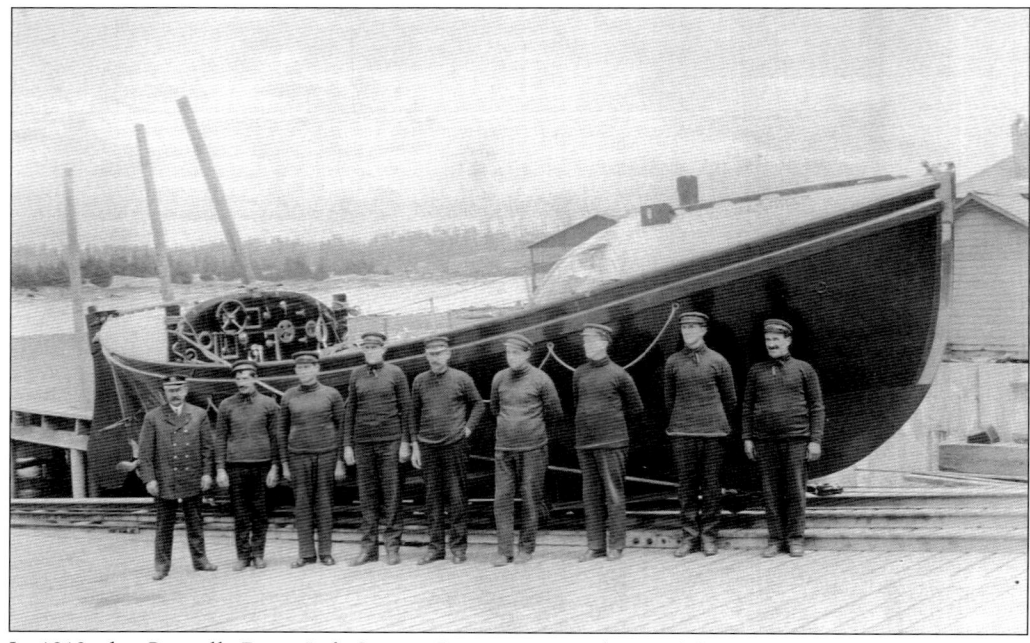

In 1912, the Coquille River Life-Saving Station received one of the new 36-foot motor lifeboats. The first true motor lifeboat was assigned in 1908 to Waaddah Island Life-Saving Station in Washington, as the Pacific Coast was the first to receive the 36-footers. Capt. Robert Johnson is at the far left. (Courtesy of Bandon Historical Society Museum.)

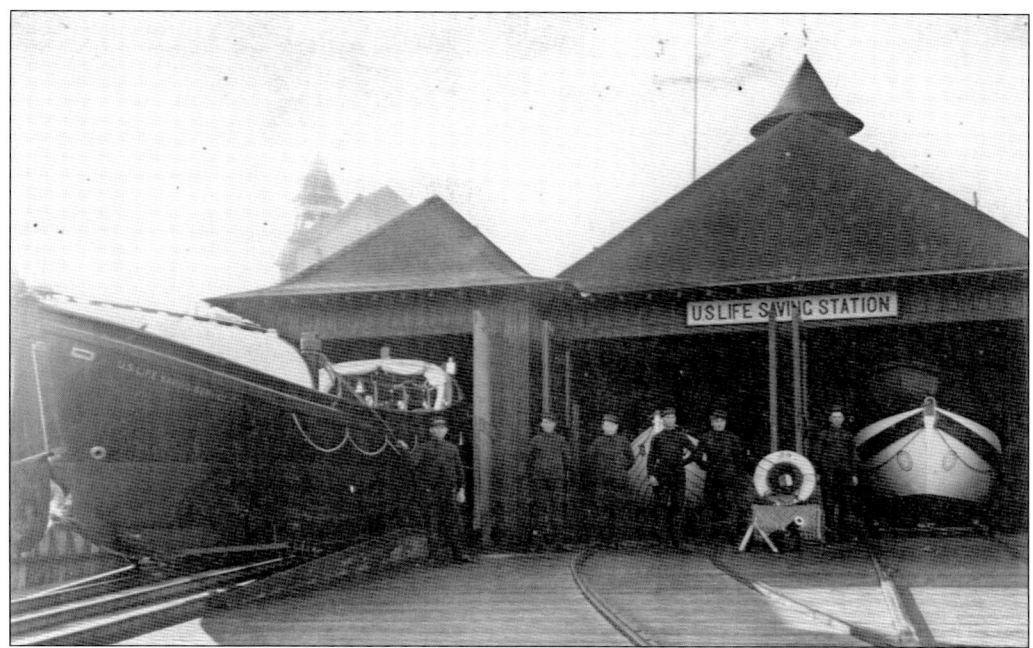

Soon after obtaining their 36-footer, a diminutive boathouse was inelegantly appended onto the original boathouse to shelter the gleaming new boat. Another launchway was built adjacent to the old one to give the new motor lifeboat a direct run into the river. (Courtesy of Bandon Historical Society Museum.)

The life-saving crews were heroes of their day and were a great source of pride and entertainment for the community. Note the large gathering on the docks watching the Coquille River crew hurtle down the launchway in their Dobbins lifeboat during practice. (Courtesy of Bandon Historical Society Museum.)

About a mile southwest of the station there was a lookout station to watch the river mouth. The watch house was similar to those mounted at other stations on a tower. This one, however, was elevated by its location on Coquille Point and had no need for additional height. The watch house was an 8-foot cube with windows on each side, capped by a hipped roof, and built on a wooden platform. (Courtesy of U.S. Coast Guard.)

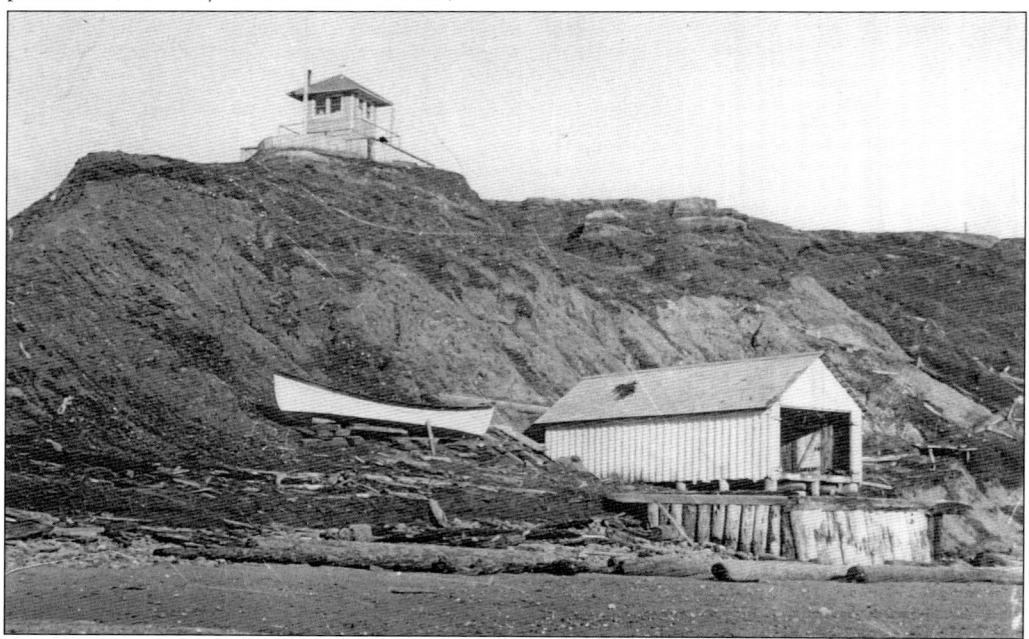

Below the lookout on the beach was an auxiliary boathouse where a surfboat and equipment were kept just in case the boats from the station could not get across the bar in an emergency. This was common at most stations. The boathouse burned in 1921. (Courtesy of Bandon Historical Society Museum.)

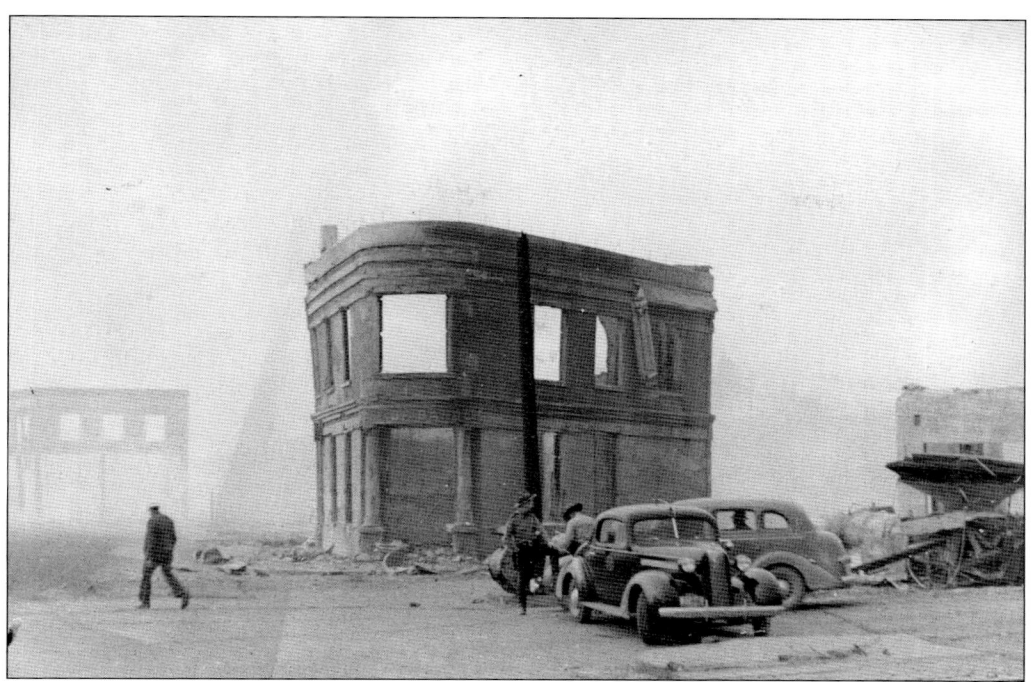

Unfortunately, most of the town of Bandon burned down in 1936. Only 16 out of approximately 500 buildings survived the blaze on September 26, 1936. The unstable Bank of Bandon seen here had to be pulled down. (Courtesy of Bandon Historical Society Museum.)

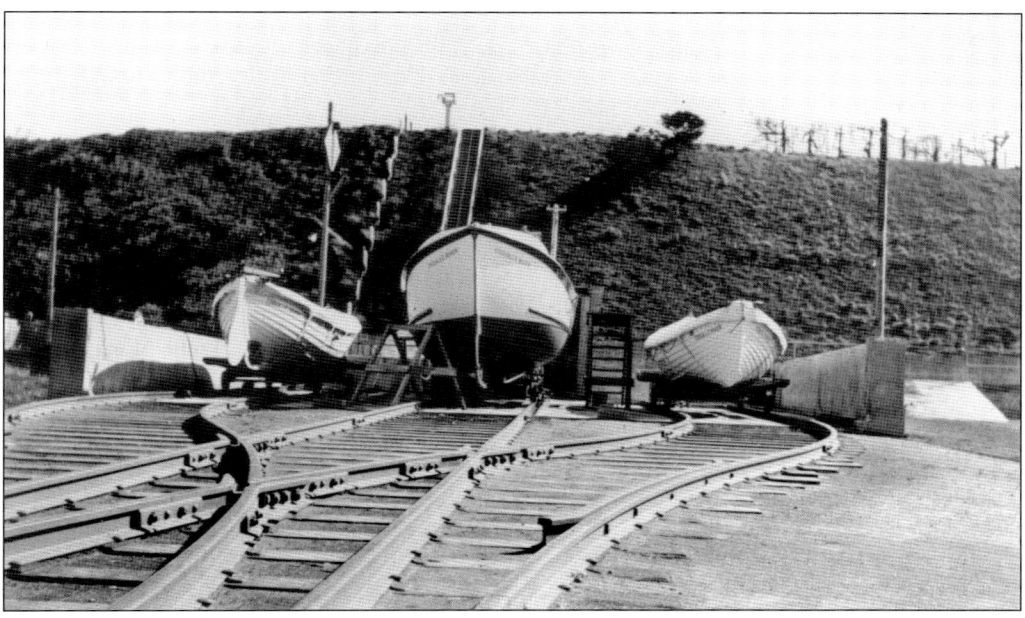

The life-saving station complex did not survive the September firestorm. All that did endure were the boats, the concrete launchway, and the bell stand on the hill. The "open air" boathouse would serve them for four years until a new station was built. (Courtesy of U.S. Coast Guard.)

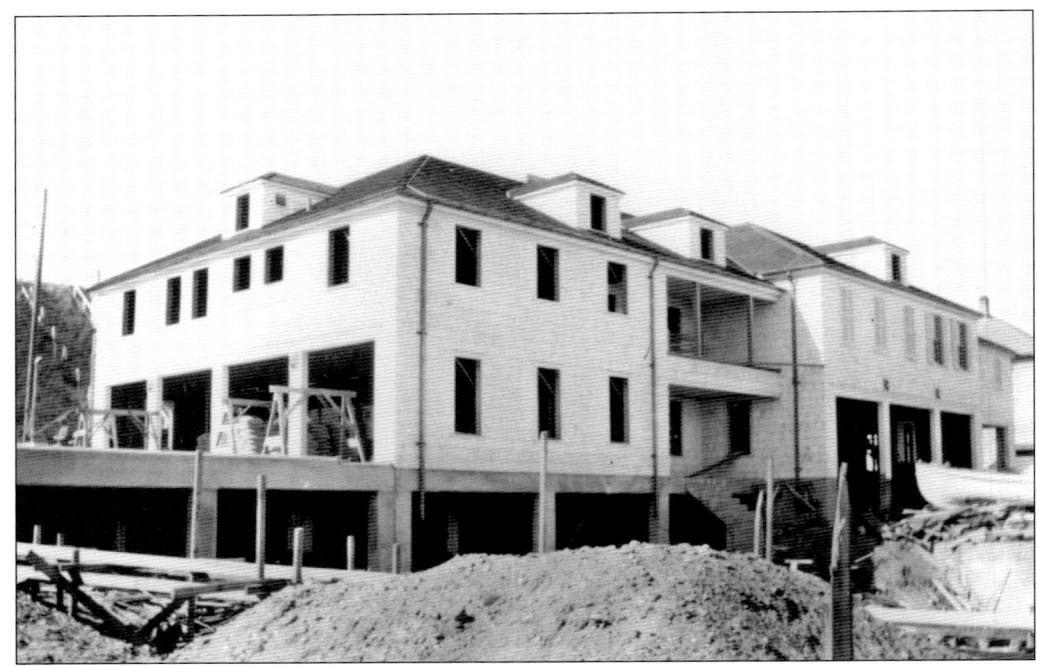

After the old life-saving station and boathouse were destroyed in 1936, the crew moved into the town's former city hall. It was decided to consolidate all of the Coast Guard operations into one building on the waterfront, similar to the one on Yaquina Bay's waterfront though larger. The structure cost approximately $80,000, but equipping the station drove the cost up to $125,000. This was by far the most expensive of the pre–World War II stations built in Oregon, and at 120 feet wide, 54 feet deep, and two stories, it was also the largest. The crew occupied the new station in January 1940. (Courtesy of U.S. Coast Guard, above; Bandon Historical Society Museum, below.)

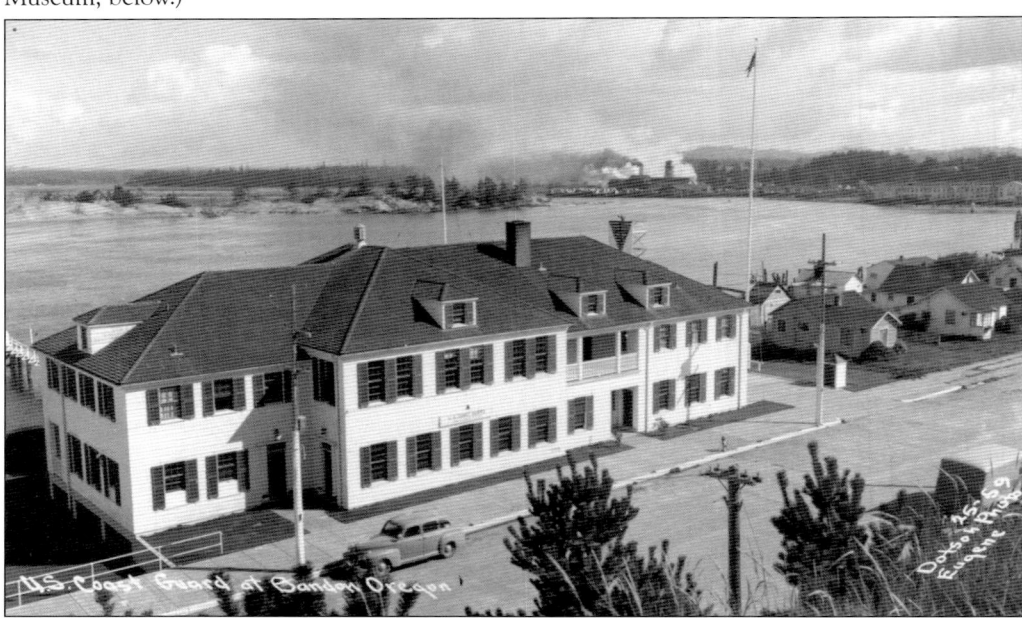

Nine

CAPE BLANCO

On the Southern Oregon Coast, Cape Blanco juts out into the Pacific creating the second-westernmost point in the contiguous United States. It is thought that Martin de Aguilar sighted and named Cape Blanco in 1603; however, his travel itinerary had the name "Cape Blanco" already on it prior to his departure. There is no proof that Aguilar even reached Oregon on his exploratory cruise up the coast from Acapulco. However, explorers Heceta, Bodega, and Cook are all credited with sighting Cape Blanco in the 1770s. On April 24, 1792, George Vancouver observed Cape Blanco and renamed it Cape Orford, as its position and dark color "did not seem to intitle [sic] it to the appellation of Cape Blanco." Vancouver named it Cape Orford after a friend, the Earl of Orford. However, the Cape Blanco label was persistent, and Cape Orford fell out of use, though the Orford name is alive and well in the town of Port Orford.

Originally the town of Port Orford was called Ewing Harbor, named after a U.S. Coast and Geodetic Survey ship, the *Ewing*. However, like Cape Orford, the name did not stick, and the name Port Orford prevailed. The town of Port Orford had started life as two block houses built in defense against the local Native American population in 1851. It was a tenuous beginning for Port Orford, but with the discovery of gold in February 1852 in the Rogue River Valley, the town of Port Orford solidified. The town became a supplier of lumber for the miners.

Throughout the Civil War, Port Orford continued to hang on. With the mines on the South Coast exhausted, there was no return of the prosperity of the 1850s. Hubert Howe Bancroft wrote about the town's isolated location, "Port Orford is a little hamlet on the wrong side of the mountain with no reason on earth for being there." Not until the completion of the Oregon Coast Highway in 1936 was Port Orford brought out of its landward isolation, though today, it is still a small, coastal community.

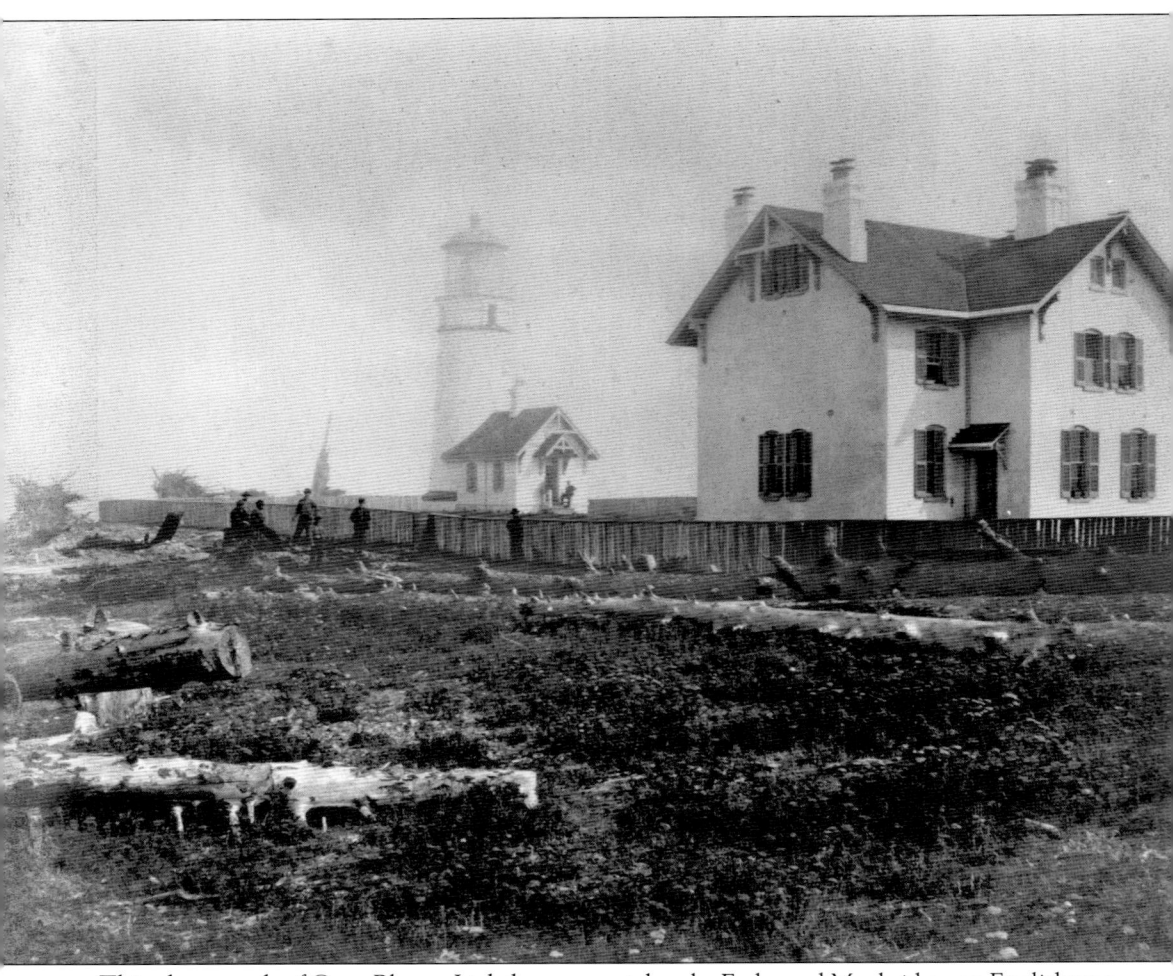

This photograph of Cape Blanco Lighthouse was taken by Eadweard Muybridge, an Englishman who emigrated to the United States and established himself in the book trade in San Francisco in the 1850s. While recovering after a serious stagecoach accident, he became completely absorbed by photography. He gained fame with a series of early photographs of Yosemite. The federal government took him on an expedition to photograph the newly acquired Alaska territories in 1868. In 1871, he traveled the West Coast between Puget Sound and San Diego taking pictures of lighthouses for the U.S. Lighthouse Board at a fee of $20 a day, this being one of his images. Muybridge went on to become even more famous for his stop-motion photography, the most famous of which settled the debate whether a horse's hooves all leave the ground simultaneously while galloping. He continued to study movement with stop-motion photography for the rest of his career. (Courtesy of U.S. Coast Guard.)

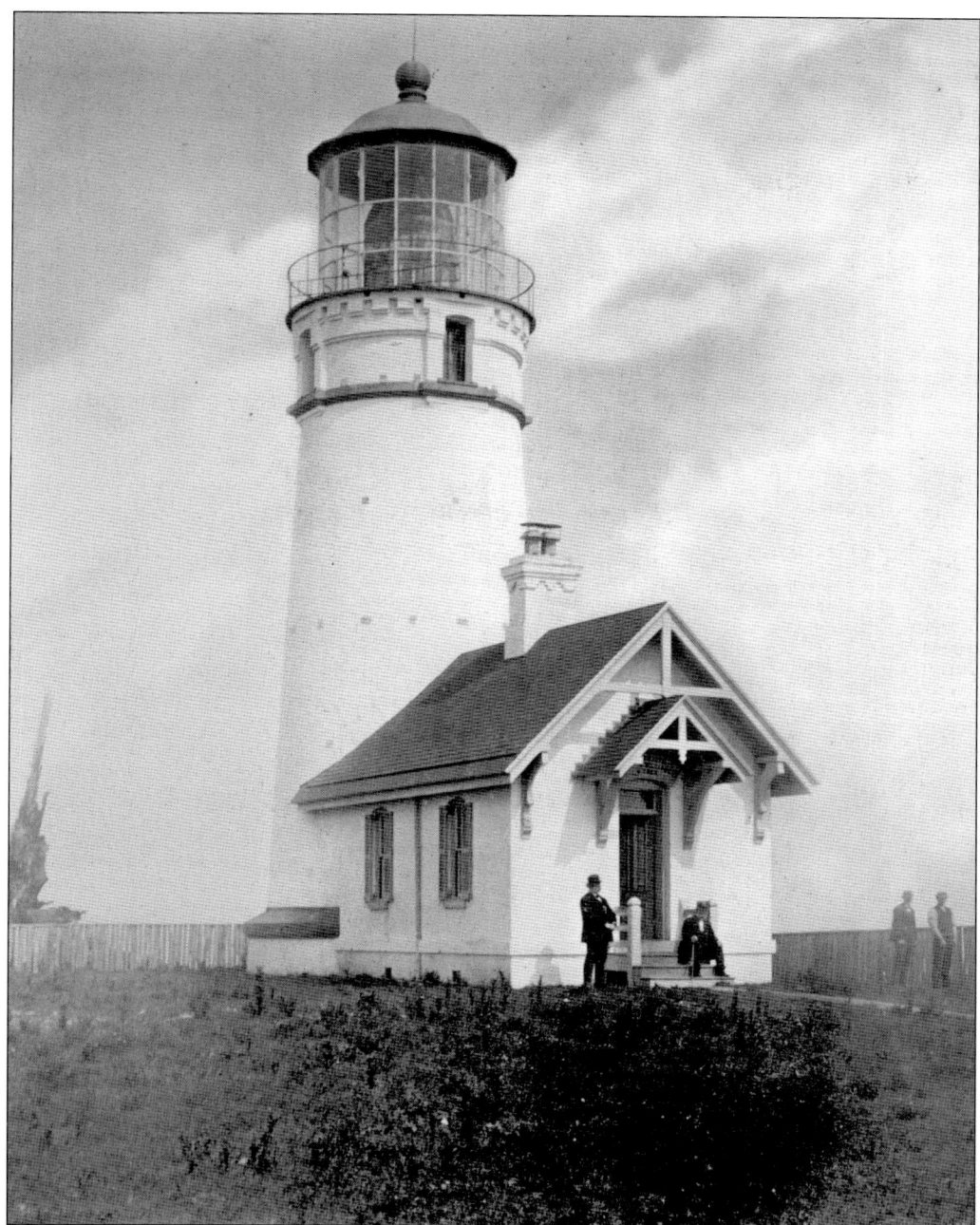

The Cape Blanco Lighthouse is the oldest-standing lighthouse on the Oregon Coast, though it was the third to be built. This photograph was also taken by Eadweard Muybridge in 1871, not long after the lighthouse's lighting on December 20, 1870. The drawings for the Cape Blanco Lighthouse were signed by Robert S. Williamson, the same engineer who designed the Yaquina Bay Lighthouse (1871). Note the small, dark squares on the lighthouse's body. These were attachment points for scaffolding that had yet to be painted. (Courtesy of U.S. Coast Guard.)

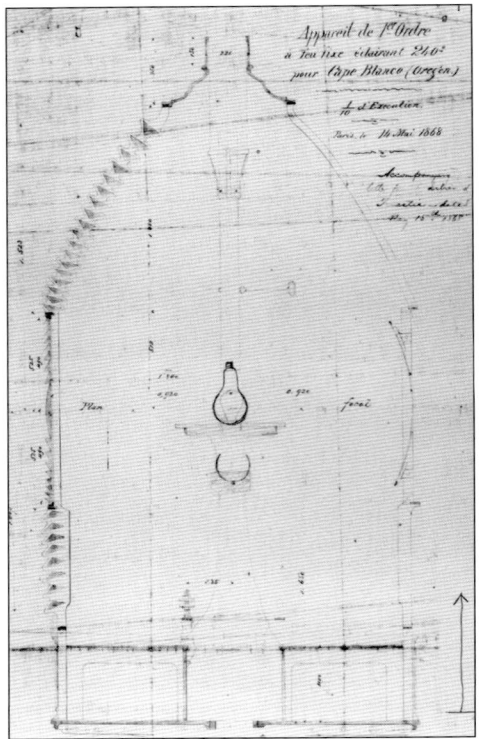

Cape Blanco Lighthouse had a first-order Fresnel lens. This is the original shop drawing for the lens apparatus made in France by Barbier and Fenstre in 1868. All units on the drawing are in meters. Later on, someone sketched in a bulb. The lens currently in the lighthouse is actually a replacement from 1936, slightly smaller than the original 1868 lens. No one knows what happened to the 1868 lens. (Courtesy of U.S. Coast Guard.)

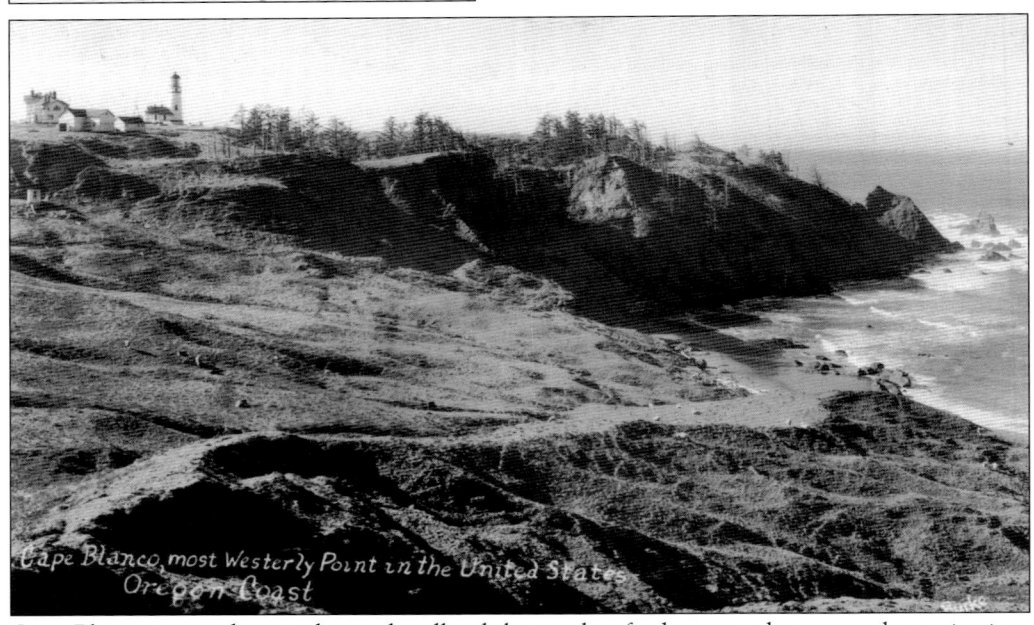

Cape Blanco is a rocky, windswept headland that pushes farther west than any other point in Oregon. This photograph incorrectly states that is it is the westernmost point in the United States. Of course Hawaii and Alaska both provide points farther west; however, they were not states when this photograph was made. Washington though was a state, and Cape Flattery on the Olympic Peninsula is a few minutes farther west. (Author's collection.)

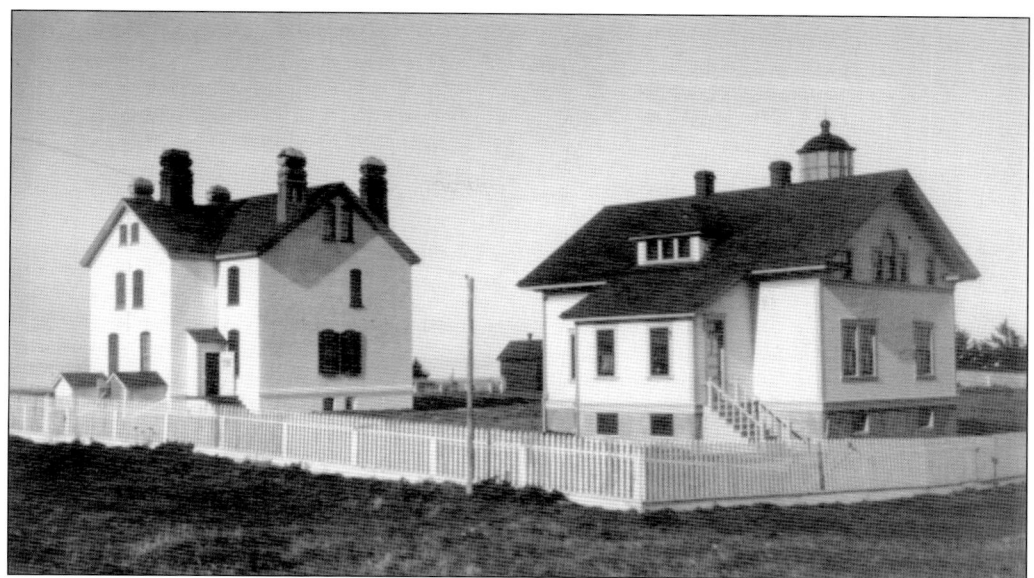

This photograph was taken by B. O. Smetzer in 1916, several years after the completion of a new keeper's residence. The old keeper's dwelling, built in 1870, was relegated to the two assistant keepers and their families. The new keeper's residence was completed in April 1910 for a cost of $6,218.40. (Courtesy of U.S. Coast Guard.)

The new keeper's dwelling was built in the latest bungalow style in 1910. Note the Palladian window in the side of the house, a fanciful architectural element for a house in the middle of nowhere. Also note the enormous wireless antennas in the background already erected in 1916 when B. O. Smetzer took this photograph. (Courtesy of U.S. Coast Guard.)

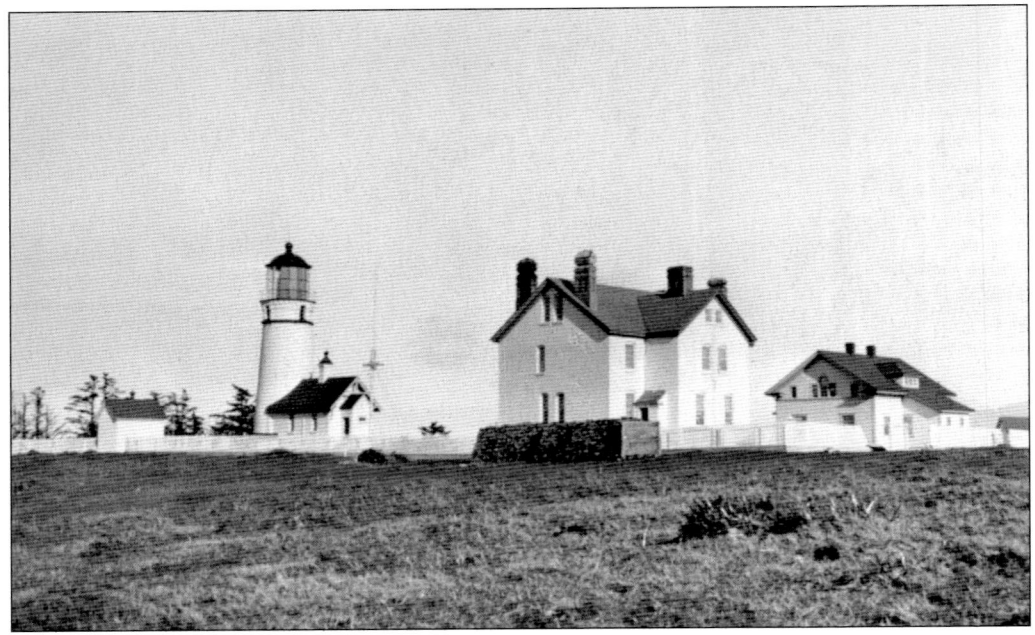
The lighthouse stations of the Oregon Coast were major complexes, since there were often three families stationed at the site far from civilization. In this 1936 photograph, note the enormous pile of wood stacked in the foreground. (Courtesy of U.S. Coast Guard.)

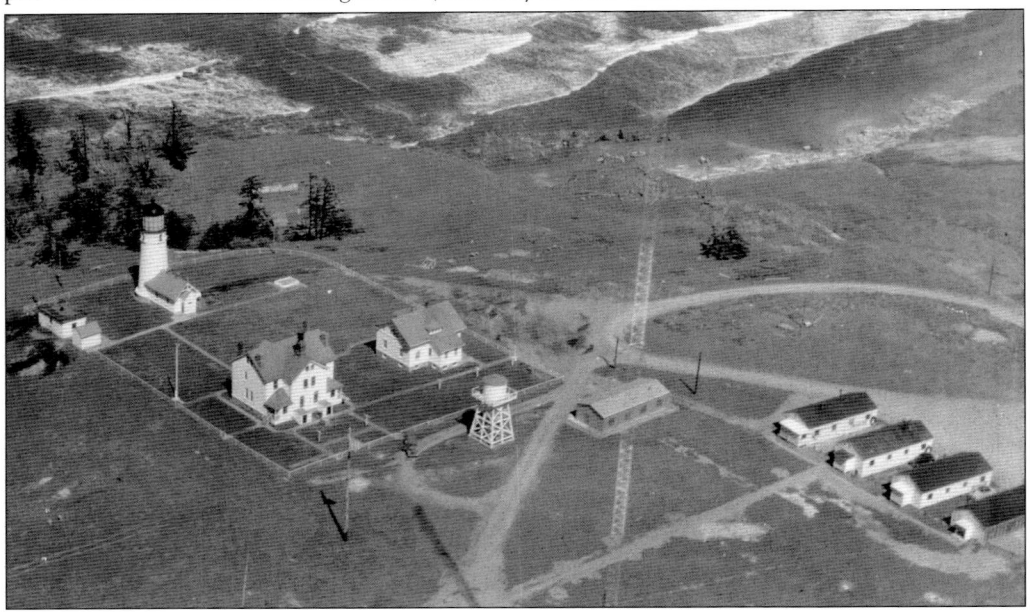
The lighthouse complex at Cape Blanco became a large antenna base during World War II and throughout the Cold War. As with many Coast Guard facilities, buildings were razed when they became surplus. The keepers' dwellings were demolished in the 1960s. The lighthouse became fully automated in 1980. With a less active role at the site, the Coast Guard in 1994 granted an interagency permit to the Bureau of Land Management to interpret the site for the public. (Courtesy of U.S. Coast Guard.)

To attract more shipping and commerce, the town of Port Orford wanted a life-saving station to guard its harbor. As early as 1889, Oregon senator John H. Mitchell requested "an appropriation for the establishment of a life-saving station and providing for a life-saving crew at Port Orford." On March 3, 1891, Congress authorized a life-saving station for Port Orford; however, location and property negotiations dragged the process on for decades. Finally, an appropriation was made in 1932 for a station. (Author's collection.)

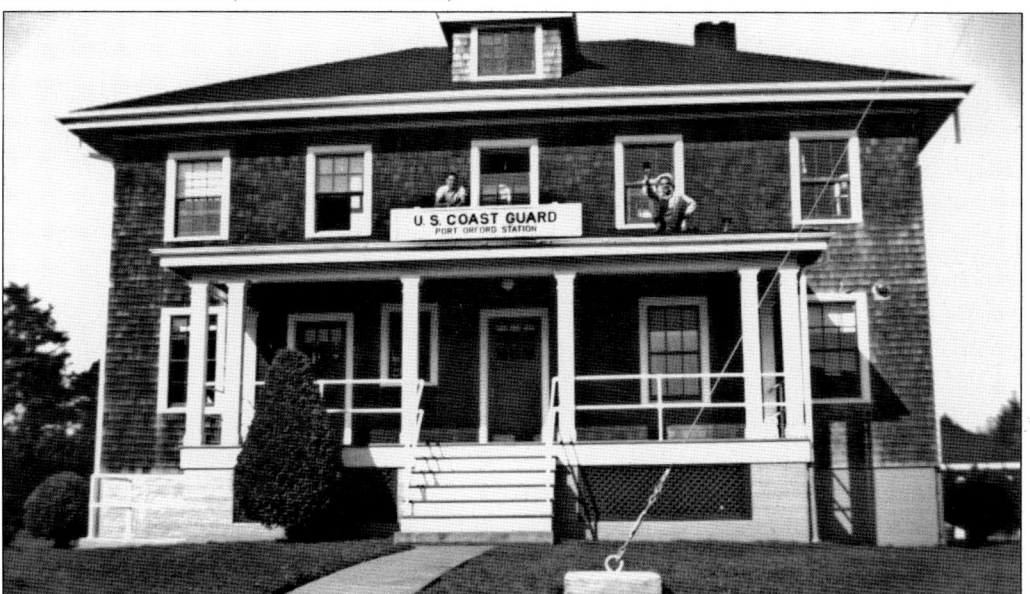

Port Orford had waited 43 years for a station, longer than any other Oregon coastal community that received a station. On July 1, 1934, the station was commissioned and put into service. Note the two coastguardsmen painting the roof of the porch with red lead. This photograph was taken during World War II by Art Hinderlie, a coastie stationed at the base. (Courtesy of Point Orford Historical Society.)

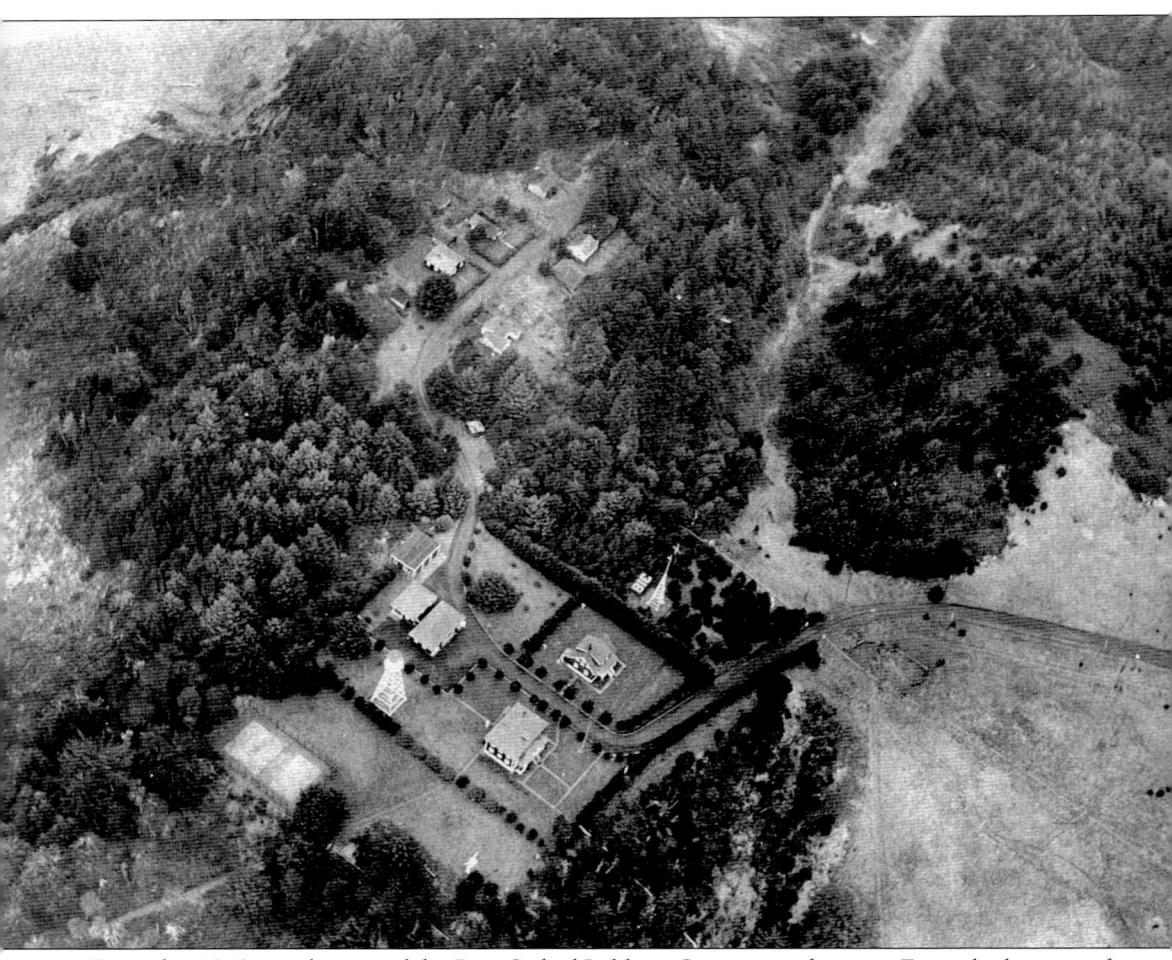

From this 1949 aerial, most of the Port Orford Lifeboat Station can be seen. From the bottom of the photograph up, one can see the wreck pole, the tennis courts, the station barracks, the water tower, three garages, the keepers' quarters, a radio antenna, and then a small grouping of houses at the top. This was "Little America," a tradition on the Oregon Coast where crew members could build a house for their family to have them nearby, as a crew member was required to live in the barracks. The small houses of Little America were usually built on government property and were sold and split off as traditions evolved. (Courtesy of National Archives.)

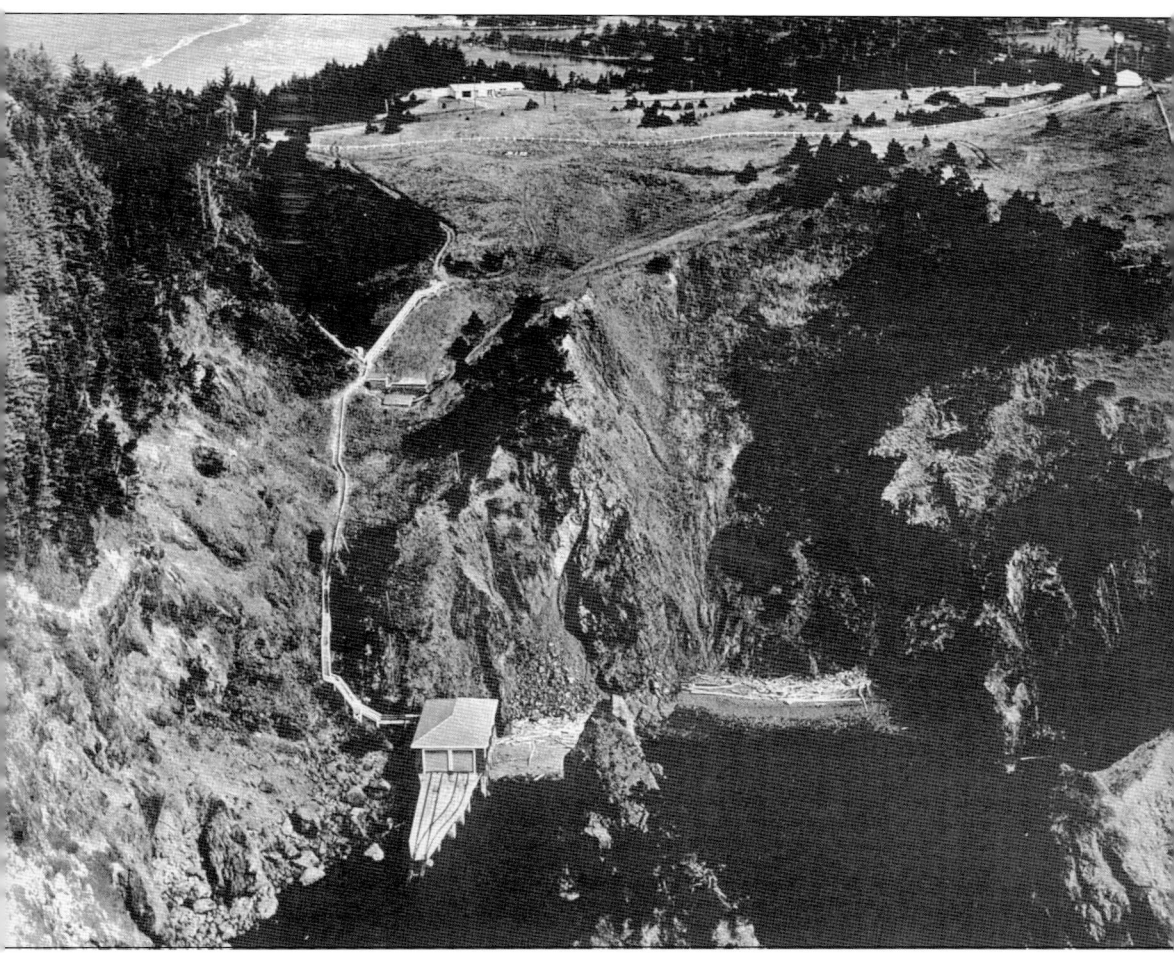

This picture of Nellie's Cove was taken in 1959 and shows the boathouse for the Port Orford Lifeboat Station at the bottom. Boathouses were always located on the water, especially after the advent of heavy motor lifeboats around 1915. As typical, this boathouse is on the water; however, what is unusual is that the boathouse is located 280 vertical feet below the station house (just visible in the upper left-hand corner of the photograph). The 532-step staircase used to reach the boathouse was known as "The Stairs of a Thousand Tears." The boathouse was 36 feet wide by 60 feet deep, was two bays wide, and capped with a hipped roof. Rails left each boat bay and joined together in a single set leading down the launchway and into the water. (Courtesy of National Archives.)

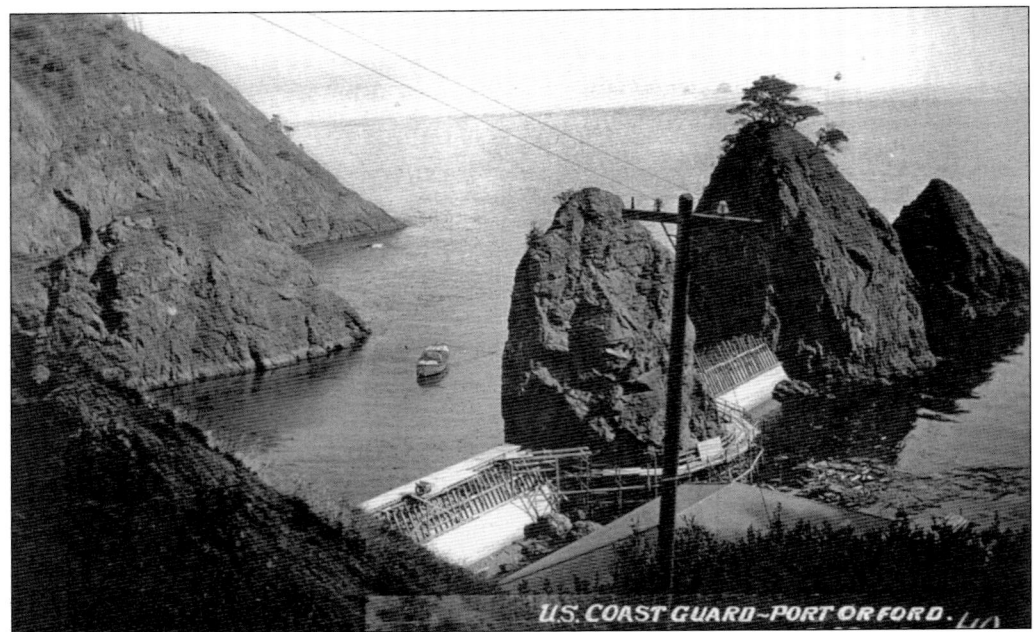

A storm damaged the boathouse and launchway extensively in 1939. This photograph shows the formwork for a massive concrete breakwater. The jagged rocks, called the Three Sisters, in the middle of the cove were connected by concrete to divide Nellie's Cove in two and to give more protection to the boathouse shown in the foreground. (Courtesy of National Archives.)

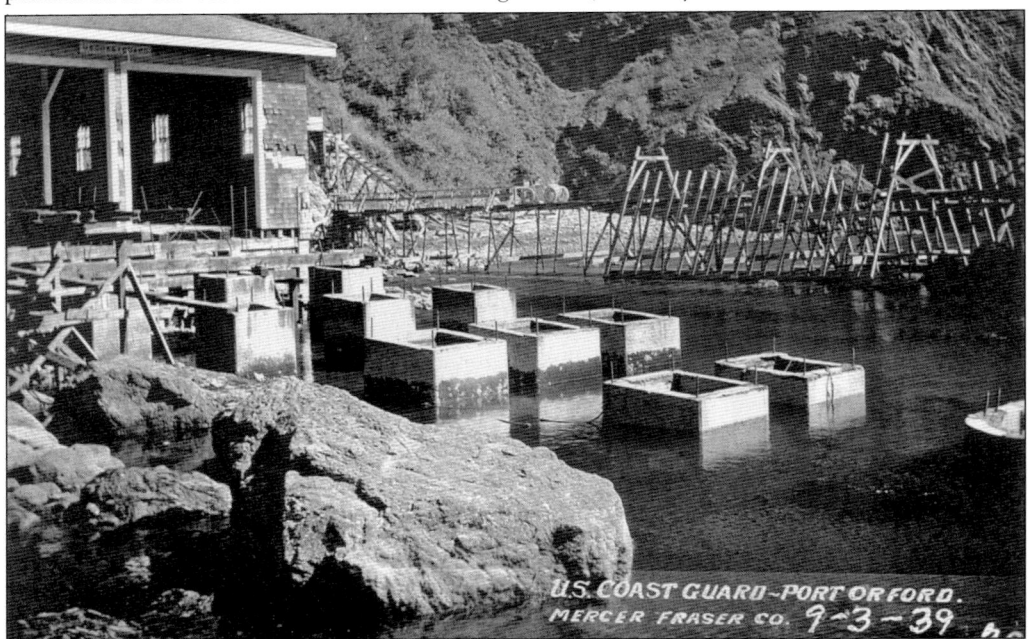

The launchway was also rebuilt in 1939 using concrete caissons instead of wooden pilings. The start of the formwork for the concrete breakwater can be seen in the background. Unfortunately, the boathouse burned down in the 1970s and all that remains today are the concrete caissons and remnants of the launchway. (Courtesy of National Archives.)

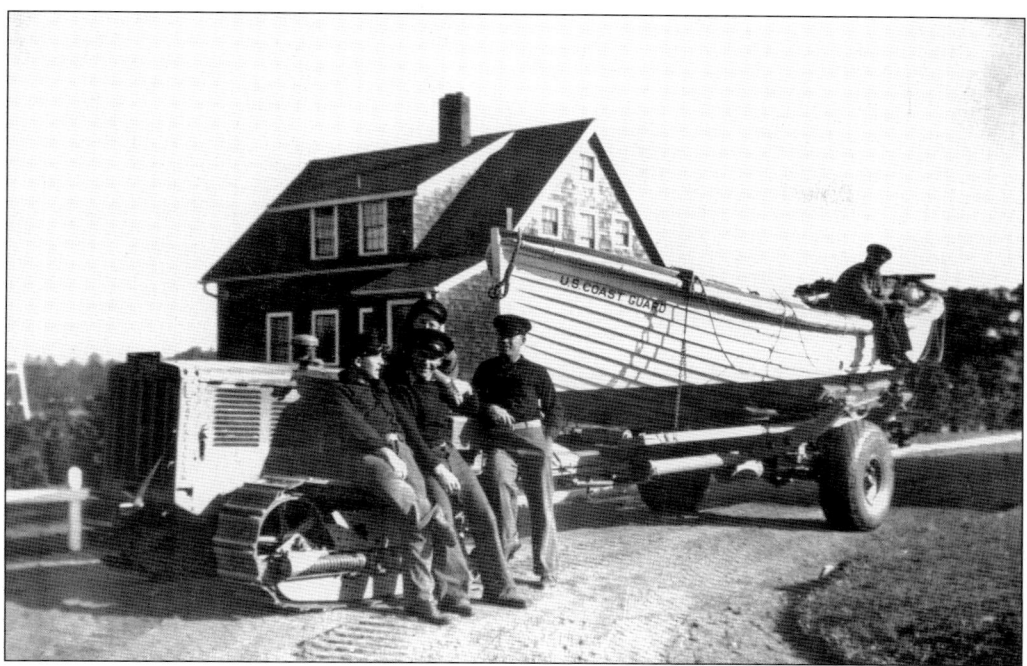

Considering the location of the boathouse, moving this motor lifeboat by tractor was only sensible. All the remaining photographs were taken by Art Hinderlie during World War II. (Courtesy of Point Orford Heritage Society.)

Playing tennis could pass the time between training, patrols, and rescues during World War II. The coasties are playing on the station's tennis court still visible at Port Orford today. (Courtesy of Point Orford Heritage Society.)

Playing cards could pass the time in the evenings. These four are playing in the station's dining room. Note the map of Japan on the wall behind the men. (Courtesy of Point Orford Heritage Society.)

The dining room would be fully laid out for special dinners. Today this room is the focus of the Port Orford Lifeboat Station Museum. In 1970, the lifeboat station was decommissioned after 36 years of service. The site was then deeded to Oregon State Parks, which created Port Orford Heads State Park. In 1995, the Point Orford Heritage Society began working with Oregon State Parks to restore former Coast Guard Station and create a maritime museum. In 2000, the Port Orford Lifeboat Station Museum opened. (Courtesy of Point Orford Heritage Society.)

Bibliography

Beckham, Dow. *Bandon By-the-Sea: Hope and Perseverance in a Southwestern Oregon Town.* Coos Bay, OR: Arago Books, 1997.

Bishop, Eleanor C. *Prints in the Sand: The U.S. Coast Guard Beach Patrol During World War II.* Missoula, MT: Pictorial Histories Publishing, 1989.

Donovan, Sally, and Barb Kachel. *National Register Multiple Property Nomination for Lighthouse Stations of Oregon.* Salem, OR: Oregon State Historic Preservation Office, 1992.

Gibbs, James A. and Bert Webber, ed. *Oregon's Seacoast Lighthouses: An Oregon Documentary.* Medford, OR: Webb Research Group, 1992.

———. *Pacific Graveyard,* 4th ed. Portland, OR: Binford & Mort, 1993.

Kimball, Sumner I. *Organization and Methods of the United States Life-Saving Service.* Washington, D.C.: GPO, 1912.

King, Irving H. *The Coast Guard Expands, 1865–1915: New Roles, New Frontiers.* Annapolis, MD: Naval Institute Press, 1996.

Leffingwell, Randy. *Lighthouses of the Pacific Coast.* Stillwater, MN: Voyageur Press, 2000.

National Park Service, U.S. Coast Guard, and Department of Defense. *Historic Lighthouse Preservation Handbook.* Washington, D.C.: GPO, 1997.

Nelson, Sharlene and Ted Nelson. *Umbrella Guide to Oregon Lighthouses.* Seattle: Epicenter Press, 1994.

Noble, Dennis L. *Lighthouses & Keepers: The U.S. Lighthouse Service and its Legacy.* Annapolis, MD: Naval Institute Press, 1997.

———. *That Others Might Live: The U.S. Life-Saving Service, 1878–1915.* Annapolis, MD: Naval Institute Press, 1994.

Shanks, Ralph, and Wick York. *The U.S. Life-Saving Service: Heroes, Rescues and Architecture of the Early Coast Guard.* Lisa Woo Shanks, ed. Petaluma, CA: Costaño Books, 1996.

U.S. Coast Guard. *Annual Report of the United States Coast Guard.* Washington, D.C.: GPO, 1915–1935.

U.S. Life-Saving Service. *Annual Reports of the Operations of the Life-Saving Service.* Washington, D.C.: GPO, 1876–1914.

Discover Thousands of Local History Books Featuring Millions of Vintage Images

Arcadia Publishing, the leading local history publisher in the United States, is committed to making history accessible and meaningful through publishing books that celebrate and preserve the heritage of America's people and places.

Find more books like this at
www.arcadiapublishing.com

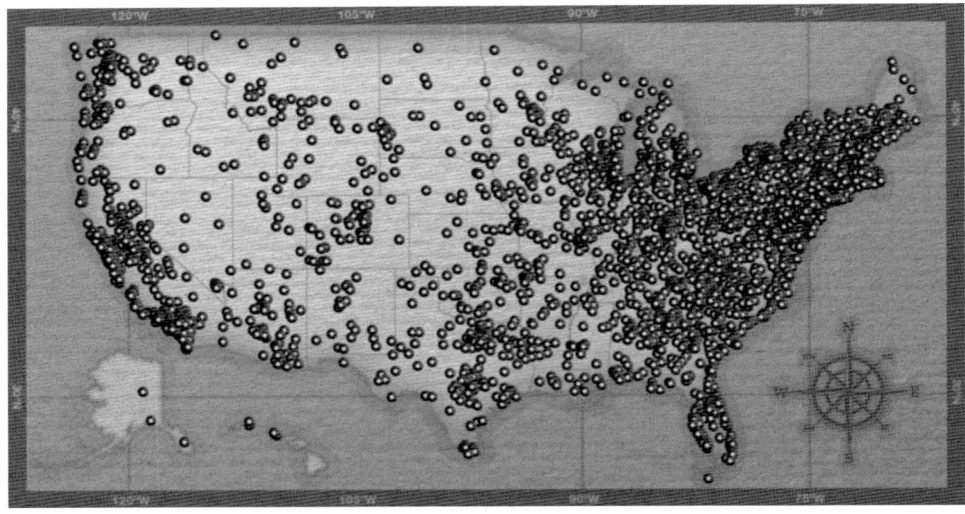

Search for your hometown history, your old stomping grounds, and even your favorite sports team.

Consistent with our mission to preserve history on a local level, this book was printed in South Carolina on American-made paper and manufactured entirely in the United States. Products carrying the accredited Forest Stewardship Council (FSC) label are printed on 100 percent FSC-certified paper.